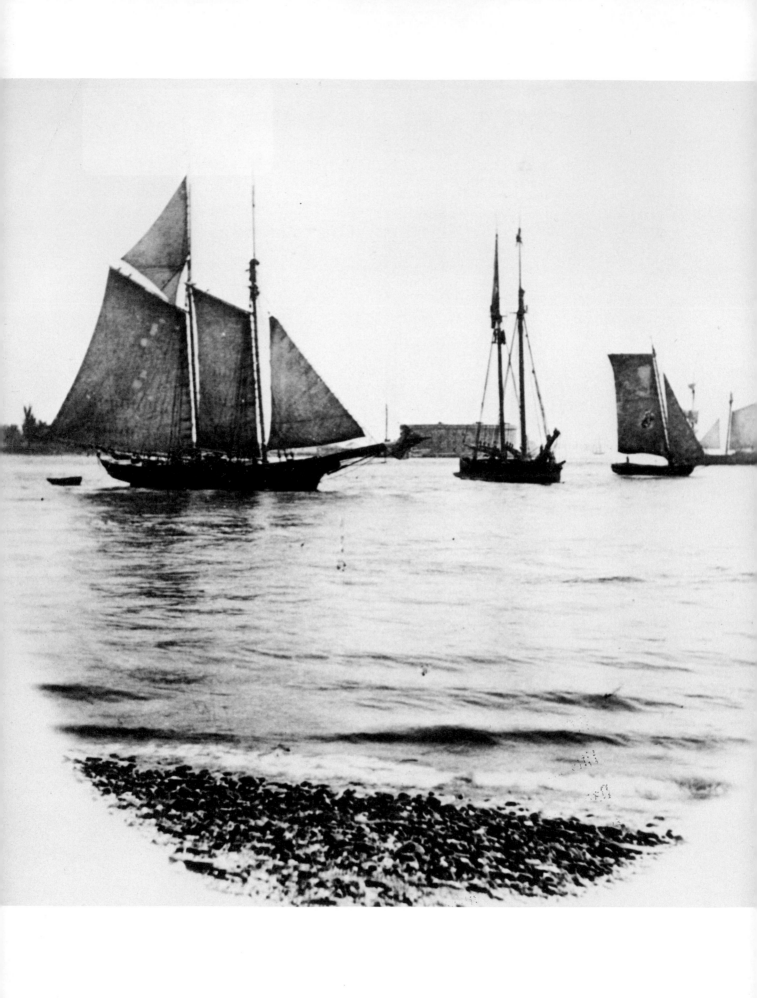

MARITIME NEW YORK
IN NINETEENTH-CENTURY
PHOTOGRAPHS

Harry Johnson
&
Frederick S. Lightfoot

Dover Publications, Inc.
New York

NOTE

Harry Johnson, coauthor of this book, did not live to see it in print. It now becomes a memorial to him, and to those remarkable qualities in his character which drove him to initiate it and then to find time in his pressing schedule for his intense, conscientious and knowledgeable search for accurate data on the vessels, docks and other subjects of the pictures in the book. He located many rare sources of information and visited other men who have loved the harbor and could help him check and recheck difficult points. The book is thus a record of his exceptional effort as well as of the harbor.

Frontispiece: An Anthony view from the Battery, taken in 1868.

Published in Canada by General Publishing Company, Ltd., 30 Lesmill Road, Don Mills, Toronto, Ontario.
Published in the United Kingdom by Constable and Company, Ltd., 10 Orange Street, London WC2H 7EG.

Maritime New York in Nineteenth-Century Photographs is a new work, first published by Dover Publications, Inc. in 1980.

Book design by Carol Belanger Grafton

International Standard Book Number: 0-486-23963-2
Library of Congress Catalog Card Number: 79-55404

Manufactured in the United States of America
Dover Publications, Inc.
180 Varick Street
New York, N.Y. 10014

FOREWORD

Most of us have probably, on occasion, regretted not being born in time to walk along New York City's South Street in the days when its piers were crowded with magnificent clipper ships and other fine craft.

The docks were relatively unrestricted then, and we could have sauntered among the cargoes, brought from all over the world, piled in the open on the docks and streets. We would have enjoyed an infinite variety of aromas and scents from tropical fruits, tea, coffee, spices, oils, bales of leather, metals, tar and other marine supplies, all blended with the smell of dray horses, sweating workmen and the fragrance of the still-clean harbor.

In those days, there was a more human and intimate atmosphere on the waterfront. In place of today's container ships and powerful cargo-handling equipment, there were small armies of stevedores and longshoremen who used their hands and hooks to grapple the sacks, barrels, bales and packing cases. Although the towering masts dwarfed the men aboard the ships, the men were indeed a real and evident part of the living vessels, climbing aloft to work on the lines and sails, painting, touching up, caulking and polishing brass. Others sat on deck splicing, while onshore their counterparts were busy making sails by hand in sail lofts. Wealthy shipowners and internationally respected merchants, who had their offices in buildings across the street from the ranks of ships, often walked over to talk in person with the ships' captains and officers. They mingled on the streets with sailors of many nationalities who jostled one another in rough camaraderie.

On South Street proper and in the side streets there were many restaurants, saloons, a variety of rooming houses and the inevitable brothels which catered to the sailors' hunger for relief from the mean diet and tedium of long voyages. In some of these establishments the sailors were cheated of their pay, drugged and sold like cattle to the shanghai gangs. At the other extreme there were church-sponsored agencies which sought to protect the sailor against himself and the harpies in wait. They provided a decent place to stay onshore and an opportunity for putting money away for the sailor's old age.

The old waterfront had many picturesque details. The abundant signs and banners, lettered in elaborately styled print and bold colors, were flamboyant. Sidewalk vendors of oysters and other foods flourished. Omnibuses and horse-cars trundled down the street along the wharves, and the drays—many of them handsomely painted—clattered on the cobblestones as they carried away cargoes or delivered "wet goods" to the saloons.

Bits and parts of the story of South Street and West Street have been rescued from the memories of a handful of veteran sailors in their nineties, although often their best recollections of the harbor do not extend much earlier than 1900. But, strangely, there has been no comprehensive presentation, in the form of an illustrated book, of the story of the harbor in the period before 1900.

The present book is an attempt to fill this gap, and to offer all who read it a chance to enjoy some of the finest seaport images taken by American photographers, many of them never hitherto published.

ACKNOWLEDGMENTS

The authors are particularly indebted to Cedric Ridgely-Nevitt, Professor of Naval Architecture, Webb Institute, Mr. James Wilson and Mr. Harry Cotterell for making this book possible. All three were most generous in freely divulging enormous amounts of technical and historical data concerning early sail and steam in New York harbor that was necessary in writing this book.

Sincere thanks are also due to Mr. Carlyle Windley and Miss Faye Argentine of Seamen's Church Institute of New York, to whom we owe an incalculable debt for their assistance in compiling and editing the book.

We wish to express our gratitude to the following people and their agencies for their invaluable cooperation and assistance in all forms and manners in completing the publication:

Captain Frank Munoz, Chief Harbormaster (Retired), N.Y. Dock Co., N.Y. and N.J. Port Authority; Mr. Roger B. Dunkerley, Director, Suffolk Marine Museum; Mrs. Gertrude Welte, Suffolk Marine Museum; Mr. Philip L. Budlong, Registrar, Mystic Seaport Inc.; Captain J. H. B. Smith, Commander Richard T. Speer, Mrs. S. R. Morrison, Department of the Navy; Captain A. L. Lonsdale, U.S. Coast Guard; John L. Lochhead, Mariners Museum; Mr. Robert A. Hogg, N.Y. State Maritime College; Mrs. Alice S. Wilson, Secretary, Steamship Historical Society; Mr. James Lorier, Seamen's Church Institute of New York; Mr. Joseph Cantalupo.

CREDITS

[Numbers refer to illustrations, *not* to pages.]

The following illustrations are from the J. S. Benton Collection and appear here courtesy of Mr. Benton, to whom the publisher would like to extend thanks for his cooperation: 4, 6, 10, 11, 13, 19, 24, 30, 42, 64, 72, 76, 79, 86, 114, 154, 186, 188, 189, 191.

Other sources providing illustrations were: Steamship Historical Society of America, Inc., 14, 15, 206; The New-York Historical Society, 18, 39, 177; The Kings Point Museum, 36, 37; The Mariners Museum, Newport News, 57, 81; U.S. Bureau of Ships, 82; U.S. Coast Guard, 98, 99; Seamen's Church Institute of New York, 107; The Peabody Museum of Salem, 125, 184; The Suffolk Marine Museum, 128, 129, 130, 198; The Behrman Collection, 131; The Staten Island Historical Society, 136; The United States Library of Congress, 155, 157; U.S. Navy, 158, 167, 168, 169; The Collection of L. and C. A. Ances, 2, 126. All other material is from the Lightfoot Collection.

CONTENTS

INTRODUCTION ix

THE NEW YORK WATERFRONT BEFORE THE CIVIL WAR 1

THE NEW YORK WATERFRONT AFTER THE CIVIL WAR 30

THE NEW YORK NAVAL SHIPYARD [BROOKLYN NAVY YARD] 116

THE BROOKLYN WATERFRONT 127

THE NEW JERSEY WATERFRONT 138

LONG ISLAND 143

THE HUDSON RIVER 148

INDEX 157

INTRODUCTION

THE STORY OF THE NEW YORK HARBOR, 1846–1900: FROM CLIPPER TO STEAM

This book is primarily a photographic record of a picturesque, vital and strongly individualistic era on New York City's waterfront, when South Street truly was a "forest of masts" with ships packed so closely that it was often hard to tell to which ship a particular mast belonged. The bowsprits did jut out over the street, with their sails drying and men crouched at work on them, repairing their fittings. The graceful lines of the ships are shown well and it is tantalizing to try to decipher the names of the ships and the announcements of their departures on banners and signs.

Prominent in many of the photographs are large, handsome sidewheeler steamboats, often built by the same yards that launched the clippers. Their white superstructures glow and their hulls have an air of speed even as they lie quietly tied to their docks.

The ferries, which inspired one of Walt Whitman's greatest poems, are seen as they shuttle back and forth between Manhattan and Brooklyn, Staten Island and "Jersey." The essential towboats and tugs, lighters (small sailing craft that carried cargo to and from the ships), water boats, pilot boats, and other small craft are documented by the camera. Also sharply recorded are the streets where sailors lounged and swapped yarns and the ancient, tiny maritime countinghouses where shipping entrepreneurs founded—and sometimes lost—great fortunes.

The photographs are also important as pictorial evidence of the changes in the design and advances in the technology of sail and steam craft. Even more significant, the pictures tell a grand story of the ebb and flow of the prosperity of men and nations vis-à-vis ocean commerce.

It is well known that New York harbor is naturally blessed with protection from the sea, access to rich markets via the North (or Hudson) River, New Jersey waterways and the broad stretch of Long Island Sound. It is less well known that much of the successful exploitation of these natural gifts was largely the result of an influx of canny and perceptive New Englanders, upstate New Yorkers and some Englishmen who helped establish the Black Ball and other packet lines to Europe —lines which ran large sailing ships on a regular and reasonably dependable schedule. These men worked astutely to have the Erie Canal built, opening the way for the bountiful agricultural shipments from the West that were destined to make New York the coast's leading grain port. And they managed, through clever bank and factoring arrangements, to have a surprising amount of the South's cotton routed to New England and Europe via New York, or, at least in later years, under the control of New York's merchants. Thus New York rose rapidly to a position of preeminence in wealth and trade on the entire Atlantic seaboard, gaining the lion's share of exports, imports and passenger traffic.

Major shipyards were also established in New York, most notably the yards of William H. Webb and Jacob A. Westervelt. Located primarily on the East River shore of Manhattan, these and other yards at one time employed over 10,000 workers. Local shippers could have ships of the highest quality built to their specifications, including 53 of the 116 clippers that were owned in New York.

The clippers (sailing ships designed along more or less extreme lines for the utmost speed) are generally considered to represent the high point in the history of sail. Their swift passages enabled them to capture the prime traffic of the packets—the passenger, mail and high-value cargo business that paid the highest rates. They carried a state-load of pioneers to California in the 1849 gold rush and swept aside opposition in roaring runs to the Far East for costly cargoes of tea and spices.

It was not unusual for a clipper to pay for the entire cost of its construction with the profits from its maiden voyage in the lucrative California or Orient route. And profits flowed freely in the waterfront sailmaker and rigging shops that supplied and maintained the tremendous spread of canvas on the clippers.

Besides clippers and packets, New York harbor was filled with a variety of other sailing craft. There were smaller ships—brigs, barks and schooners engaged in trade with overseas and domestic ports. They could bring sugar and molasses from the Indies; cotton, tobacco, lumber and marine stores from the South; or manufactures from New England—to name but a few of their cargoes. They might return with converted goods to the Indies and the South, and with cotton and imports to New England. On the Hudson River, the sloop was the principal carrier for freight.

All this emphasis on sail should not obscure New

York's claim of being the cradle of American steam navigation. The first viable steamboat service in America was initiated by the trip of Robert Fulton's North River steamboat, popularly known as *Clermont*, from New York up the Hudson on August 17, 1807. In 1809, the steamboat *Phoenix* sailed on the open ocean, leaving New York harbor from Hoboken and ending up in Philadelphia. The first steam-ferry service on the Hudson began between Hoboken and Manhattan in 1811, aboard the *Juliana*. Long Island steam service was established on a regular schedule to New Haven in 1815 and Cornelius Vanderbilt advanced his career through steam-ferry service to Staten Island in 1817 with the *Nautilus*.

By the 1850s, far larger, faster and safer steamboats and steam ferries were in use on all these routes and steamships were running to the South as well as to Europe. On the Hudson River and Long Island Sound, the steamboats had wiped out the packet business which the sloops and schooners had formerly controlled. In 1852, a steamboat could make a round trip from New York to Albany and back in twenty-four hours, whereas a sloop, dawdling leisurely, could take as much as a week, one way.

The steamboats were side-wheelers, which American designers brought to high levels of beauty, speed, efficiency and comfort. However, when it came to ocean steamships, American designers and builders lagged behind their European competitors. Partly because sailing ships could be built more quickly and cheaply, American shippers had a fixation on sail and ignored or underestimated the threat posed by the ocean steamships being developed in England for the Cunard Line. When the Cunarders came to New York harbor, federal subsidies were hastily authorized to help finance an American answer, the New York and Liverpool United States Mail Steamship Company, better known as the Collins Line. The steamships built for this line were very fast and the height of luxury in their passenger accommodations, but errors in their engineering required excessively expensive repairs at frequent intervals. They could not compete economically and disasters at sea, coupled with the end of government subsidy, bankrupted the line by 1858.

Other American steamships might have proved capable of challenging Europe's best, but the Civil War forced Northern shipyards to concentrate on warships. Confederate raiders drove Yankee merchant ships off the seas or made shippers afraid to use them. As a result, European steamship lines consolidated their position. After the war the construction of new American ocean steamships was quite limited. It was easier for capitalists to make handsome profits with investments in Western railroads, mining and other enterprises. Young Americans were more inclined to "go West" than to go to sea.

The coming of age of the ocean steamship devasted the clipper. What happened on rivers and bays was repeated

RIGHT: *New York Harbor, 1866.*

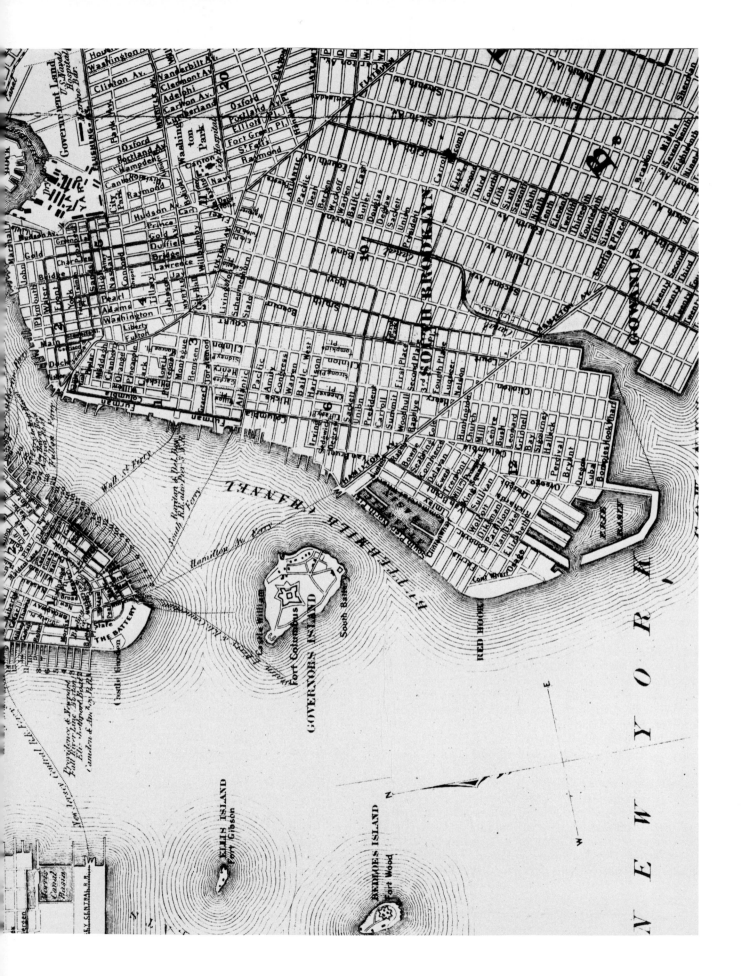

on the ocean. Mails, first-class passengers and choice freight shifted to the more reliable steamships (except on very long runs to the Orient, where there were not as yet adequate coaling stations for steamships). The clippers could not compete with the more conservatively designed sailing ships for bulk cargoes because their sails required the expense of large crews. In 1857, scores of clippers lay idle at South Street, while their owners vainly sought cargoes in the midst of a national recession.

In time, many of the clippers were returned to the sea, shorn of much of their glory. To reduce their crews, masts were shortened and canvas was reduced. Speed was sacrificed for economy; the clippers ended up with bulk cargoes their owners once would have spurned.

The decline of the clipper and the ascendancy of European steamships was seen as a national catastrophe by those who believed that American goods should be shipped in American bottoms. For many years Congress was bitterly besieged by a lobby advocating generous subsidies for the reestablishment of America as the world's leader in merchant-marine tonnage. There was little response for over thirty years.

It might be well to note that the number of steamships on hand after the Civil War could handle only a small percentage of the total trade. In 1866, the tonnage of active sailing vessels was six times that of steam. Sail was not eliminated—only humbled and deprived of easy profits.

South Street was drastically affected by this transition. Virtually all of its first-class transatlantic shipping was lost. New docks were constructed on the North River for ocean liners and freighters which found it easier to maneuver there in the wider channel and slower tides. The offices of major shipping companies also migrated westward to the Hudson and larger buildings went up to house them.

Other freight business left South Street for Brooklyn, where cheaper waterfront land permitted the construction of larger, more modern warehouses. But there was more than enough business to keep everyone in the port happy. As late as 1879, 681 sailing ships, 3,234 barks, 1,028 brigs and 1,548 schooners were reported as arrivals in foreign trade, while the increase in coastal trade was phenomenal. Arrivals and departures at New York in coastal traffic soared from 14,370 in 1865 to 28,665 in 1870, with the 1870 figure representing vessels of considerably larger size.

The key carrier in coastal operations was the schooner. Two-masters up to 150 tons were typical before the Civil War, but were launched in sizes up to 435 tons after the war. Three-masters, which had been developed in the 1850s, became more popular in the 1860s. Some were as large as 969 gross tons. The advantage of the schooner over the steamboat was that it could more easily adapt its route to whatever destination was required for available cargoes. Thus it commonly entered harbors which steamboats bypassed. This flexibility allowed some of the schooners to pay their way well into the twentieth century.

For a long time it looked as though sail would be able to compete indefinitely with steam, but the expansion of railroad lines along the coast and the combination of some of these lines with railroad-owned steamboats slowly but surely eroded the stake of the schooners. More and more, skippers had to fall back on such low-value bulk cargoes as coal, bluestone, brick, lumber or ice, sacrificing beauty of line in their craft for capacity and ease of unloading. But even this strategic retreat ultimately proved only a delaying tactic; steam towboats and tugs, powered with improved engines and driven by propellers, began to move long strings of ponderous barges through such waters as the Hudson River. Gigantic cargoes could thus be transferred with only a few men in the tow. Such competition could not be met by the windship.

Sail survived longer on the open sea. During the 1870s and 1880s some superb, large wooden square-riggers, the "Down Easters," were built expressly for long-distance coastal trade and ocean shipments. They brought hard wheat from San Francisco to New York and then on to Liverpool. They hauled fantastic quantities of anthracite and soft coal from New York to Boston and other New England ports. Hawaiian sugar, Chilean nitrates and cans of kerosene for the Orient were other cargoes delivered aboard these sturdy, long-lasting ships. Built to an average size of 1,500 tons in the 1870s and to 2,300 tons by the 1880s, they were able to operate with small crews and make a profit for their owners.

Steel-hulled sailing ships superseded the Down Easters and managed to obtain cargoes until advances in steam-engine designs made it possible for steamships to run more cheaply and to allocate less hull space to fuel. Some of the last sailing ships built were schooners with four, five, six and even seven masts, employing steam-powered machinery on deck for managing their huge sails. Those with more than four masts proved to be difficult to control and were found to be unsafe in dangerous seas, but over 300 of the four-masters served well for many years and in World War I an additional 109 of them were built to fill the need for a quick increase in tonnage.

The end of sail came rather abruptly at South Street. There were 27,000 arrivals and departures in coastal traffic in New York in 1890, with sail dominant, but by 1906 steamers and barges controlled more trade. It is reported that in 1907 not a single sailing vessel was docked at South Street in the winter. Of course, sailing craft continued to dock in New York harbor for many years after that, but they no longer were a significant market factor. The port's attention was now focused on the giant turbine-powered ocean liners which enhanced its prosperity. It was a new century in many ways.

PHOTOGRAPHY AND NEW YORK HARBOR

Photographs brings us the most faithful and detailed images of the harbor as it was. Of all the forms of photography that flourished in the nineteenth century, it is the long-neglected stereoscopic view that proves to be our richest source of pictures of the bay, the wharves, the streets and the buildings of the waterfront.

In theory, the daguerreotype, introduced in America in 1839, should have left us a superb record of the clippers working out of New York in the days of the 1849 Gold Rush. As early as 1840, Samuel Morse, taking pictures of Brooklyn over the rooftops of Manhattan, may well have captured the masts along South Street on his plates. Yet, incredible as it seems, not a single daguerreotype of the South Street and West Street waterfront is known to have survived. This book does offer one daguerreotype, taken in 1846 (page 117), of the construction of the first dry dock in the Brooklyn Navy Yard, and another, dated 1856 (page 118), of a ship built there, the U.S.S. *Ohio*, taken while she was anchored in Boston. Otherwise, only a poor reproduction of a daguerreotype of a scene on the North River is known to exist.

The reason for this state of affairs seems to be that the genius of the New York daguerreotypists was devoted mostly to perfecting portraiture, with particular attention to preserving the visages of famous statesmen, military men and other personages. Outdoor work was only a sideline and there was no one who had both the capability and the inclination to record regularly the progress in marine navigation and the comings and goings of ships in the harbor. One man, a Mr. Cady of New York City, made instantaneous photographs of steamboats leaving their slips in the harbor in 1851, but examples of his pictures have not been located. Some of his instantaneous harbor daguerreotypes were taken to England but, unfortunately, they perished in a fire while on exhibition.

Paper-print photography gained professional acceptance in the United States in the 1850s, and the existence of a "salt-paper" print of the United States Hotel (page 19), which includes part of the South Street Seaport Museum's blocks, suggests that other pictures in that vicinity were taken in this medium before 1860. Again, the search for such images has run into a virtual stone wall, for large paper prints of the harbor do not become reasonably common until the period of the 1880s.

But all was not lost. The advent of the stereograph, or stereoscopic view, in the 1850s, led to a tremendous interest in outdoor photography and part of the resultant activity centered on the harbors of the world, including New York's.

The stereograph, invented by Sir Charles Wheatstone of England, is a double picture which yields a single image with three-dimensional effect when examined through the optics of a stereoscope. The novelty of this effect so amazed people that, when the inexpensive and convenient stereoscope was made available to them, sales of stereoscopes and views for them reached fantastic numbers. From 1860 to 1900, there was hardly a household above the poverty level that did not have a stereoscope and a basket of views resting on the parlor table for the entertainment of guests. Wealthy families had cabinet viewers holding up to 200 views on an internal revolving belt and some enthusiasts had bookcases filled with special boxes containing thousands more of the views.

Great quantities of views of cities, towns and rural subjects were produced for sale to tourists and armchair travelers. The continuing demand induced publishers of the views to send out photographers to add new series to their catalogs as well as update old series as time brought about changes in city landscapes. Luckily for our purpose, a very small but important part of the views prepared was of New York harbor.

The first known "stereos" of the harbor were taken in 1856 by the American pioneers in the medium, the Langenheim Brothers of Philadelphia. During their visit to New York in that year, they made a number of negatives on the waterfront with their twin-lens cameras and later printed them up both as paper and glass transparency stereos. Because the stereo boom had not yet occurred, and their product was too expensive for the general public, sales of these views were small and examples of them are consequently very rare.

Other photographers followed the Langenheims' example in the years thereafter and it is interesting that quite a few of the men attracted to the harbor came from inland towns. George Stacy, for example, had his factory at Scotland Hill, a locality near Nanuet in Rockland County, New York. Franklin White, known mainly for his views of the White Mountains, traveled all the way to New York from Lancaster, N.H., a small farming community in the northern part of the state. His views of New York are so rare that an adequate criticism of them is impossible, but he deserves immortality in this field if only for his views of the full-rigged ship *Ocean Belle* docked at South Street in 1858 (page 4), an extremely choice representative of one of the sailing ships engaged in the California trade before the Civil War. Babbitt, the famous Niagara Falls daguerreotypist, was another early visitor to New York bent on taking stereoscopic views.

It is Stacy to whom we owe special thanks for the best views of the giant steamship *Great Eastern* (page 14) as she lay in dock after her maiden voyage. His excellent, clean-cut technique and good eye for composition are also evident in his picture of the ship that brought the Prince of Wales to America in 1860. His interiors of the steamer *Commonwealth* (page 23) set a standard for later photographers in this vein. There are other notable marine subjects beautifully portrayed in his views. Stacy, along with Hoyer (known to us only as a name on the labels of his views) also took pictures of the clipper *Great Republic*.

The greatest technical triumph in the early days of stereoscopy was the perfection of the instantaneous process with exposures that were approximately one-fiftieth of a second. The small size and short-focal-length lenses of the stereoscopic camera, anticipating the modern 35mm camera, were contributing factors to this advance, as were the efforts of such lens makers as C. C. Harrison in improving the lenses. The British were the first to report success with instantaneous stereos, and William England, serving the London Stereoscopic Co., demonstrated the technique in America in 1858 when he took photographs of action on Broadway and in the harbor of New York.

American photographers considered themselves the

best in the world and set to work feverishly to outdo England's accomplishments. Henry Anthony of New York, a brilliant chemist, came forth with a superior process in 1859. Photographers working under his supervision and in the employ of his brother Edward quickly brought out a series of instantaneous views of vessels in the bay. For many years afterwards, their men—most notably Thomas C. Roche—turned out scores of the most beautiful and historically important pictures of the harbor, ranking with the finest work of this genre in the world. The quality of the prints is also exquisite—richly toned and of strong contrast. Their subjects ranged from major foreign ships in the bay through exteriors and interiors of the more important Hudson River and Long Island Sound steamboats to sloops and canal boats. Scenes at the regattas of July 4th of 1859 and 1860 (pages 6 and 15) were carried in their catalogs for many years. A large number of views of ferries indicated some special predilection for them.

Although the demand for stereos fluctuated after the Civil War, new photographers kept visiting the New York waterfront. John Soule of Boston made a small but superb group of instantaneous views of small sailing crafts, towboats and ferries right after the war, and was followed later by J. and J. W. Moulton of Salem, who did some exceptionally fine steamboat interiors and a rare view of the old, ramshackle buildings of Fulton Fish Market (page 43)—later replaced by the well-remembered brick structure.

G. W. Pach, predecessor of the famous Pach Bros. studio, also took some notable waterfront shots when not busy at Long Branch and other Jersey shore points. There were also top-notch photographers we regret we cannot name and honor because the publishers who used their negative chose, for unknown reasons, not to identify themselves or their cameramen. Views of the construction of the Brooklyn Bridge and wonderful aerial views of the New York and Brooklyn waterfront were taken from atop the bridge piers by these men.

Other anonymous photographers were responsible for poorer-quality stereos placed on the market at low prices in the 1870s and 1880s. A few of these are worth attention because of their rare subjects, such as the oyster barges on the North River.

By 1880, the bloom was gone from the stereoscopic view business, and only publishers who could mass-produce views at minimum cost could rely on this source of income alone. The Kilburn Bros. firm in Littleton, N.Y. was one of these and we are fortunate that, continuing into the 1900s, its catalog was regularly bolstered with new series of views taken at New York. A fairly high percentage are of harbor scenes and many are packed with fascinating details. Among Kilburn subjects are yacht races, close-ups of ships at dock, views along South and West Streets and glimpses down the side streets where the elevated steam train wended its way. We cannot help but feel they were taken *con amore*, as their rarity indicates that they did not sell well enough to compare favorably financially with many other stereos sold by the company.

Charles Bierstadt of Niagara Falls (brother of the painter Albert Bierstadt) is another photographer we should mention, for his small group of views of South Street and the harbor in the 1880s is distinguished by above-average composition. Stoddard, famous for upstate New York views, may also deserve our accolades, but too few of his New York harbor views have turned up to permit a fair evaluation of them.

A new boom in stereoscopic views developed in the 1890s and hopeful publishers proliferated rapidly. Underwood & Underwood, the H. C. White Co., and the Keystone View Co. were to become the giants of the industry; they, as well as many of the smaller fry, inevitably sent their men to New York for a series of negatives of the city. The views from this period record the last years in which sail lined South Street, and include some fine shots of American and foreign warships in the harbor during the Columbian Exposition celebration (April 1893) and the Spanish-American War. Advances in photography had made instantaneous exposures at high speed on dry plates relatively easy and the best photographs from this era have a technical perfection which has not been surpassed in mass production.

We can offer but a passing salute to the photographers of towns along the Sound and the Hudson whose pictures of shipping related to New York harbor are shown in this book. Little or nothing is known about many of them, despite their obvious rank as artists, but without their work this book would have been incomplete.

NOTE

Whenever possible, statistics are given for the ships being discussed. The first figure is the length; the second, the beam; the third, tonnage.

MARITIME NEW YORK
IN NINETEENTH-CENTURY
PHOTOGRAPHS

THE NEW YORK WATERFRONT BEFORE THE CIVIL WAR

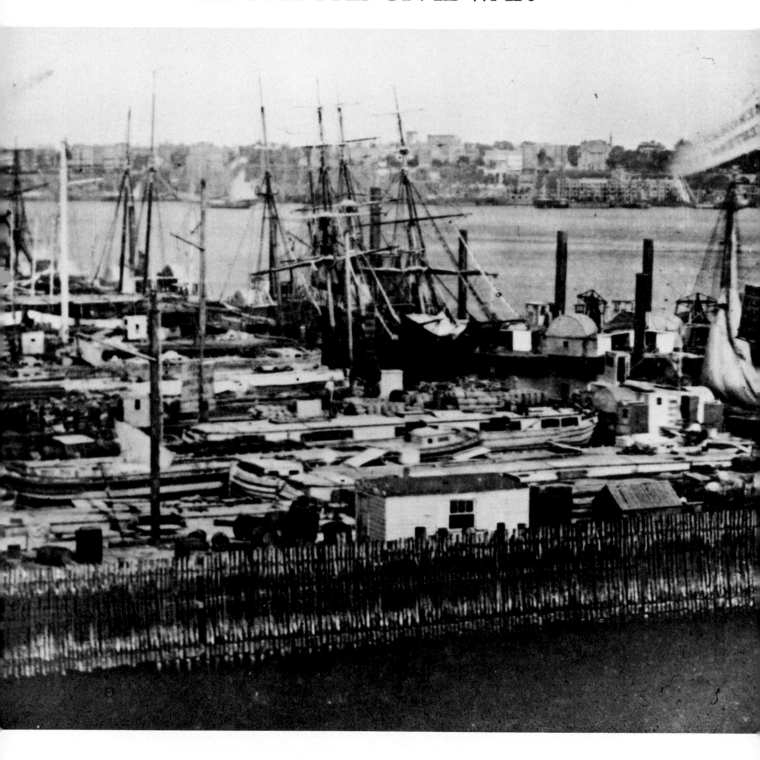

1. Although daguerreotypes of New York harbor were reported in contemporary publications in the early 1850s, this glass stereograph, published in 1856 by the Langenheim Brothers of Philadelphia, appears to be the oldest surviving photographic image of any part of South Street's docks. It shows the Canal Basin at the southern end of the street, and is sharp enough to allow the lettering on the banner to be read.

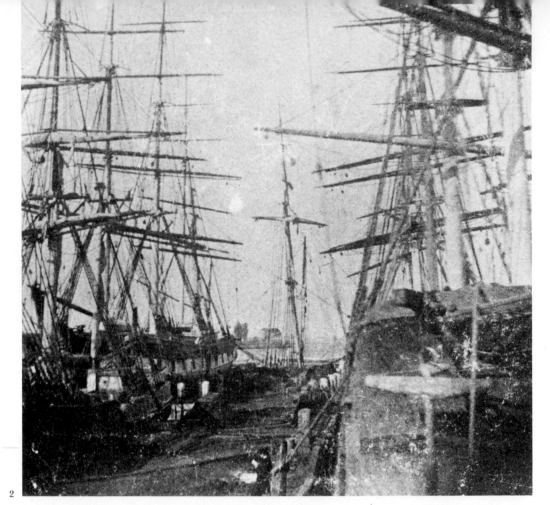

2

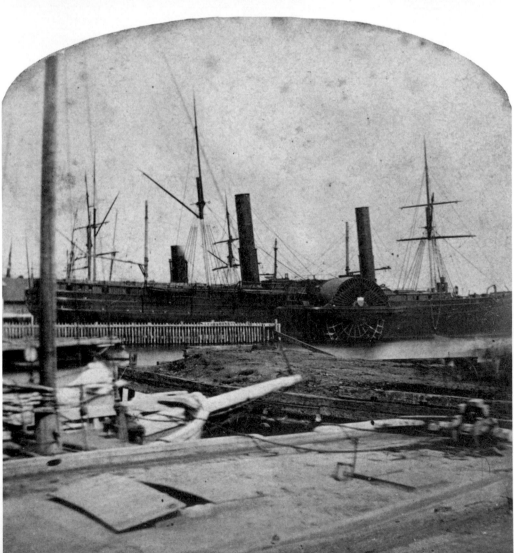

3

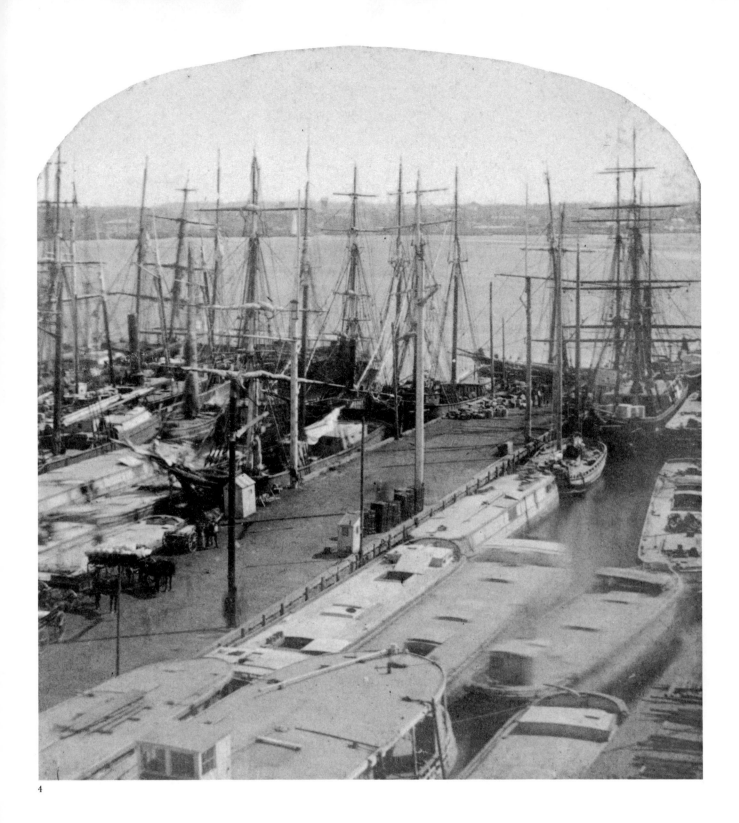

4

2. Another 1856 Langenheim view, from a rare paper print, shows packet ships tied up at Pier 2 on the East River, at Whitehall Street. The rough texture of the paper of the very early paper photographs limits their sharpness.

3. In an important photograph taken by the little-known photographer Fronti in 1857, the *Adriatic* is at her builder's, the George Steers Shipyard at East 7th Street and the East River. Completed that year, the *Adriatic* (355'–50'–4,114 gross tons) was the fastest, largest and last steamship to be constructed for the Collins Line. It made but a few transatlantic crossings before the line collapsed financially.

4. An unknown photographer took this 1858 view of shipping and canal-boat activity along Pier 3 on the East River, at Moore and South Streets.

The New York Waterfront before the Civil War 3

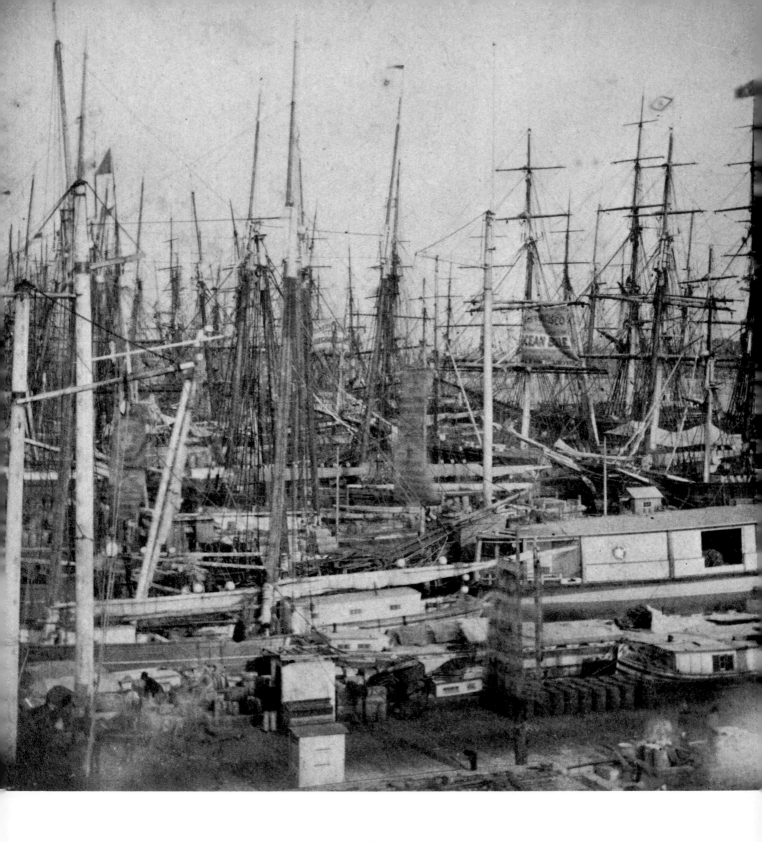

5. Franklin White of Lancaster, N.H. visited New York in 1858 and recorded this, possibly the only extant view showing a ship at South Street ready to sail in the California trade before the Civil War. The *Ocean Belle*, with a banner in her rigging advertising her destination as San Francisco, and her name, was a full-rigged ship of 1,097 tons, built at Waldoboro, Maine in 1854. According to Lloyds, she cleared New York on October 18, 1858 and arrived in San Francisco March 27, 1859.

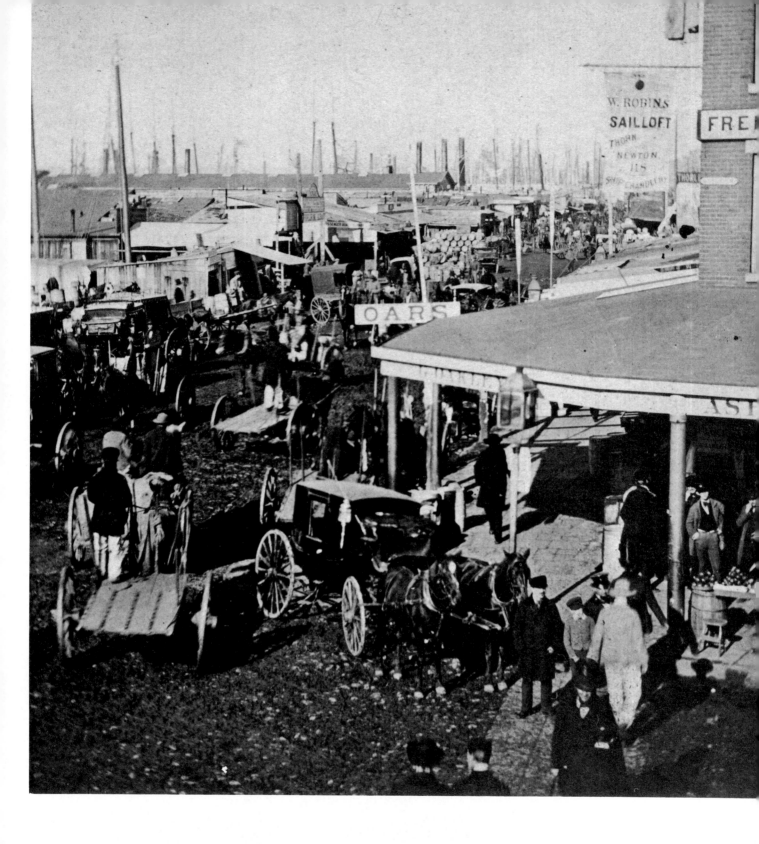

6. An instantaneous photograph of 1859 published by Edward Anthony shows intense activity along West Street. Drays, wagons, carriages and fruit vendors are in evidence at ground level. Overhead is a sign for W. Robin's Sail Loft and Thorn, Newton's Ship Chandlery at No. 118.

The New York Waterfront before the Civil War 5

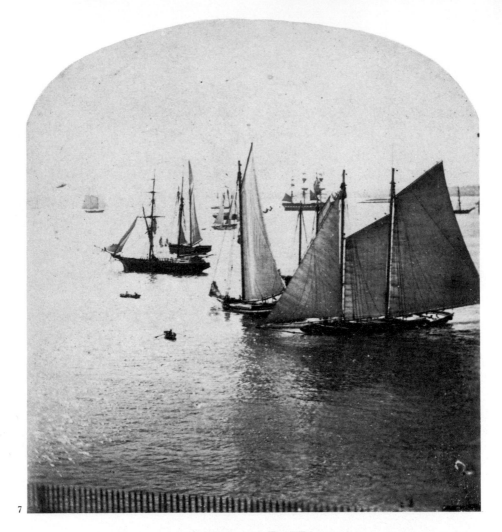

7

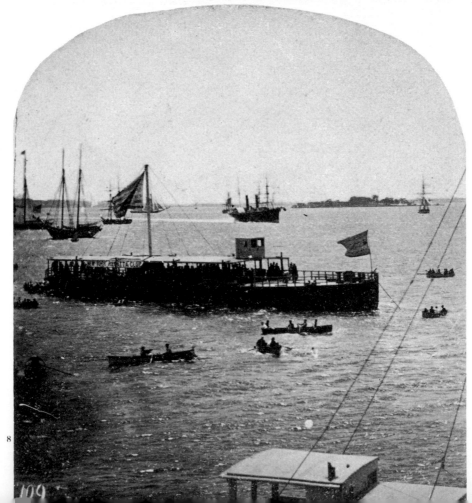

8

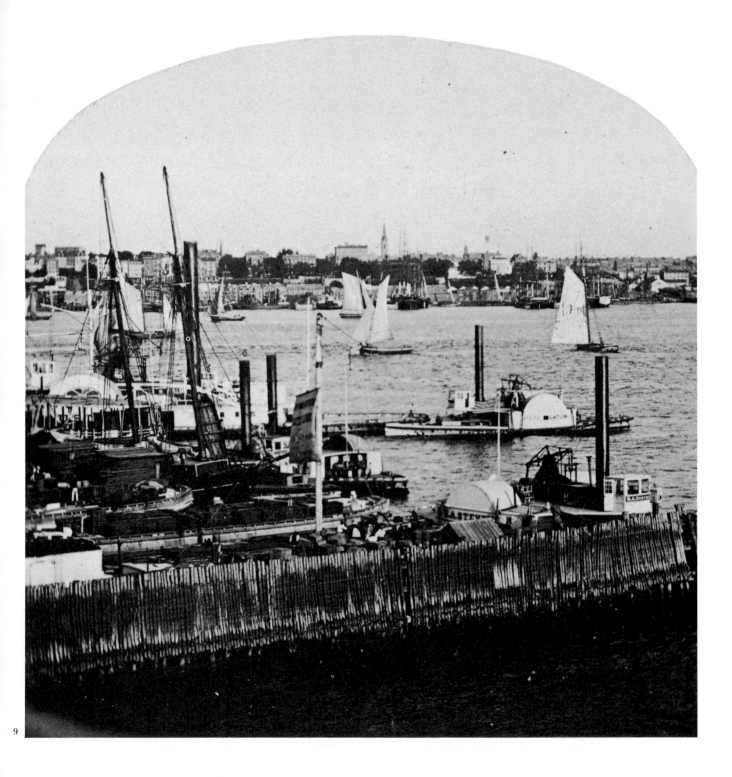

9

7. The Battery, where the ever-changing patterns of vessels anchored or passing by presented many opportunities for pleasing compositions, was a favorite spot for photographers who had mastered the instantaneous process. In this example by an Anthony artist, a Hudson River schooner narrowly skirts the stern of a Hudson River sloop and seems due to miss a rowboat ahead. Lying at anchor are a half-brig or brigantine (left foreground) and a large U.S. Navy frigate (in the distance).

8. A Battery marine view packed with interest was taken by Anthony during the New York Regatta Club's Fourth of July festivities in 1859. It shows the steamship *Quaker City* (227'–36'–1,790), marked by her two smokestacks, making her way up the Bay. A sidewheeler of wooden construction, she was built by Vaughan and Lynn in Philadelphia in 1854. She operated on the Philadelphia, Havana and Mobile run, but switched to service between New York and Havana in May, 1859. The Civil War interrupted the service; the ship became part of the Union fleet, seeing action near Charleston, S.C. and, in 1864, at Cape Fear River, N.C. After the war, she cruised to the Mediterranean and Black Sea. Mark Twain's *Innocents Abroad* (1869) was written about this voyage.

9. Improvements in the quality of paper photographic prints was rapid, once the market for them expanded. Note the sharpness of this Anthony 1859 view of Brooklyn Heights, taken from South Ferry. In the foreground are the paddle-wheel towboats *R. A. Stevens* and *George Catlin*.

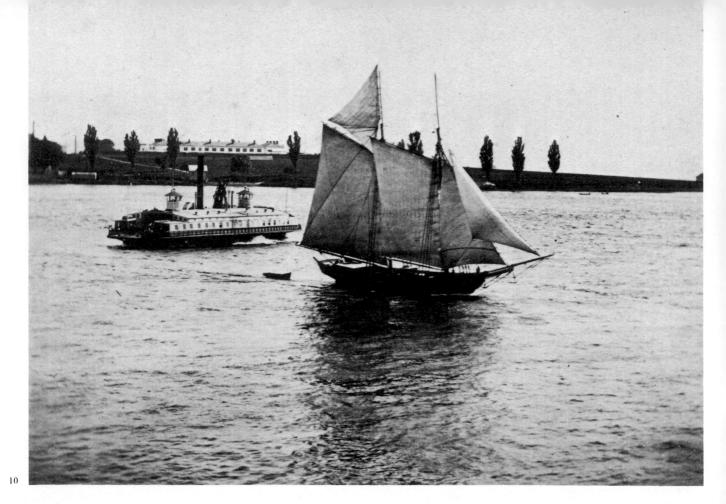

10

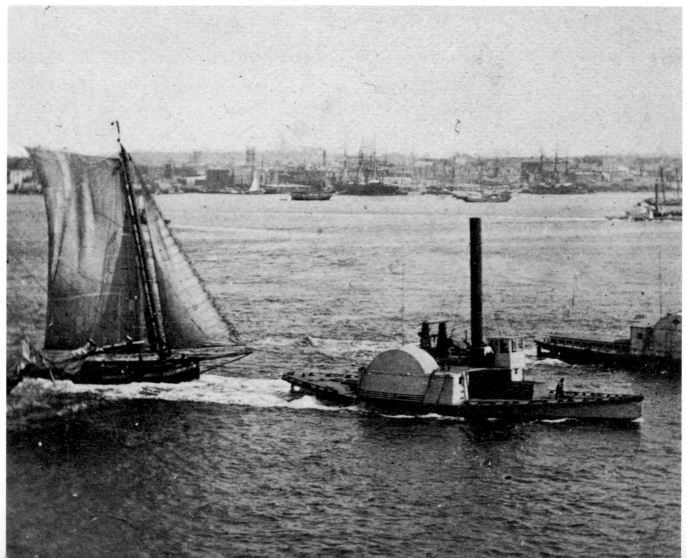

11

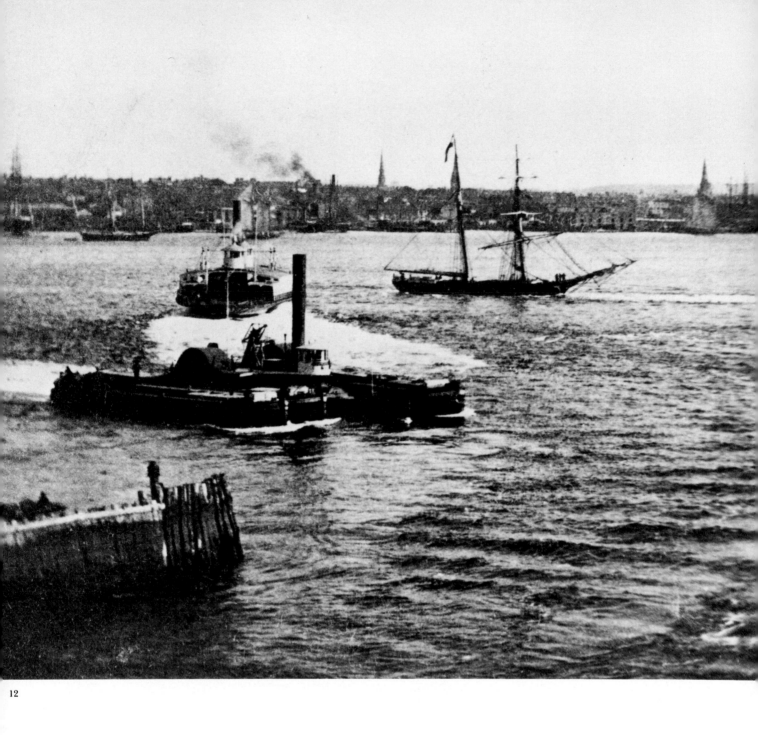

12

10. Coastal trade relied heavily on the two-masted schooner before the Civil War. In this instantaneous photograph of 1859, published by Edward Anthony, a lofty specimen, with most of its sail set, heads down New York Bay, the west side of Governors Island being seen in the background. A Union Ferry Co. ferry is passing astern.

11. Another interesting scene published by Anthony in 1859. The two side-wheeler towboats are old models with the original Fulton-type crosshead engines. By 1840, the walking-beam design, shown in other photographs, began to replace the crosshead. The harbor lighter at left is not under tow, but is sailing rapidly through the wake of the towboat. Lighters were mostly used to transport cargo within the harbor, from one ship or dock to another ship or dock.

12. A sample of the active traffic on the East River in 1859–60. A powerful towboat moves three barges briskly past Whitehall Street, while a second, not in the picture, tows a half-brig to the Bay. The Atlantic Avenue ferry is en route to Brooklyn. The view is probably the work of George Stacy.

The New York Waterfront before the Civil War 9

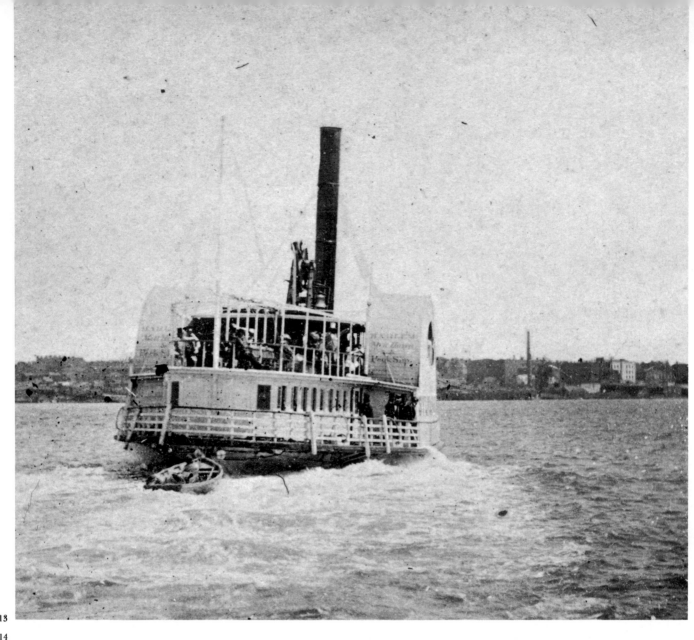

13

14

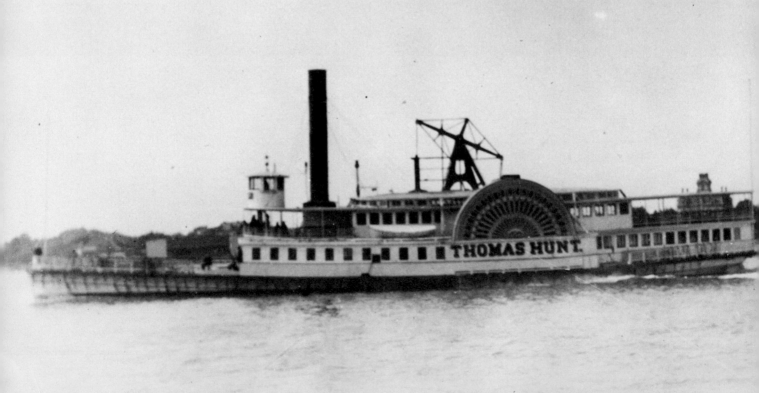

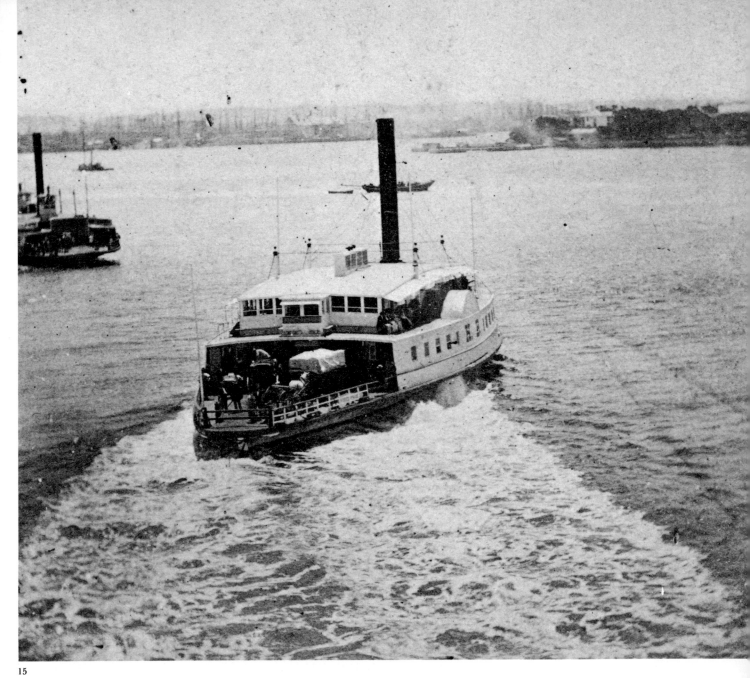

15

13. Commuters of 1859 were carried by steamboat from East 130th Street in Harlem Village to Peck Slip on the East River in downtown New York. The steamboat *Sylvan Glen*, with skiff in tow, is shown on this run in an Anthony print.

14. Commuters from New Jersey and Staten Island also enjoyed a pleasant trip as they rode to work aboard the *Thomas Hunt* (160′10″–29′6″–370), a side-wheeler built in 1851 by William Collyer of New York. All told, she served the public for 58 years.

15. The ferry *Hunchback*, of Cornelius Vanderbilt's Staten Island & New York Ferry Company fleet, is seen in an 1859 Anthony view. The *Hunchback* operated on the run from 1852 to 1862, when she was purchased by the government for conversion to a gunboat during the Civil War.

The New York Waterfront before the Civil War 11

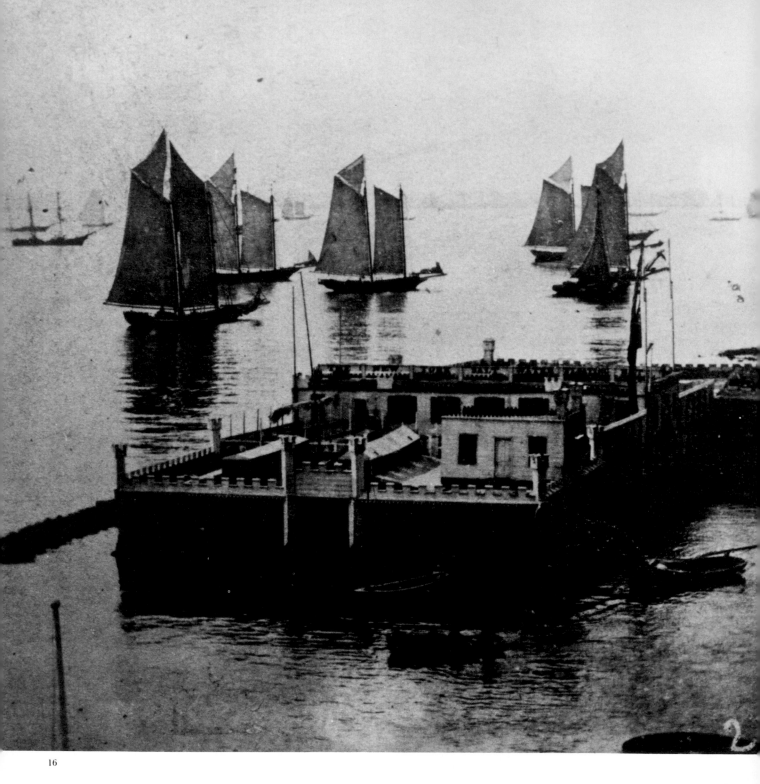

16

16. A classic marine photograph shows several Hudson River schooners with foresails and mainsails set, waiting for a breeze to start their run up the Hudson. In the foreground is the New York Salt Water Floating Bath, established by Dr. Jacob Rabineau in 1826. It was reached by a footbridge from the Battery and was used for personal bathing by men who had no access to a bath at their lodgings. Although pollution of the harbor became a problem as early as the 1870s, there were two such baths anchored off the Battery seawall in 1899. Dr. George A. Soper, famous for tracing the carrier "Typhoid Mary," waged a vigorous campaign from 1908 to 1915 to have fresh water used instead of river water in the floating baths. In July 1915, the first of six new free New York City Floating Baths was opened.

17. The great Russian steam frigate *General Admiral* (313′7″–54′6″–4,600), is seen here in the Hudson prior to her departure for Cherbourg, France on June 16, 1859. The largest and fastest man-of-war at the time she was launched, she was built for the Imperial Navy by William Webb in his East River yard. Her keel was laid September 21, 1857, and she slid down the ways a year later. When she sailed for France, she was under the command of Capt. Joseph J. Comstock, one of the original Fall River Line skippers. William Webb himself, and his family, were also aboard and sailed all the way to Cronstadt, where the Russian Navy took possession of the ship. She proved to be very fast, both under sail and under steam. Her propeller apparatus could be raised clear of the water in 30 minutes when it was desired to use sail alone.

12 The New York Waterfront before the Civil War

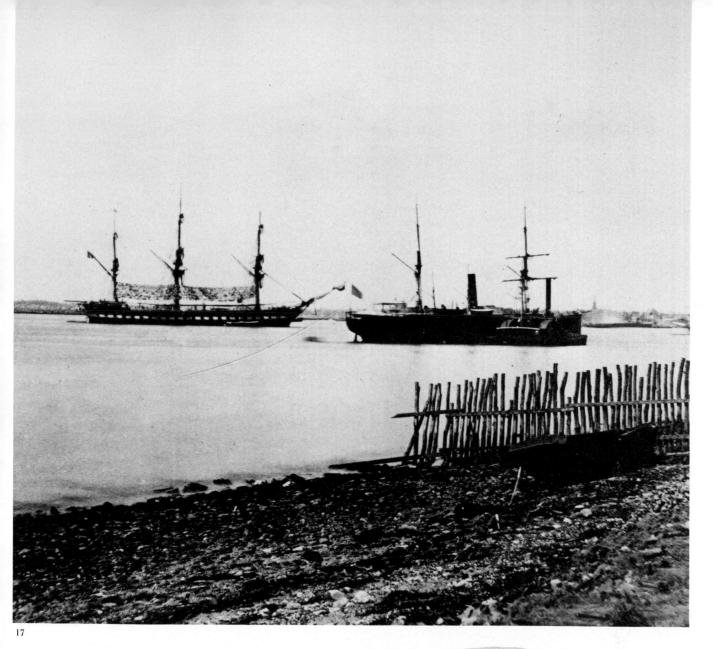

17

18. A photograph of 1859 shows William Webb's *General Admiral* docked at Pier 42, at Canal Street. Until 1858, when it went bankrupt, the famous Collins Line had operated its fleet of transatlantic steamships from this pier. The *Adriatic*, the last and largest of the Collins steamships, is moored on the opposite side of Pier 42. The steamship visible alongside the *Adriatic* is either the *Atlantic* or the *Baltic*, of the same line. A ferry of the Hoboken Land and Improvement Co. rests in its Canal Street slip, left foreground. The line was controlled by the Morris and Essex Railroad Co., which later became part of the Delaware, Lackawanna and Western Railroad.

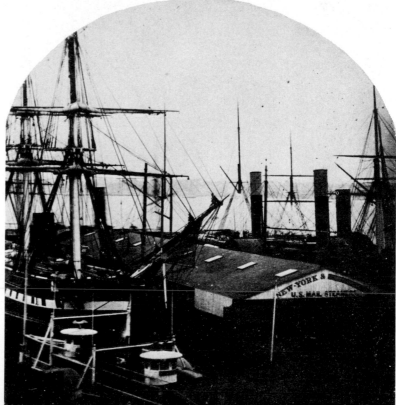

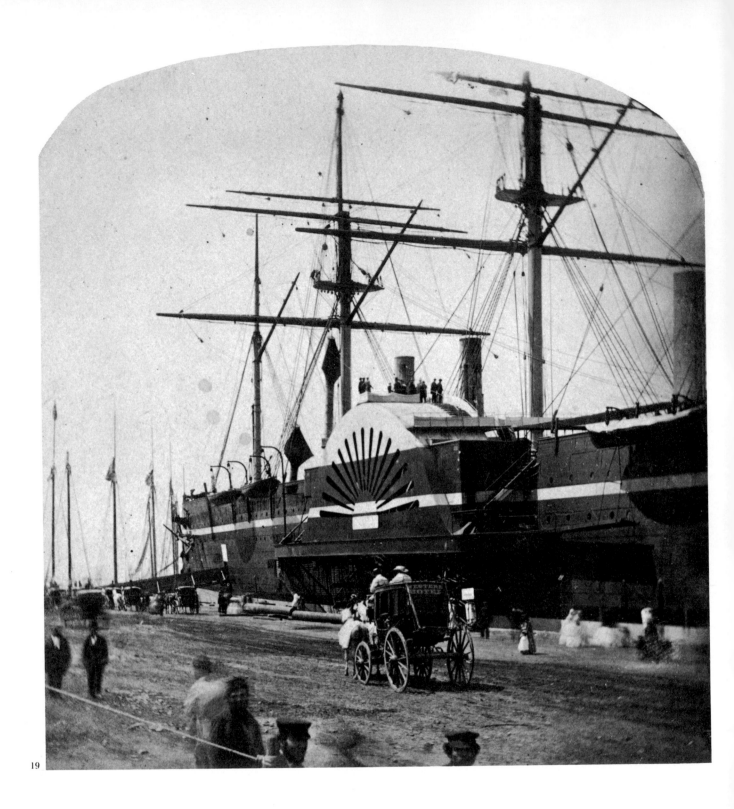

19

19. When the *Great Eastern* (693'–120'–22,500) first arrived in New York harbor she was berthed at a pier on the Hudson in Greenwich Village between West 11th and 12th Streets. Launched in 1858, she was the largest vessel afloat for the next 31 years and carried 6,500 square yards of sail on six masts, along with a combination of five funnels, a 24-foot propeller and two huge 58-foot paddle-wheels. While in New York, she was visited by a tremendous number of curious visitors and was photographed by several firms. The best work was done by George Stacy, one of whose views is shown here. Taken in 1860, it includes a coach from the Western Hotel on the dock.

20. Standing on the Battery landfill, spectators watch the 1860 Fourth of July Regatta as the waters are filled with racing shells and Whitehall boats. This is one of over a dozen stereoscopic views of the event published by Anthony. The Whitehall boats were used as water taxis to shuttle crews between the piers at the Battery and ships anchored in the Bay. In the Regatta, the New York Whitehall boat crews raced against rowing teams that came from Boston, Newburgh, N.Y. and St. Johns, New Brunswick.

21. During the Regatta, a Long Island Sound Sloop, inbound with a load of cordwood piles as high as the boom would allow, sailed by.

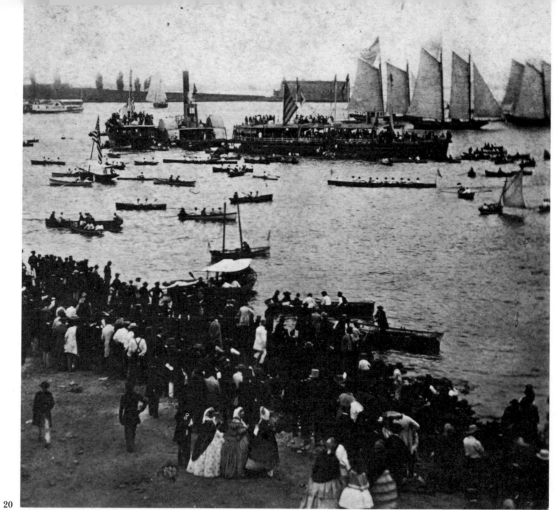

20

21

22

23

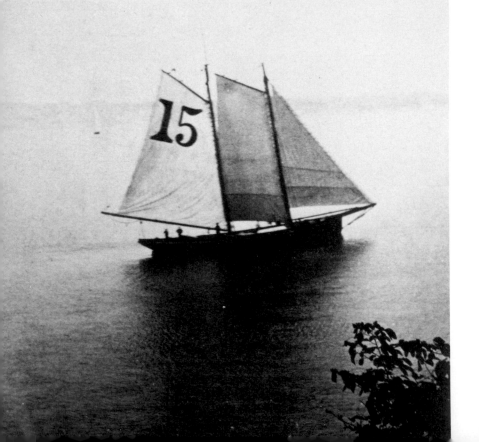

22. In 1860 Anthony published this unusually well detailed view of a Hudson River sloop, laden with cargo, heading up the East River with all sails set. Note the patches in the topsail, which became more frequent as sloops faced increased competition from schooners and steam vessels. The ferry is running from Whitehall Street, Manhattan to Hamilton Avenue, Brooklyn.

23. In the 1860s, pilot boats were sailing craft. The New York pilots sailed out to sea on these boats, sometimes long distances from shore, in search of large incoming ships. The pilot, wearing a beaver hat as a sign of his importance, would board the large ship from the pilot boat and direct a safe entry into the harbor. On outgoing trips, the pilot boat would pick up the pilot after the ship in his charge had cleared the harbor. This boat, No. 15, is the 125-ton *John D. Jones*, shown idling off Staten Island. On the night of March 18, 1871, she was run down and sunk by the Inman Line steamer *City of Washington*. Luckily, all hands were rescued.

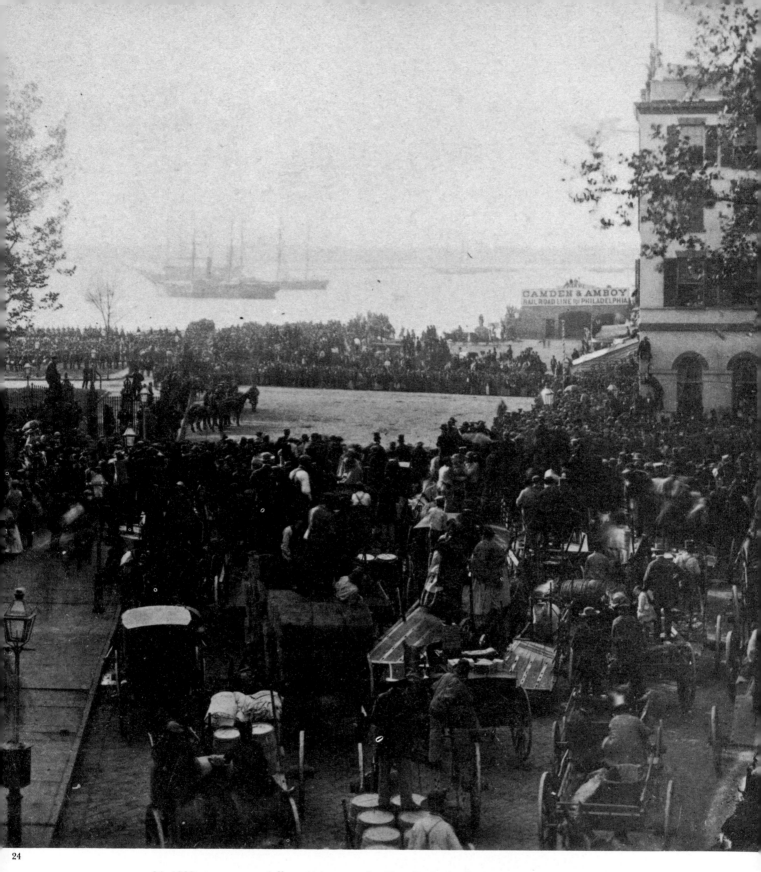

24

24. 1860 was an especially exciting year for New York: the first Japanese envoys to the United States visited the city; the giant steamship *Great Eastern* made its first appearance in the harbor. But the year's highlight was the visit of the handsome, popular Prince of Wales, later Edward VII. Here we see the crowd gathered at the Battery to witness the arrival of the Prince as he disembarked from the cutter *Harriet Lane*, the closest vessel in the picture. He was welcomed by Mayor Fernando Wood at the water gate of Castle Garden. At the right rear is the Camden & Amboy Railroad Line terminal for Philadelphia.

The New York Waterfront before the Civil War 17

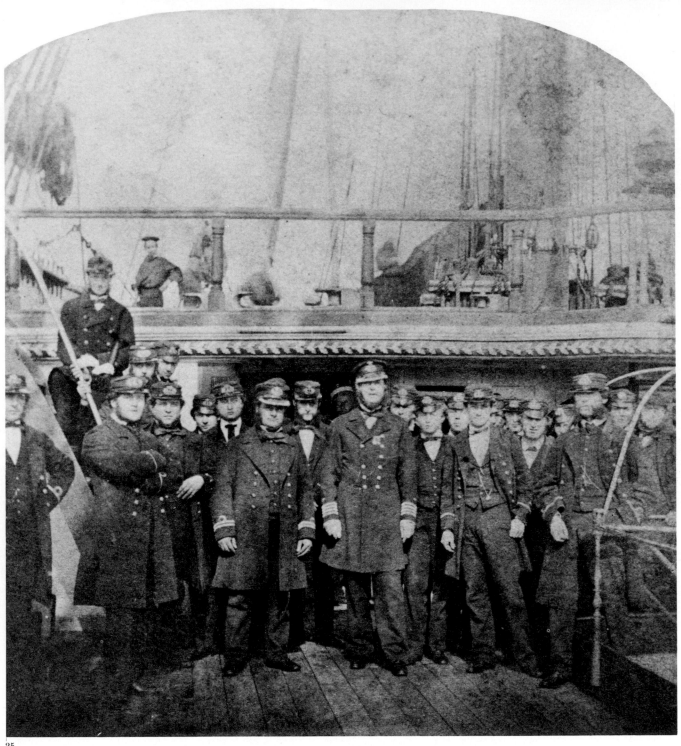

25

25. The Prince of Wales came to America aboard H.M.S. *Hero*. Commodore Seymour and other officers of the ship posed on deck for George Stacy.

26. The United States Hotel, opened in 1833 as Holt's Hotel, stood at Fulton and Water Streets, an area now part of the South Street Seaport Museum. The landmark, which had a steam-powered elevator for carrying luggage, was demolished in 1902. Several instantaneous stereoscopic negatives were made of it for E. Anthony in the early part of 1860, and from its roof panoramic views were taken of the waterfront a few years later.

27. The buildings along West Street on the Hudson received little attention from photographers. In 1860 George Stacy gave us what seems to be a unique view of a few blocks along the street. The tower in the center and the building with the long sloping roof, to its right, can also be seen in the 1873 panorama of the Hudson River on page 52.

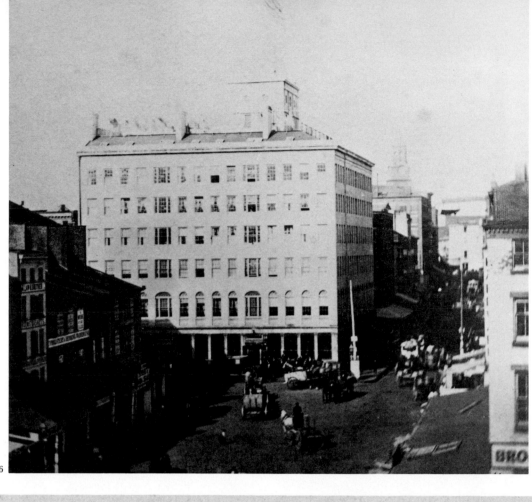

26

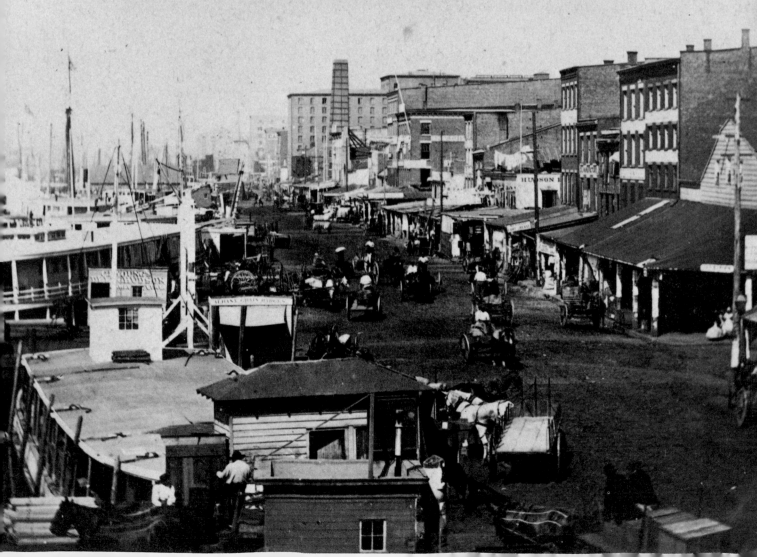

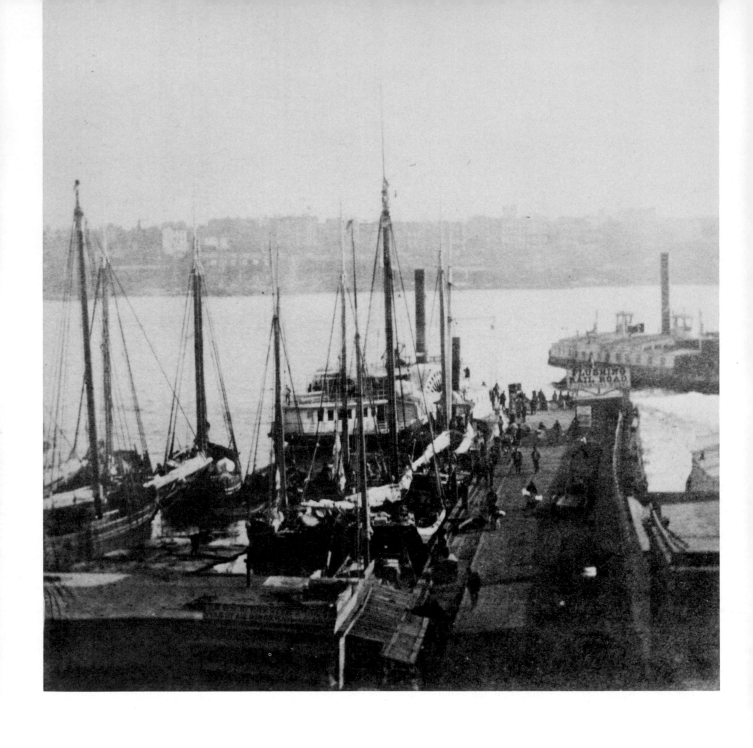

28. Fulton Ferry as it was recorded by Anthony in 1860. From this point steamboats left for the terminal of the Flushing Rail Road. The side-wheeler at the left is the *Morrisania*, ready to make its commuter run to Astoria and Harlem.

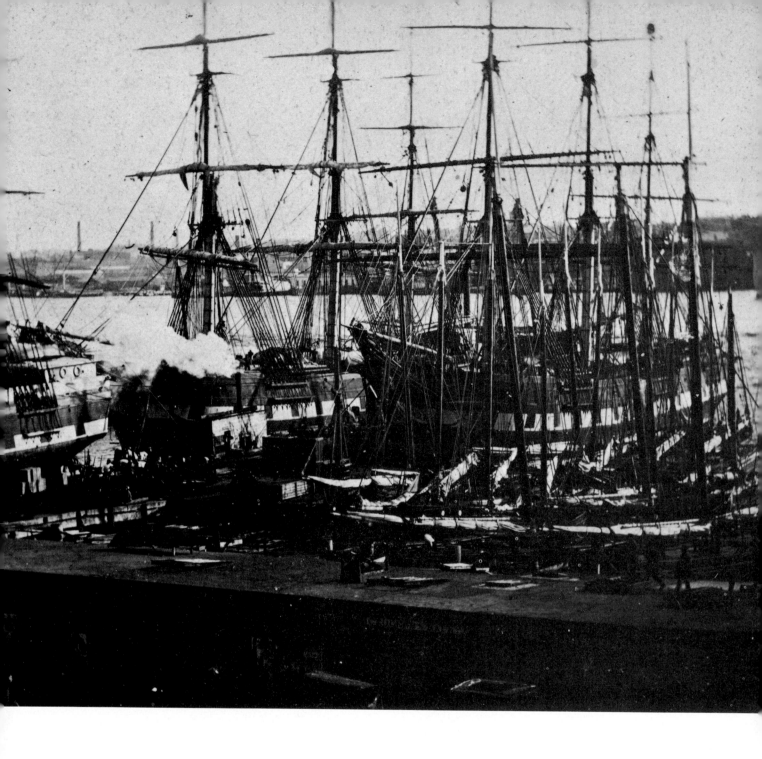

29. This exceedingly rare and important Anthony photograph of 1860 is apparently the only known close-up of the famous Black Ball packets in New York before the Civil War, when they were still doing a highly profitable business in English railrorad iron and emigrants. All Black Ball packets were built in New York on the East River. The line inaugurated the first scheduled packet service between New York and Liverpool in 1817 and did not cease service until well after the Civil War. In the foreground is the long, low building of the old Fulton Market. Comstock & Harris, Crocker & Haley, and Fowler & Pearsall were fish merchants with stalls in the market. Fishing schooners are tied up behind the shed.

The New York Waterfront before the Civil War 21

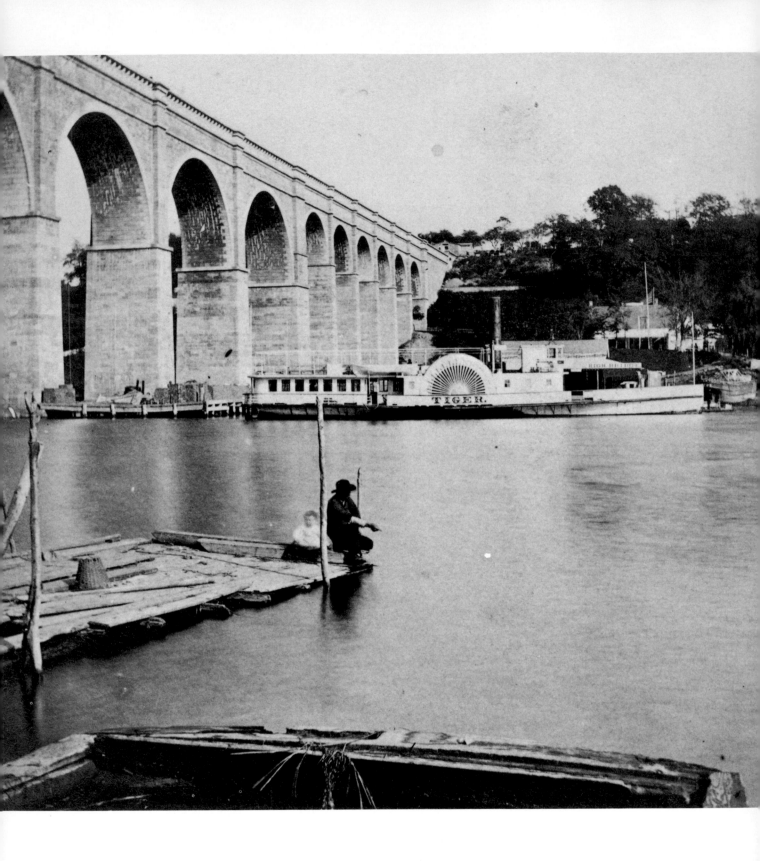

30. The Harlem & Spuyten Duyvil Navigation Co. steamboat *Tiger* was photographed by D. Barnum in 1860 on the Harlem River. The boat, originally named the *Tiger Lily*, was built in 1852 at Pawcatuck, Conn. She connected at East 130th Street with the steamers *Sylvan* and *Morrisania*, which drew too much water to navigate the rest of the Harlem River, and took their passengers on to Fordham, Highbridge, Marble Hill and Spuyten Duyvil. The *Tiger* and her companion, the *Emily*, maintained half-hour service during commuting hours. The High Bridge shown in the photograph was built as an aqueduct for Croton water under contract by the famous steamboat entrepreneur "Live Oak" George Law, a major stockholder in the United States Mail Steamship Co., Panama Railroad Co., and Pacific Mail Steamship Co. The Hudson River sloop *George Law* of Cornwall carried stone for the aqueduct down the Hudson.

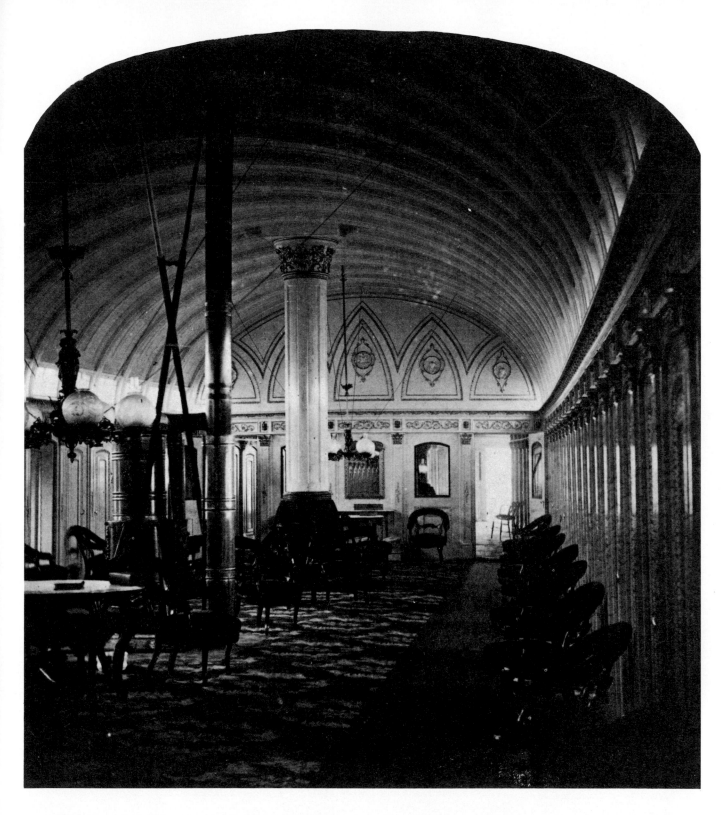

31. The *Commonwealth*, a superb 320-foot steamboat completed in 1854, was termed "the finest boat for rough water ever built in this country," by her captain, Jerome W. Williams. Williams, who sailed the treacherous waters of Long Island Sound for almost 50 years, was well qualified to judge. He became so fond of the *Commonwealth* that he had a detailed model of her wrought in gold, with a mechanism that caused her walking beam and wheels to move when a coin was inserted. The captain never recovered fully from the loss of his favorite craft in a fire at Groton, Conn. on a night in December, 1865. The fire started there in the dock depot and spread until it destroyed the *Commonwealth* and 34 railroad cars loaded with merchandise for Boston. Williams's men strove frantically, but in vain, to save the boat; the tide was out and her hull was firmly grounded on the bottom alongside the dock. The view shown above of the interior of the *Commonwealth* is one of the earliest American photographs of a steamboat interior, and was taken, probably in 1860, by Stacy. The fairly simple and chaste design has some touches which foretell the transition to the ornate interiors created a few years later.

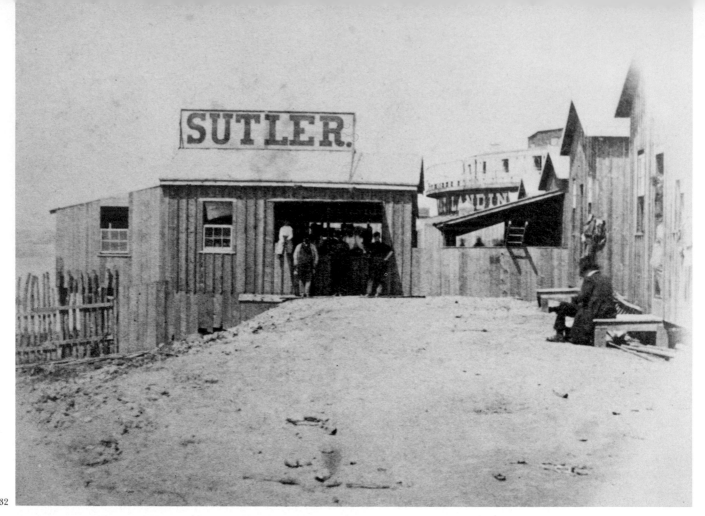

32

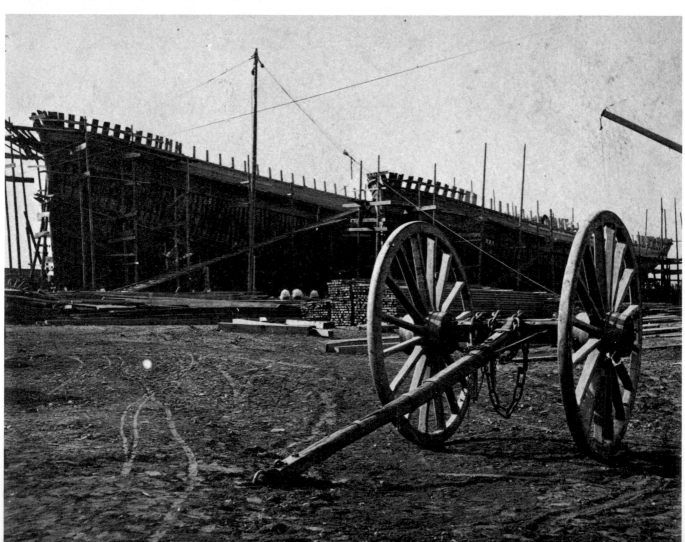

33

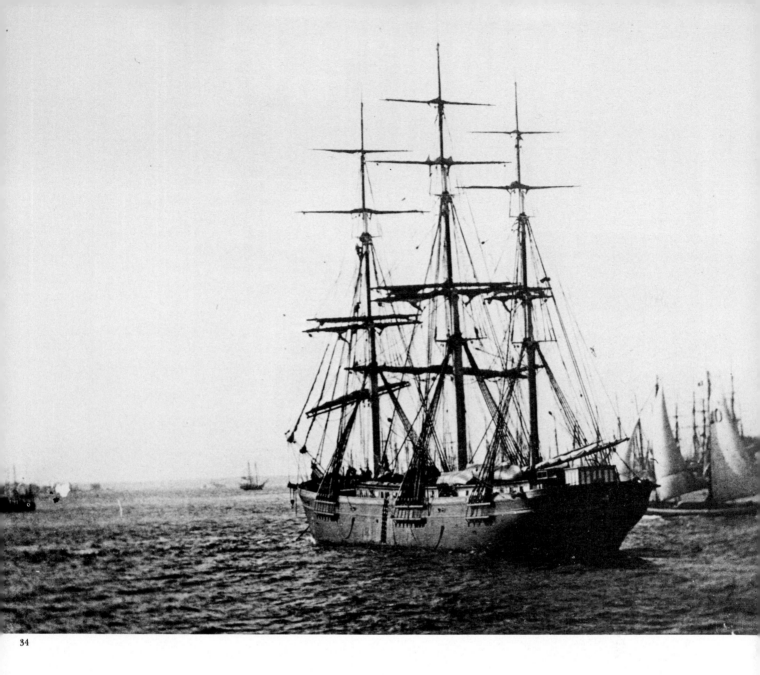

34

32. Although the effect of the Civil War on New York harbor was drastic, little of this was recorded by the camera, partly because several of the best photographers of the harbor were transferred to the war front and, for a time, there was a sharp drop in the public's interest in stereoscopic views. One of the few photographs showing wartime activity is this Anthony view of 1861, of a sutler's store at the Battery. (A sutler was a private businessman who sold provisions, liquors, etc., to soldiers and sailors.)

33. New York shipyards hummed during the war, converting civilian craft to military use and building a new fleet of armed ships and transports. In this 1862 view, two steamers are under construction at the J. B. & J. D. Dusen Shipyard, located at the foot of East 18th Street. They had wooden hulls

(200'–35'–1,200) and were intended for the Neptune Steamship Co. After their service in the Navy during the war, they were purchased by the Baltimore & Ohio Railroad for use in coastal and transatlantic trade. The two-wheeled conveyance in the foreground was drawn by a team of horses to skid heavy timbers about the shipyard.

34. A close-up of a square-rigger at anchor in the East River was taken for Anthony in 1861. The Jacobs ladder is over the port side and half-loops of rope hang from the hull, ready to be engaged by the boarding hooks of the Whitehall boats, ferrying the crew out to the vessel. In the background, Pilot Boat No. 10, the *J. M. Waterbury*, heads out for her station from the pilot's office, located in Burling Slip.

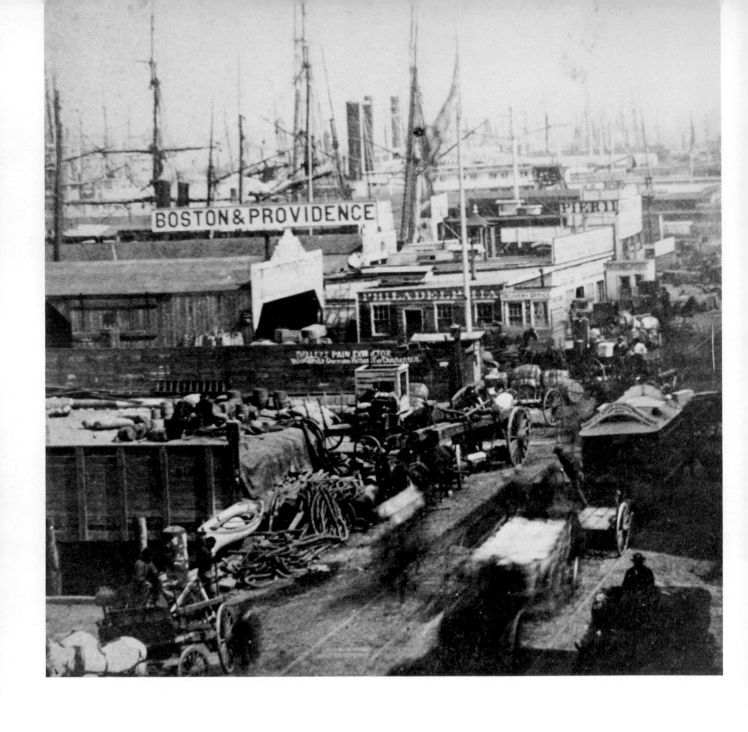

35. In 1863 G. W. Thorne recorded this scene of waterfront activity along West Street and the North River, looking from Rector Street toward the Merchants' Despatch Propeller Line for Philadelphia, via Delaware & Raritan Canal, Pier 10; and the Boston & Providence Propeller Line operations at Pier 11.

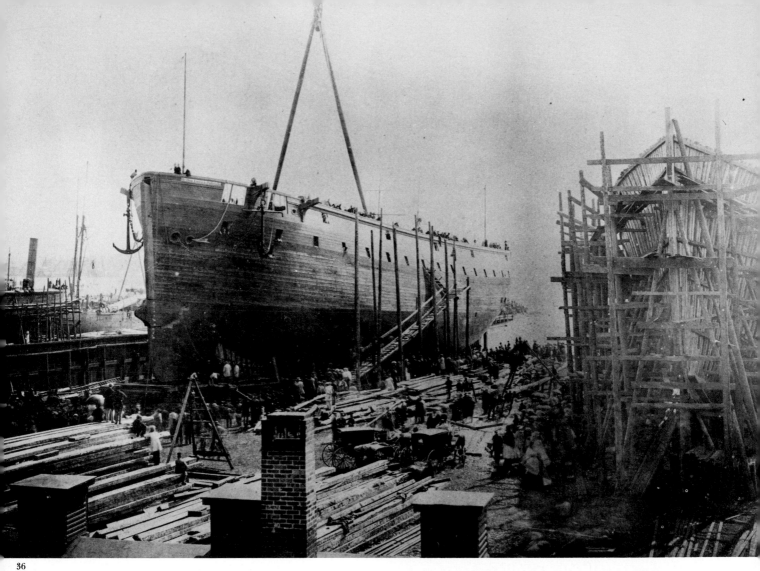

36. At the famous William H. Webb Shipyard on the East River between 5th and 7th Streets, the ironclad *Re di Portogallo* (left) built for the Italian Navy, is nearing completion. Launching took place on August 29, 1863. The yard turned out more than 150 of the finest vessels ever constructed in New York, including packets, clippers, warships and steamships of both wood and iron construction. On the stocks (right) the Pacific Mail Steamship Co. sidewheeler *Colorado* is taking shape. She was commodious, elegantly furnished and proved to be one of the fastest steamships of her day, operating in the Pacific between San Francisco and Panama. In 1867, the *Colorado* opened the transpacific route for Pacific Mail S.S., running from San Francisco to Hong Kong and Japan.

37. In 1867 William H. Webb (1816–99), the brilliant naval architect, master shipwright and successful businessman, was photographed by A. Liebert & Co. in Paris, after he had delivered the *Dunderberg*, a large ironclad (ram-style) warship to the French government. His ability and versatility were such that he was able to design masterpieces in sail and steam for both naval and commercial use. He was genuinely appreciated by foreign powers, but often rebuffed by his own government.

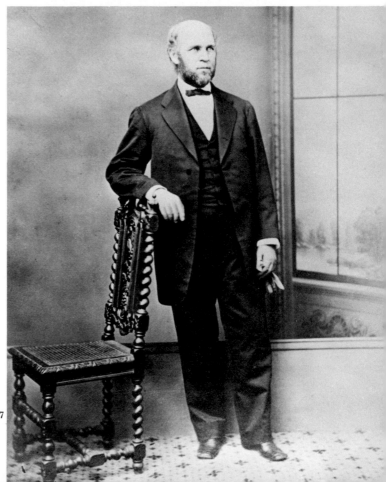

37

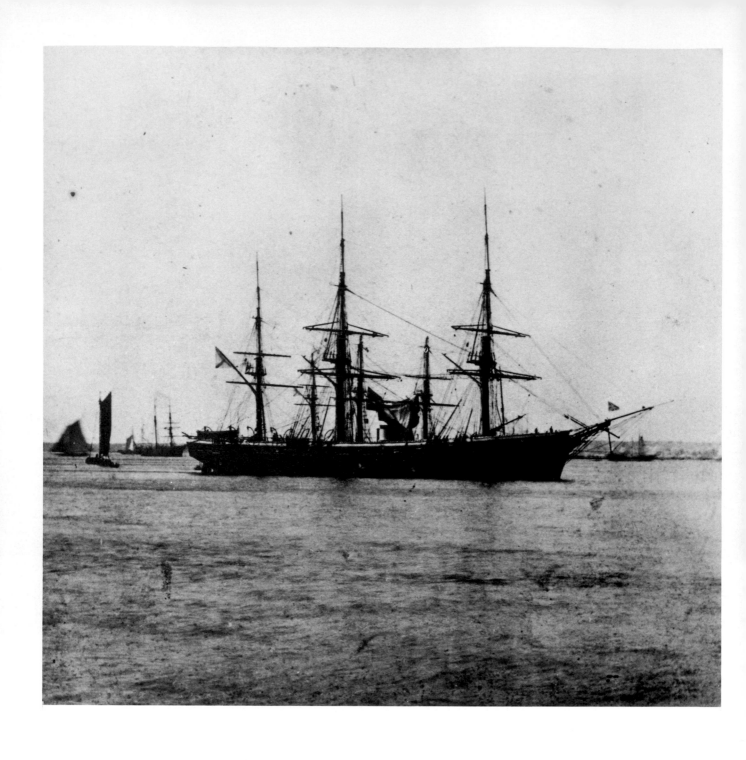

38. The war affected relations of the Union government with various European nations, depending in part on the economic interests the latter had in their trade with the Confederacy. Russia demonstrated her sentiments by sending a fleet of six warships to New York in September, 1863. This Anthony view shows the flagship of the fleet, the 51-gun frigate *Alexander Nevsky*, at anchor in the Hudson.

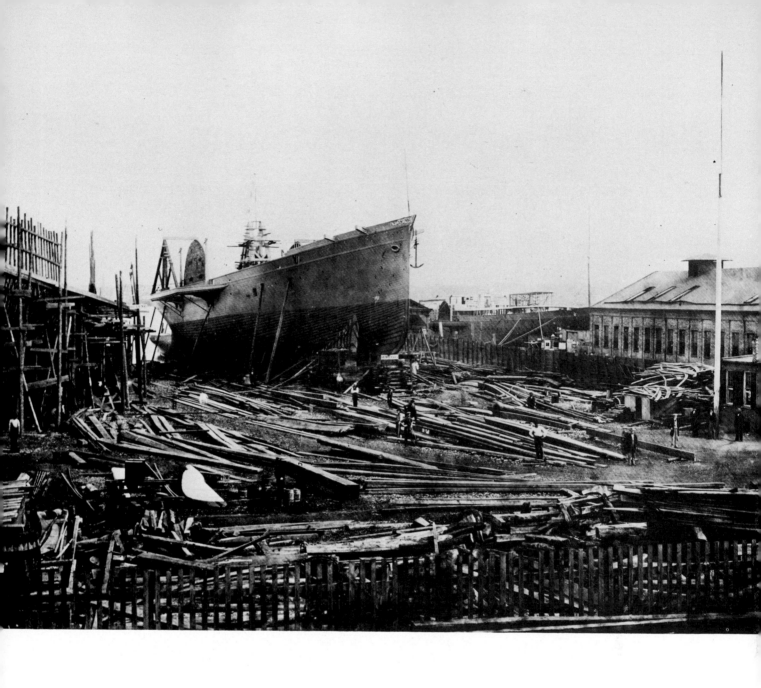

39. The *Suwonada* (258′–38′2″–1,082) was photographed cleared of scaffolding, soon to slide down the ways at the John Englis Yard on the East River between 10th and 11th Streets. Built for Chinese coastal service in 1864, she operated for the greater part of her career on the Shanghai–Hong Kong run. After striking submerged rocks and running aground a number of times, she struck a rock off Hainan Island in 1872 and was a total loss. At the left, construction is progressing on hull no. 46, the steamboat *Yang-Tse-Kiang*, also designed for Chinese coastal service.

The New York Waterfront before the Civil War 29

THE NEW YORK WATERFRONT
AFTER THE CIVIL WAR

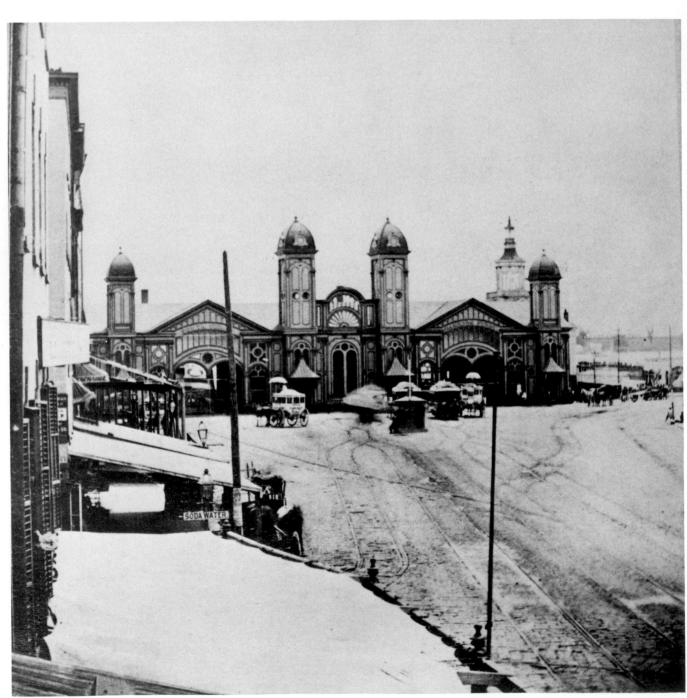

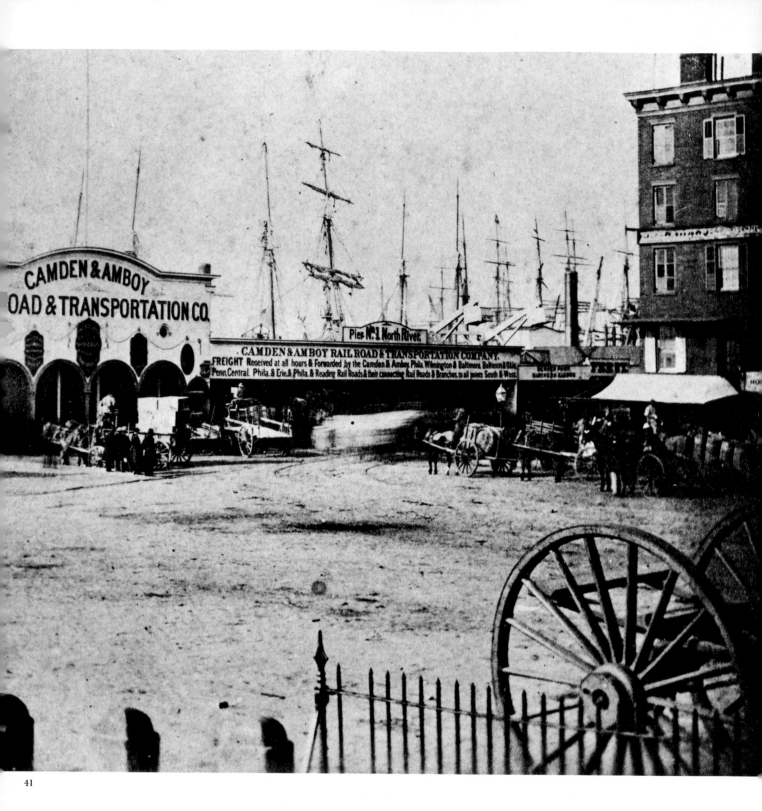

41

40. The growth of the city and its wealth led to the construction of increasingly elaborate terminals for ferries, such as this one for the South and Hamilton Street ferries for Brooklyn. To its right is Pier 1 for the Staten Island Ferry, with the New York Barge Office in the background. Both horsecars and horse stages (or omnibuses), started out from the Ferry. In fact, in the 1850s 12 of the 27 stage lines on Manhattan had routes starting at South Ferry. The Broadway stages were in service daily until 11:30 P.M., and charged a fare of ten cents. When a passenger decided to disembark from a stage, he signaled by tugging at a leather strap attached to the driver's leg. In time, horsecars replaced almost all of the stages.

41. A photograph of 1865 shows the rebuilt Camden & Amboy Railroad & Transportation Co. terminal at Pier No. 1, Hudson River. The steamboat *William Cook* made two round trips daily between Pier No. 1 and South Amboy, N.J., connecting with the Camden & Amboy trains running to Philadelphia. While aboard the Black Ball packet *Hibernia* on a transatlantic crossing, Robert Stevens, of the Stevens family that owned the Camden & Amboy R.R., conceived the design of the "T" rail still used by railways. Ferry service to Bergen Point and Mariners Harbor was provided from the slip at the right.

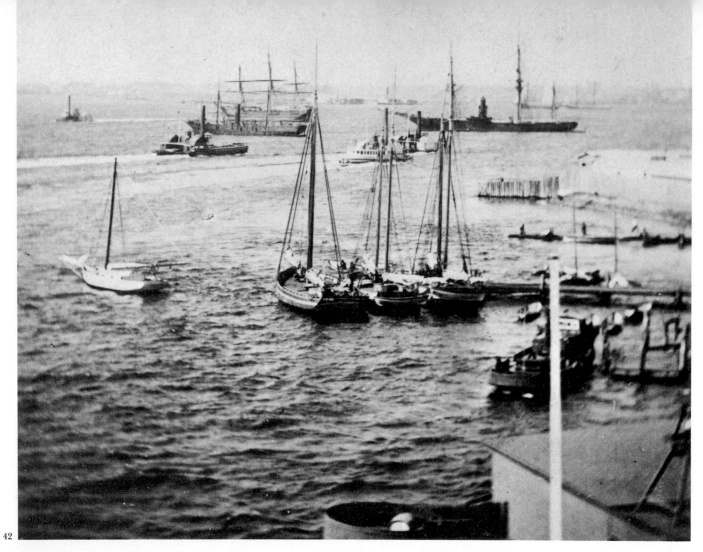

42

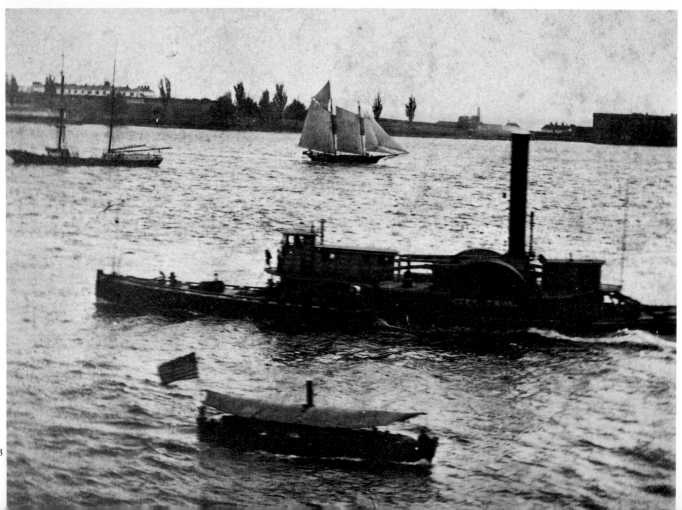

43

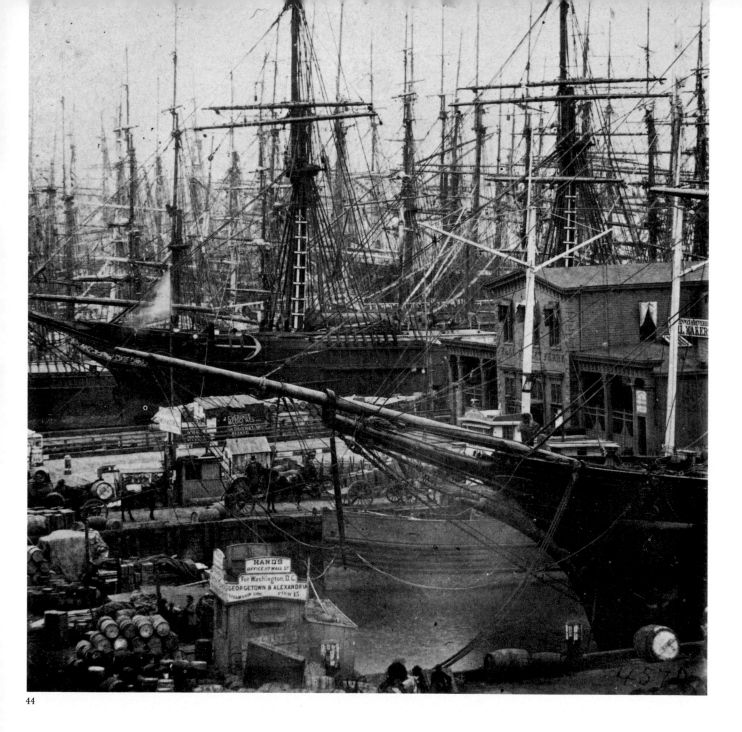

44

42. John Soule, one of the finest photographers in Boston, was in New York shortly after the Civil War and made a number of instantaneous views of shipping at or near the Battery. In this one of the North River from the Battery, he affords us a glimpse of the foreign vessels that frequented the harbor at that time. In the center, a screw-type, square-transom steamer lies at anchor, while to the right a bark-rigged, single-stack naval screw steamer is seen. The latter has an escape pipe forward and aft of its stack. Four towboats are also seen under way.

43. Another instantaneous view by Soule—shot against the sun—portrays the giant towboat *City of Troy* heading for the East River, with Governors Island in the background. The lines of this towboat suggest that she may be a recently reconverted double-ended naval gunboat, with an incline or

horizontal engine, which once had her pilothouse at the other end of the deck.

44. Here we have an 1865 Anthony bow view of the famous packet ship *Dreadnought* alongside Pier 15 on the East River at Wall Street. Considered a "medium" clipper (one not of extreme design), the *Dreadnought* (210′–40′–1,413) was built at the Currier & Townsend Yard at Newburyport, Mass. in 1853. She sailed under the St. George Line's Red Cross Flag with Capt. Samuel Samuels as master and accounted for many fast passages in approximately 75 transatlantic voyages. She was wrecked off Cape Horn in 1869. All hands were saved after 14 days in the lifeboats. The sign on the pier shed advertises "Hands Office, 117 Wall Street, for Washington, D.C., Georgetown & Alexandria Steamship Line, Pier 15."

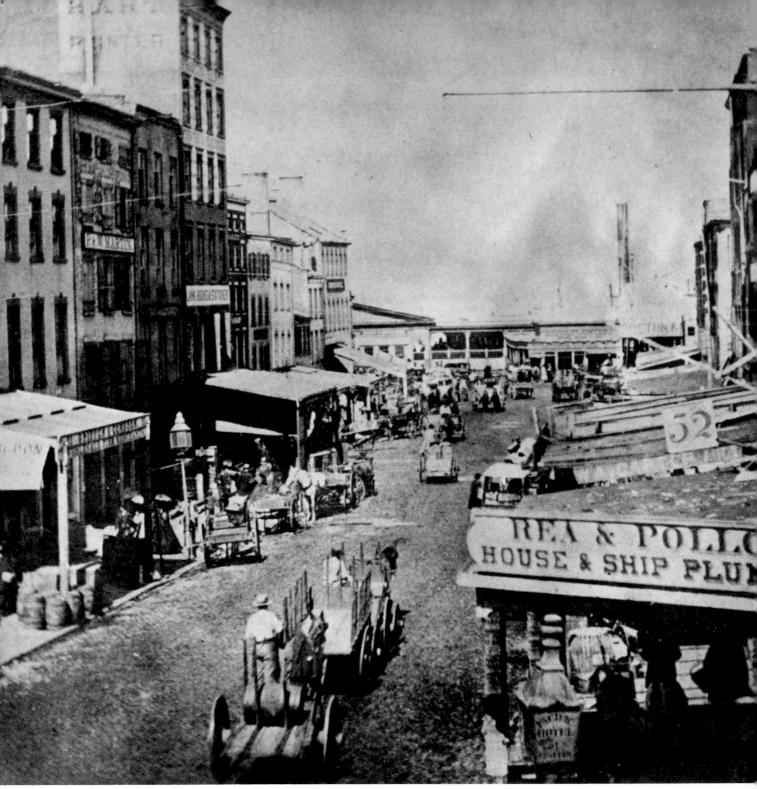

45

45. The business of the waterfront spilled over into the side streets and even some of the streets one or two blocks inland. Here, on Cortland Street (1865), there are immediately evident the firms of Rea & Pollock, House and Ship Plumbers and, across the street, a wholesale fish house. Pier No. 17, the Jersey City Ferry, and Pier No. 18, the Staten Island Ferry, face the end of the street. This is one of the first views presented here which can safely be attributed to Thomas C. Roche, who had returned from the war to resume local photography for the Anthony Brothers.

46. Thomas Roche also took this stunning view of South Street in 1866. The Union Ferry Co.'s *Monticello* is shown at South Ferry. Later renamed *Shinnecock*, she was in commission until 1928. (All the following Anthony photos are by Roche.)

47. 14th Street was "uptown" to New Yorkers in the 1860s and much of the land north of 42nd Street remained suburban or rural until the elevated railroads spurred its development. Along the East River above 59th Street there were large picnic grounds where families could enjoy the cooling river breeze and a glass of lager beer from the local breweries. This picture, taken at 59th Street in 1865, shows some of the grounds and a river steamboat, probably delivering more excursionists.

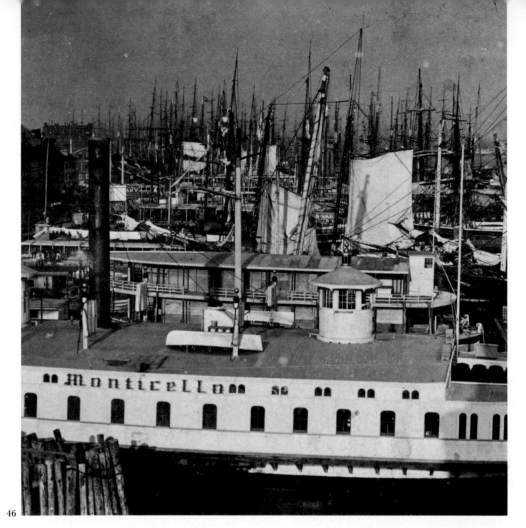
46

47

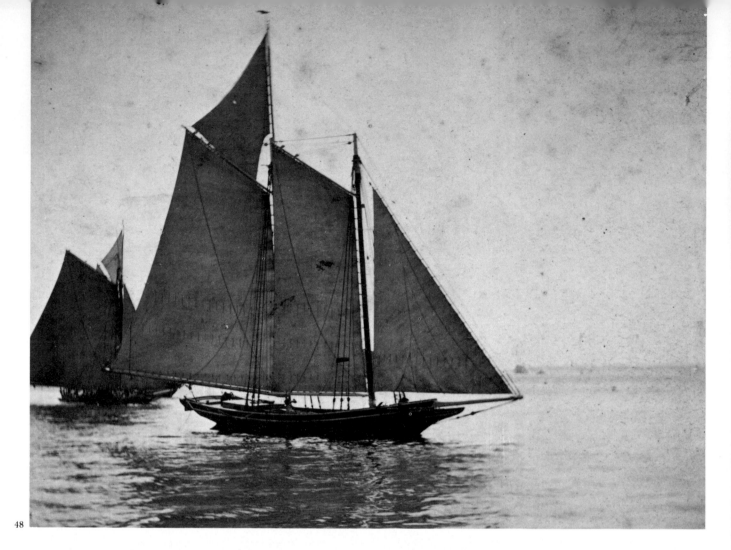

48

49

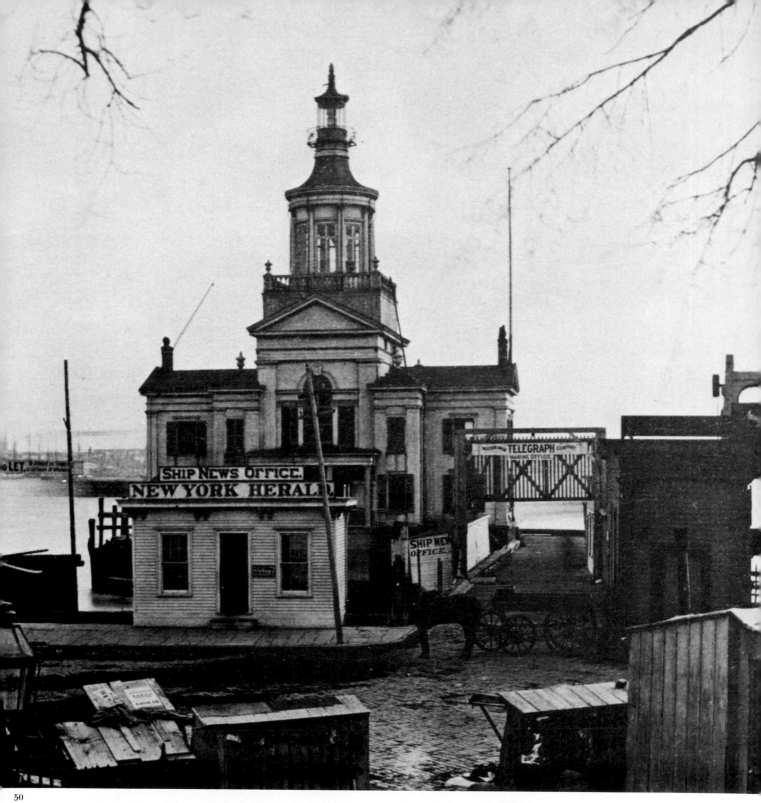

50

48. The beautiful lines of some of the Hudson River schooners, worthy of a fine yacht, are perhaps best shown in this 1866 Anthony image. The schooners replaced sloops because they could be managed with fewer men. Later, as competition from steam forced schooners to concentrate on cheap bulk cargoes, the lines of the schooners were coarsened, tending to make them more like sailing barges. Sailing ships prospered after the war. Reconstruction, the release of pent-up consumer demand, the opening of the West and renewed immigration caused a boom in the economy, creating needs that could not be served by steamboats alone.

49. The Wall Street Ferry building on the New York side, as it appeared about 1866. The Broadway and 40th Street stage

awaits the arrival of the ferry from Montague Street, Brooklyn. Steamships for Savannah and Newbern are advertised at the left.

50. Of several known photographs of the Barge Office, this Anthony view of 1866 best displays its graceful, classic design. It provided housing for the customs inspectors waiting to board incoming vessels, the boathouse of the Harbor Police, and the Marine Office of the Western Union Telegraph Co. In the foreground is the Ship News Office of the *New York Herald*, which first published in 1835. The publisher, James Gordon Bennett, specialized in ship arrivals and all related marine news. A portion of the Staten Island Ferry slip is shown at the right.

The New York Waterfront after the Civil War 37

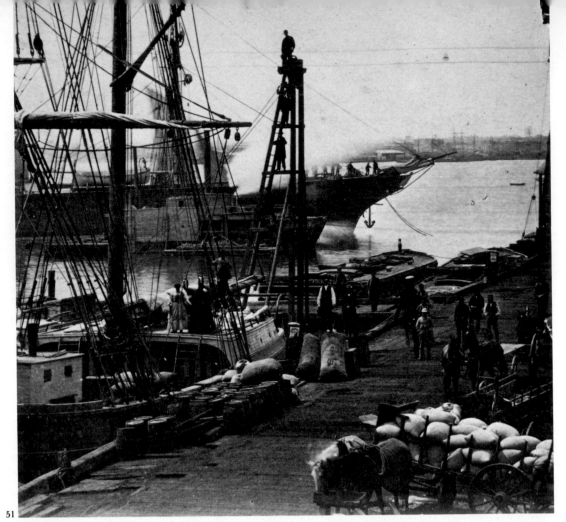

51

52

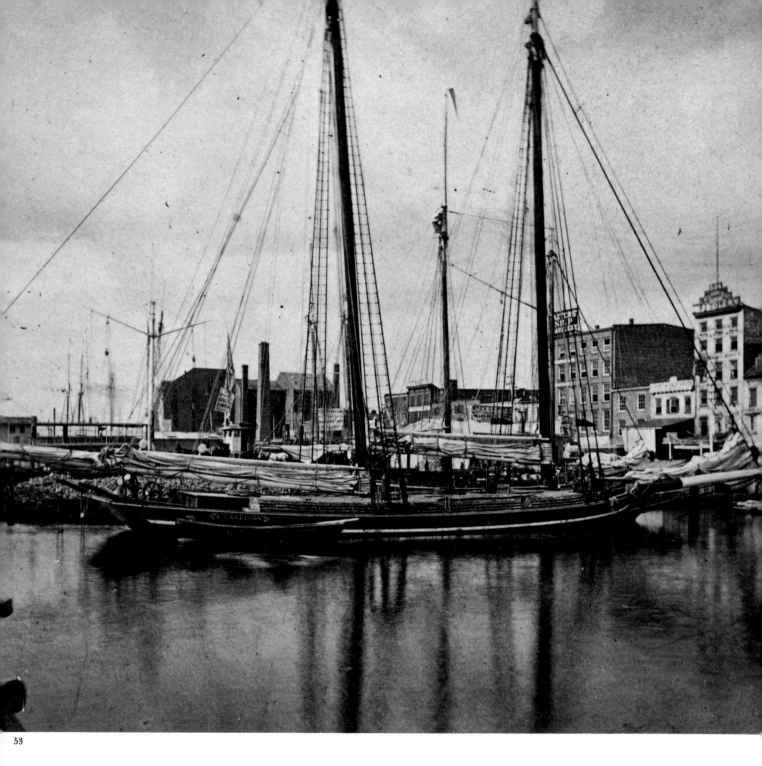

53

51. Pier 46, on the North River at King Street, 1867. Everybody stopped to have his picture taken in this one, including the four men posed on the piledriver alongside the dock. A half-brig is to the left of the piledriver and canal barges are tied up beyond it. In the stream, a side-wheeler towboat blows off steam as it docks a *Europa*-class Cunard Liner, its clipper bow and figurehead silhouetted against the harbor waters.

52. New York's importance in the export of grain is recalled in this dramatic Anthony photograph of a floating grain elevator in the East River, with its conveyor removing grain from the *Simcoe*, a canal boat from Oswego, N.Y. The elevator is discharging the grain through one of the two discharge tubes visible on the near face into receptacles aboard a barge at left. Another grain elevator is visible on the left side of the photo and the three-masted bark *F. Reck* (132'–31'4"–526), built in

New York in 1865, figures prominently.

53. An Anthony photograph of 1868 shows the extraordinary two-masted Hudson River schooner *C. S. Allison* of Stony Point, N.Y. tied up at the foot of Spring Street and the North River. She was built in 1866 at Stony Point and operated on the Hudson until she was purchased by the Conway family of Cambridge, Md. and was transferred to Chesapeake Bay. She served there for many years, was renamed the *Betty I. Conway*, and was converted into a powerboat in the late 1920s. At the ripe old age of 106 she was involved in a collision on December 6, 1972, and sank, ending her career as one of the oldest active registered vessels on Chesapeake Bay, as well as in the country. The ability of a hull to survive over a century of pounding by the seas and by its own internal engine for almost 50 years is a convincing testimony of the workmanship of the old Hudson River shipyards.

The New York Waterfront after the Civil War 39

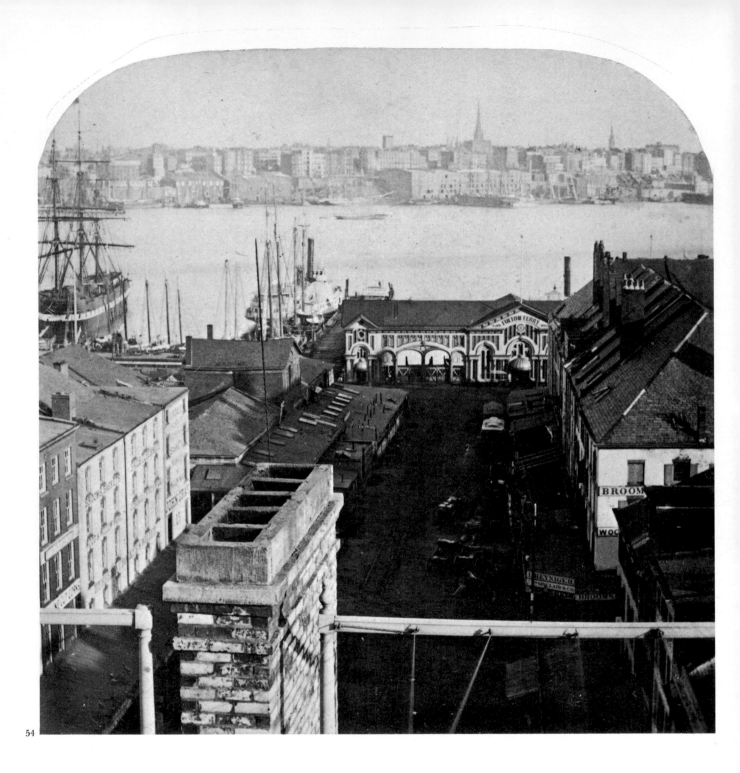

54

54. Here is the earliest-known overall photographic view of Schermerhorn Row, the group of eighteenth-century buildings at the right which today forms the nucleus of the South Street Seaport Museum. The panorama was taken from the United States Hotel, looking toward the Fulton Street Ferry, a cast-iron building completed in 1863. It predates the construction of the new Fulton Market building. An early type of packet ship of the Black Ball Line is visible at the left.

55. The Fall River Line's *Newport* steams up the East River, with the Brooklyn Navy Yard in the distance. The wooden-hulled steamship (350′–43′–2,151 gross tons) was built in 1865 by John Englis & Son at their yard on the East River between 10th and 11th Streets. Her four stacks were an unusual arrangement. The steamscrew frigate *Colorado* is visible at the left.

56. Castle Garden, shown in a photograph of 1868, was originally a fortification built in 1807 on a small island off the Battery. Intended to protect New York from what was then the very real possibility of a foreign naval attack, it was first called the West Battery, but later became Castle Clinton. In March 1822, Congress ceded the fort to New York, and it was opened as a place of public entertainment. Italian operas were presented here, and P. T. Barnum introduced Jenny Lind to America on its stage in a legendary performance. The building later was taken over by the New York State Commissioners of Immigration, and was used as an immigrant landing depot for 35 years. In 1890 it was reopened as an aquarium. Castle Williams, on Governors Island, in the distance, was also a port fortification.

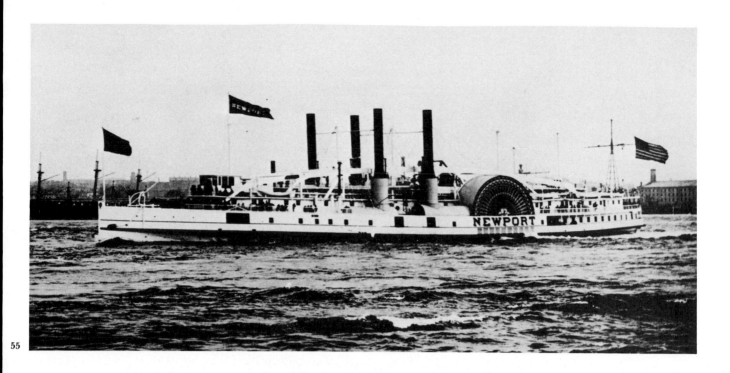

55

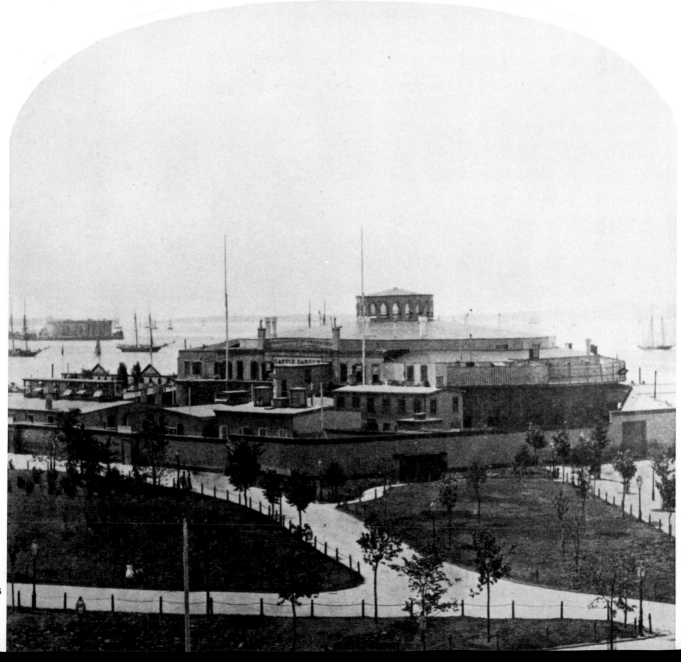

56

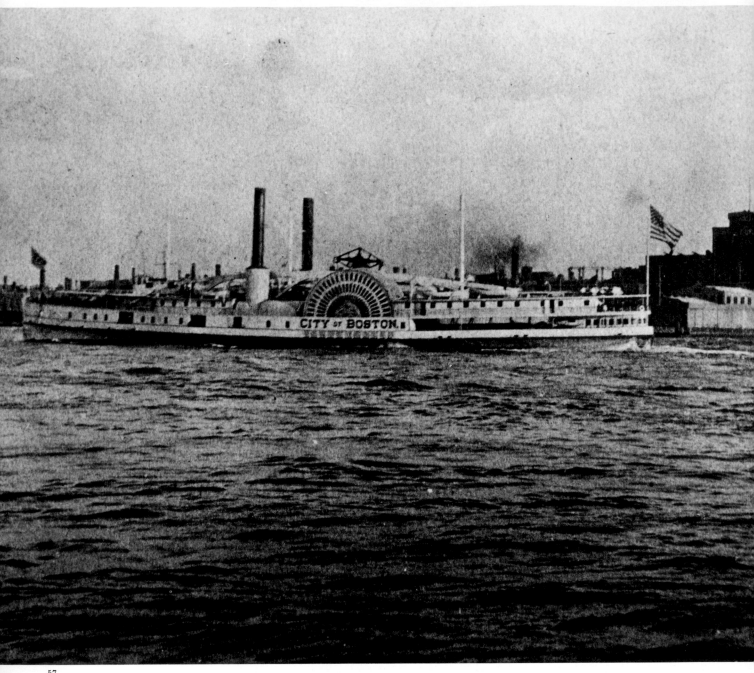

57

57. A steamboat that seemed to have a cat's proverbial nine lives was the *City of Boston*, built by Samuel Sneeden of New York in 1861 for the Norwich & New York Transportation Co. A sister ship of the *City of New York*, she had a wood hull (301′–40′–1,497) and a vertical beam engine. At their completion, both boats enjoyed the reputation of being the fastest on the Sound. The *City of Boston* soon became involved in a series of collisions. On October 22, 1863, she sank the steamboat *Oregon* in the Hudson River. She was rammed and damaged by the *State of New York* off Saybrook, Conn. on July 2, 1868. The Providence Line propeller *Electra* rammed her again on April 21, 1874, as she was rounding the Battery. In the resulting confusion, the tugboat *Camilla* sank the tugboat *S. J. Christian*. Then, on May 18, 1882, the *City of Boston* toppled from the Big Balance Drydock on the Manhattan side of

the East River while being raised for repairs to her engine keelsons. Her hull was severely damaged, necessitating replacement of most of her bottom. She and her sister ship went out of commission in 1896 when steamboat service between New York and Norwich was discontinued. She was broken up in Boston in 1898. While in service, she sailed from Pier 39, North River.

58. The ancient Fulton Market Buildings, sprawling into the streets, seem to have been overlooked by photographers, except one, representing John S. Moulton of Salem, who visited New York in about 1870.

59. Moulton's man also captured this prospect of South Street from a cathead on the starboard side of a vessel, looking towards Peck Slip and the New Haven & Hartford Steamship Line Pier.

58

59

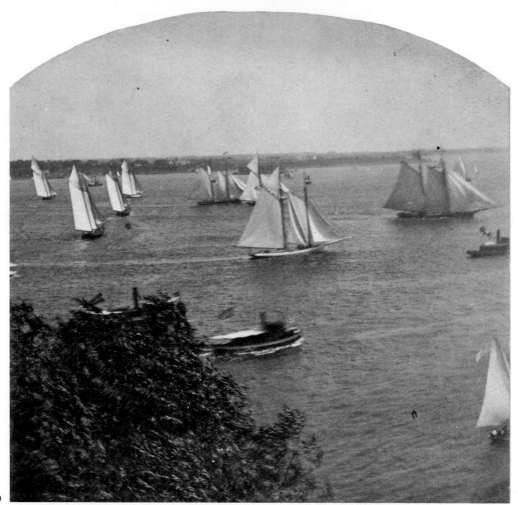

60

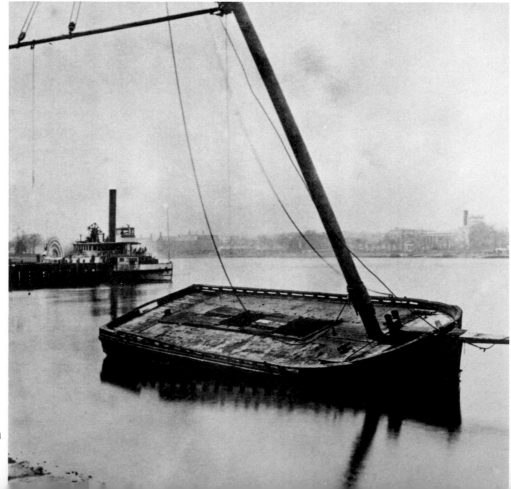

61

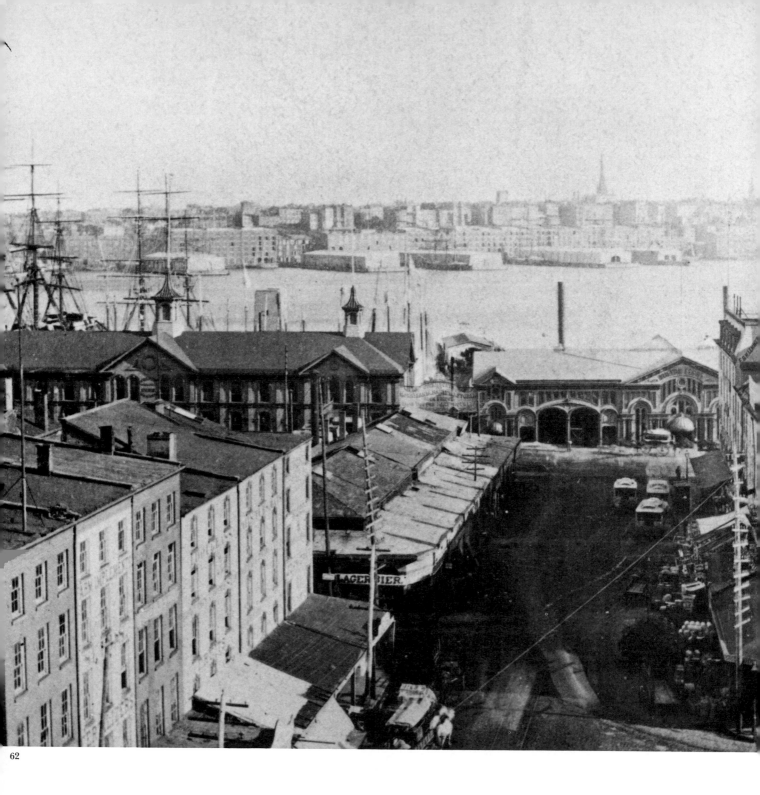

62

60. Yachting in New York Bay became more popular after the Civil War; on August 8, 1870, the first challenge race for the America's Cup was held. Seventeen yachts of the New York Yacht Club vied with a sole British contender, the *Cambria*, representing the Royal Thames Yacht Club. All were schooner-rigged. *Magic*, shown at far right, won the race, and *Cambria* finished eighth, dropping to tenth on corrected time. This rare photograph, discovered only recently, shows eight of the schooners off Staten Island.

61. The common fate of worn-out lighters and other wooden craft in the old days is well shown in this Anthony shot taken at Astoria, Long Island in 1870. Their hulks, stripped of easily removable hardware, were simply abandoned along the shore or up creeks, sometimes becoming navigational hazards. In the background, the steamboat *Sylvan Shore* is tied to its pier. The distant shore is Manhattan.

62. By 1870, the New York and Brooklyn shores, as seen from the United States Hotel, showed major changes. Fulton Market now boasted a large, new and impressive market building, while the Brooklyn waterfront was lined with several substantial covered piers, reaching out for a greater share of the harbor's expanding trade. The pier between the Fulton Ferry and Fulton Market buildings has a sign that reads, "Steamers for Morrisania, Harlem, Astoria and Highbridge leave this pier halfhourly." Masts of the Black Ball packets are at the left. This venerable line survived until 1878.

The New York Waterfront after the Civil War 45

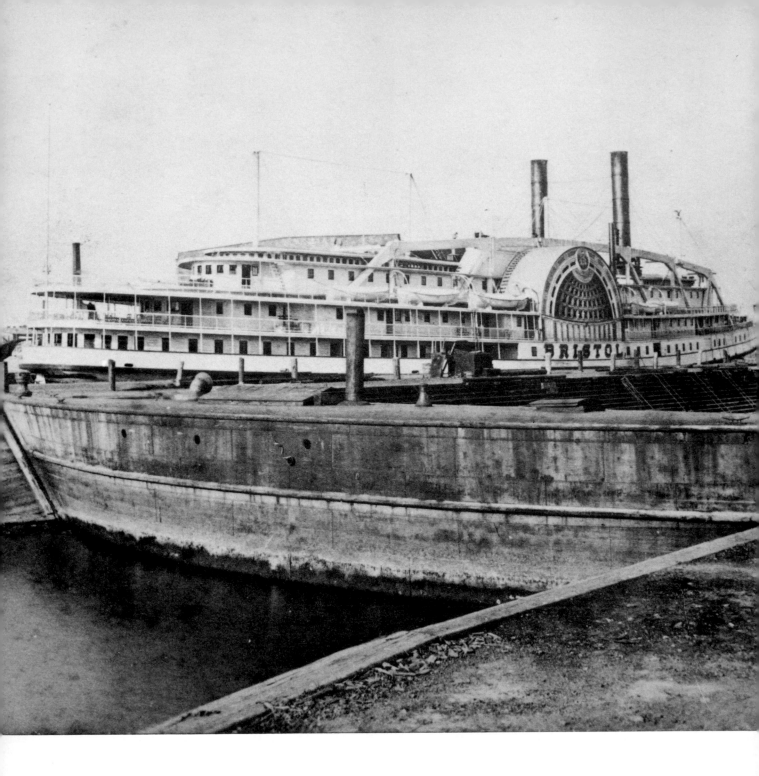

63. Long Island Sound and Hudson River steamboats of the late 1860s and 1870s were superb vessels—huge, powerful, fast and dependable. They were also beautiful, being lavishly decorated inside and out. Two of the most magnificent of a long string were the *Bristol* (360'–48'–2,962 gross tons) and *Providence*, built by William Webb, New York, in 1866–67. They were of all-wood construction, with watertight compartments, and had 38'8" paddle-wheels driven by beam engine. They had three decks with 240 staterooms capable of accommodating over 800 passengers. The cost for each boat was over $1,250,000, a very sizable sum in 1866. They were originally operated as night boats by the Merchants Steamship Co. on the run from New York to Bristol, R.I. Later purchased by the Narragansett Steamship Co., their run was extended to Fall River, Mass. with a stop at Newport, R.I. In an Anthony picture of 1870, the Bristol is in one of the John N. Robins Co. Erie Basin dry docks in Brooklyn. (The yard was later acquired by William H. Todd and is now operated as Todd Shipyards' Brooklyn Division.)

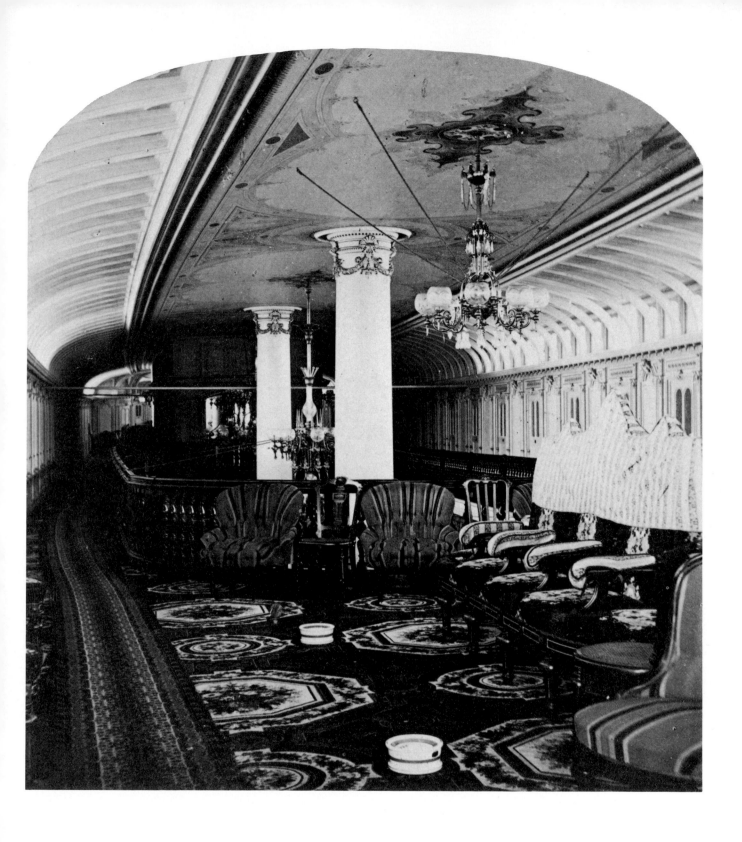

64. A view of the saloon of the *Bristol* details its wood carving, ornate ceiling decoration, crystal chandeliers, richly upholstered chairs, lush carpeting and gilt-edged spittoons, all exemplifying the elegance once found on coastal steamboats. The end of the *Bristol* came on December 30, 1888 when fire destroyed this grand specimen as she was laid up at Newport.

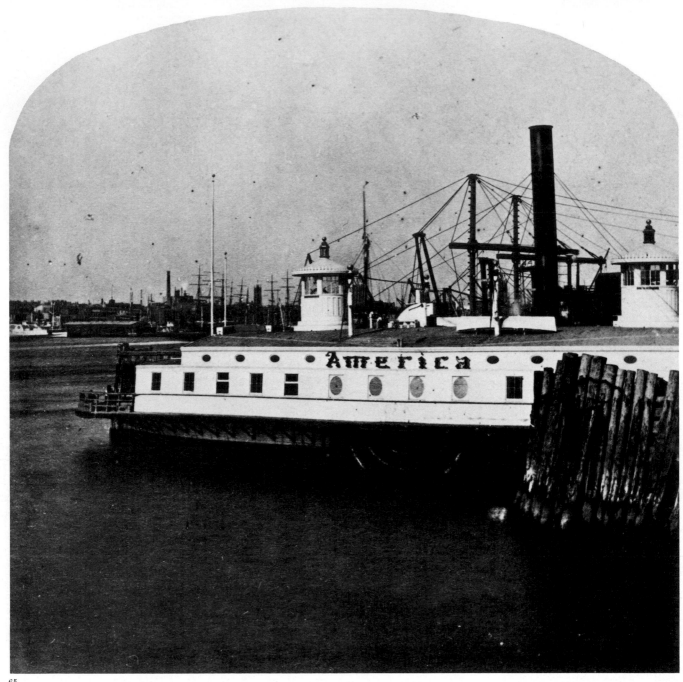

65

65. One of the ferries that crossed the East River, joining Grand Street on the Manhattan side with Williamsburgh on the Long Island side, was the *America*, shown here in her Manhattan slip in an 1872 Moulton view. Webb & Bell of Greenpoint, Long Island built her in 1862 with curved roof and inclined engine, for the Union Ferry Co. of Brooklyn.

66. The abundance of fish in the waters near New York made it possible for fishing schooners to bring a fresh catch daily to Fulton Market. A few of these boats behind the market, and the ferry *Mineola*, are neatly framed in this view published by Moulton.

67. A rare view of a square-rigger in dry dock in New York, 1872. The ship is the *Greenock* (157'4"–29'7"–640), built by MacMillan in Dumbarton, Scotland, and rerigged as a bark in 1873. The dry dock is the Big Balance, on the East River at Rutgers Slip, built in Williamsburgh in 1854 by William H. Webb.

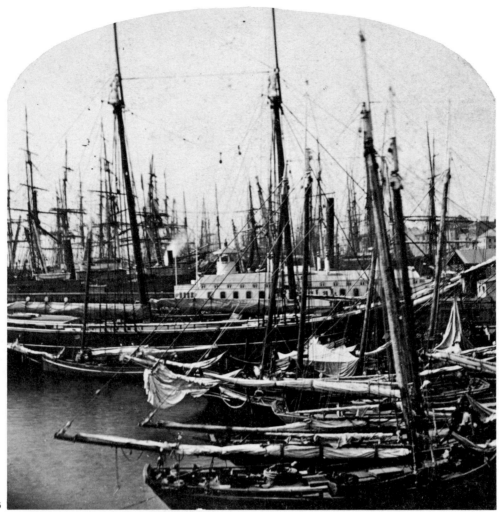

66

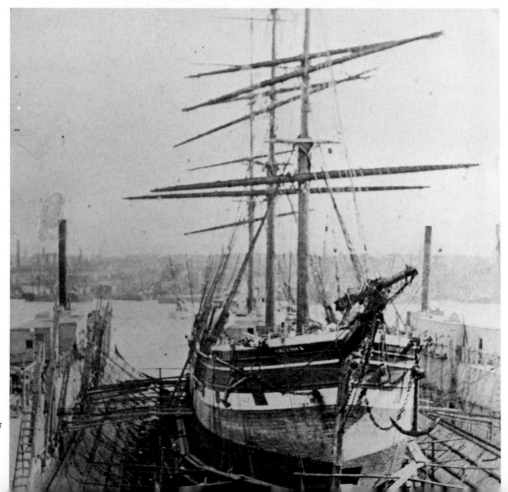

67

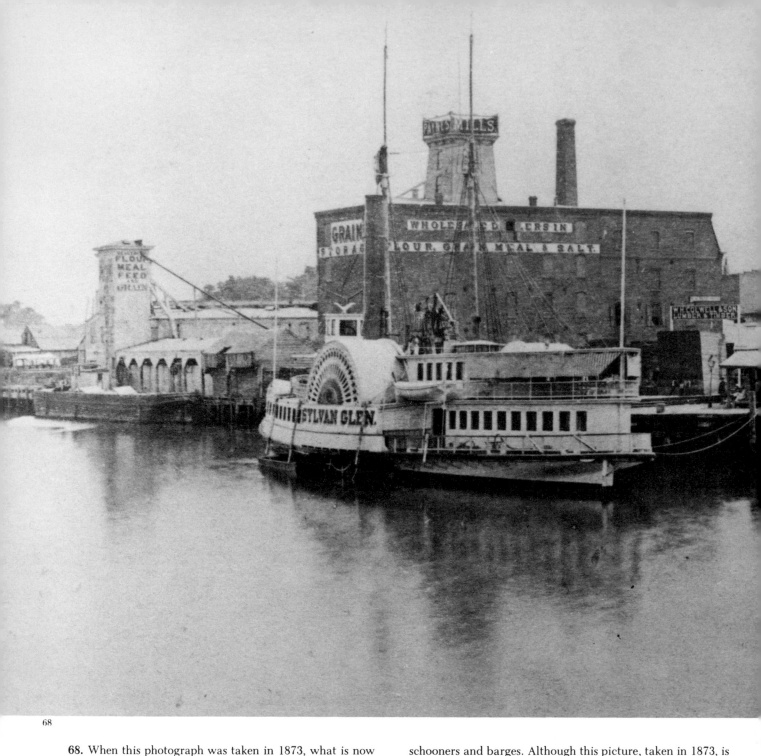

68

68. When this photograph was taken in 1873, what is now the Bronx consisted of many rural villages. Wealthier residents commuted to work or went shopping in lower Manhattan by taking a steamboat down the Harlem and East Rivers. A quick stop was sometimes made at Astoria to pick up extra passengers. The Morrisania Steamboat Company, with three boats, started at Mott Haven. Its rival, the Harlem & N.Y. Navigation Co., boasted five boats: the *Sylvan Glen*, *Sylvan Shore*, *Sylvan Grove*, *Sylvan Stream*, and *Sylvan Dell*. The wooden-hulled *Sylvan Glen* (153'5"–27'–350), was built by Lawrence & Foulkes of Brooklyn in 1869. The pretty boat could make 17.5 miles an hour. In the background are large businesses dealing in grain, feed, flour, meal and salt—reminders of the huge grain trade New York harbor once enjoyed.

69. A seldom-photographed section of the waterfront was the stretch south of 53rd street, where lumber, timber, coal and building-material companies received their supplies from schooners and barges. Although this picture, taken in 1873, is an Anthony issue, it is from an early dry plate and is not of the same quality as their wet-plate photographs.

70. Stonington, Conn. was a port of considerable commercial importance throughout most of the nineteenth century and was favored with daily steamboat service from New York in season. The *Stonington* (253'–40'–1,633), shown here in 1873 on the East River en route to Connecticut from her North River berth at Jay Street, alternated arrivals with her sister ship *Narragansett*. She was originally built as the *Grampus* for the New York & Philadelphia Steamboat Co. but was not picked up by that company, remaining in an unfinished condition until she was purchased by the Stonington Steamship Co. in 1868. She had a wood hull, vertical-beam engine and ran on her route for 26 years with but one serious accident: on the foggy evening of June 11, 1880, while headed for New York, she collided with her sister ship near Cornfield Light, causing the loss of over 30 passengers on the *Narragansett*.

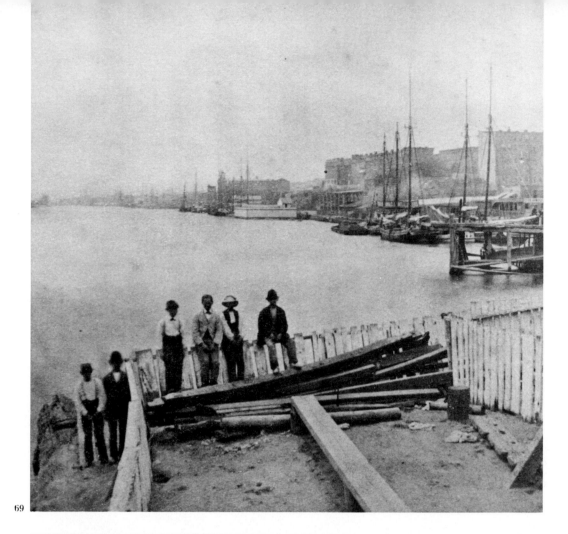

69

70

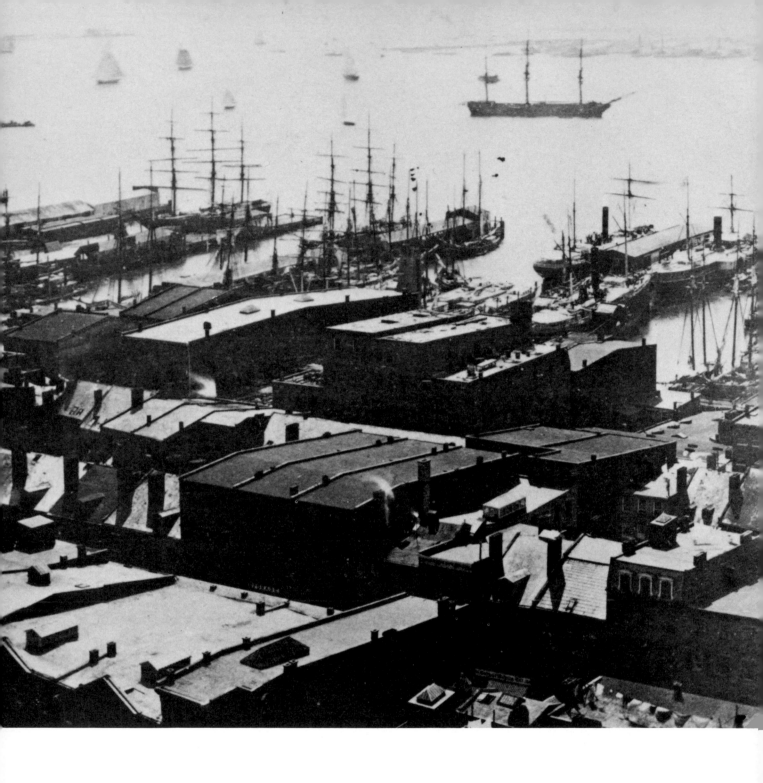

71. A panorama of the Hudson River in 1873. Starting at Pier 4 on the North River, on the right are three large steamboats belonging to New York & Havana Direct Mail Line. The one closer to shore on the right is the *Morro Castle* (260′–40′–1,680) a side-wheeler with a wooden hull. At the head of the pier, on the same side, is the *Columbia* (230′–35′–1,347), another wooden-hulled side-wheeler. On the left side is the *Crescent City* (265′–33′–1,731), of a more modern design, a screw-propeller, iron-hull ship.

52 *The New York Waterfront after the Civil War*

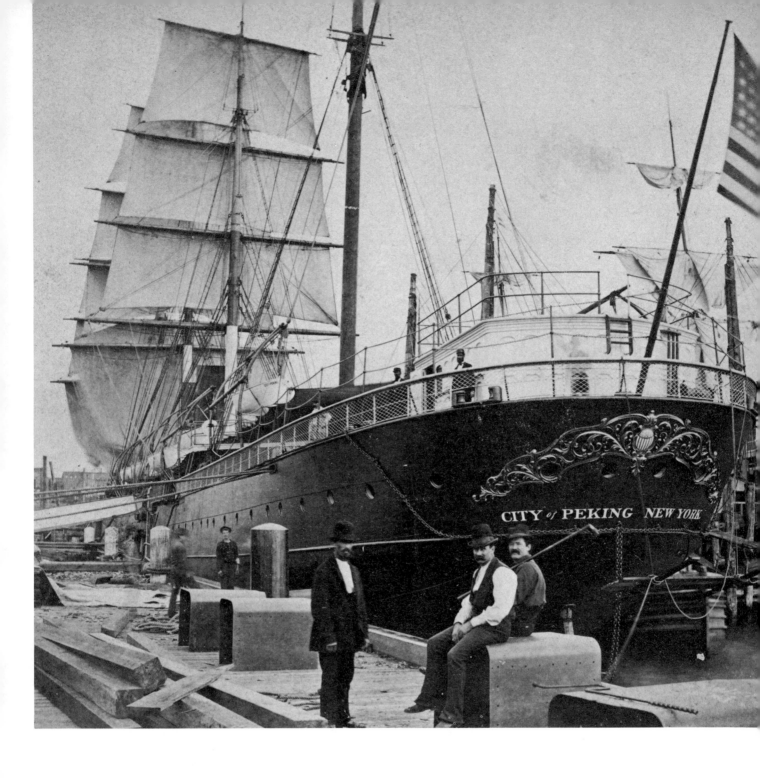

72. What American shipbuilders could do in steam when they had the opportunity is beautifully demonstrated in this picture of the *City of Peking* (408′–47′–5,080) taken by Geo.W. Pach (founder of Pach Bros.) in 1874 at Pier 42 on the North River at Canal Street. This great ship was launched on March 18, 1874 by John Roach & Son at Chester, Pa. for the Pacific Mail Steamship Co., to run between San Francisco and Japan. She had four masts, two funnels, and an iron hull. She and her sister ship, the *City of Tokio*, were the largest Amer- ican ships to be constructed up to that time. Thirty thousand people observed her launching and President Grant and other dignitaries were aboard on her maiden voyage. The *City of Peking* was capable of 15¼ knots and made the 4,750-mile San Francisco-to-Yokohama voyage in 15 days, 9 hours. The last voyage made by the renowned clipper-ship captain, Nathaniel B. Palmer, was on the *City of Peking* in 1877, when he returned from a trip to Hong Kong at the age of 78. She was broken up in San Francisco in 1910.

The New York Waterfront after the Civil War 53

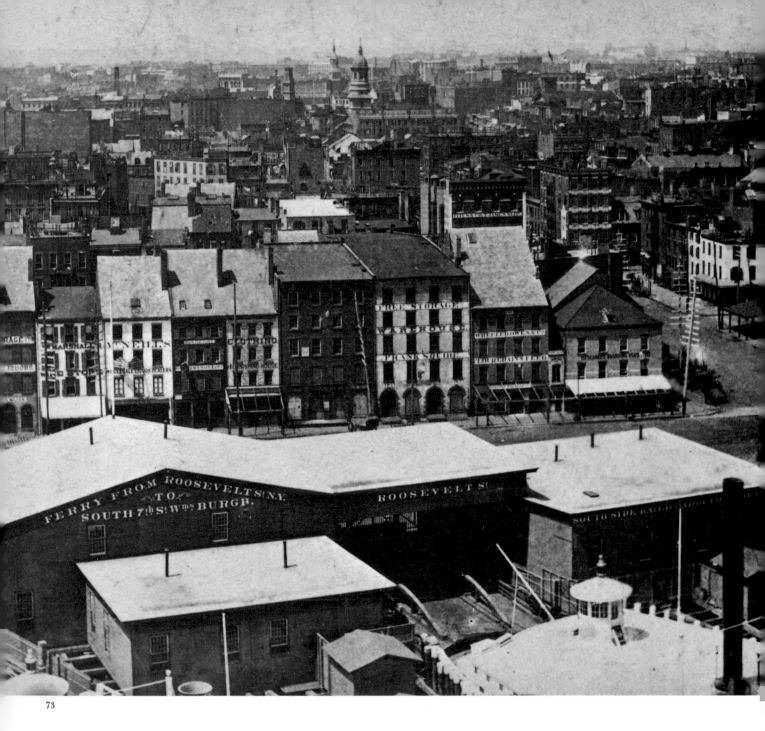

73

73. This view taken in 1874 at the Roosevelt Ferry shows clearly some excellent examples of South Street architecture, starting with the Seamen's Boarding House (right) on the corner of James Slip and South Street. This area was served by a number of ferry lines. At the right of the Roosevelt Ferry is the South Side Railroad's ferry terminal. This was an independent railroad built along the south shore of Long Island from Long Island City to Patchogue to compete with the Long Island Railroad. Ferry service was provided to Hunters Point in Queens to make train connections.

74. Excursions aboard a steamboat were the only way many of the city's poorer citizens could afford to escape the city's heat and spend a pleasant day outdoors. Trips to Coney Island—and later to the Rockaways, Long Island and Hudson River picnic sites and Jersey beaches—were popular. The *Thos. P. Way* brought countless thousands of excursionists from New York and Newark to Jersey beaches and other spots from the 1860s on. A 369-ton side-wheeler, she was built in

1859 at Keyport, N.J. and at first was assigned to Hudson River service from her home port at Perth Amboy. She gained fame on March 23, 1878, when she was instrumental in minimizing a disaster. The steamer *Magenta* blew up while running from Sing Sing to New York. The *Thos. P. Way* rescued her passengers and took her in tow. The *Way* herself, shown here in an 1875 view, was abandoned in 1889.

75. Large square-riggers continued to visit South Street in the 1870s, although they now sought bulk cargoes such as wheat, coal and lumber which did not require the faster transit offered by steamships. This ship is the *Cyclone* and is actually a medium clipper design, the successor to another ship of the same name. She was built by Briggs Bros., Boston for Curtis & Peabody of the same city, who had been the builders and owners of the first ship. She was wrecked in 1886. Note the sailor tarring down the jibboom. This photograph was published by A. Veeder, Albany in 1874.

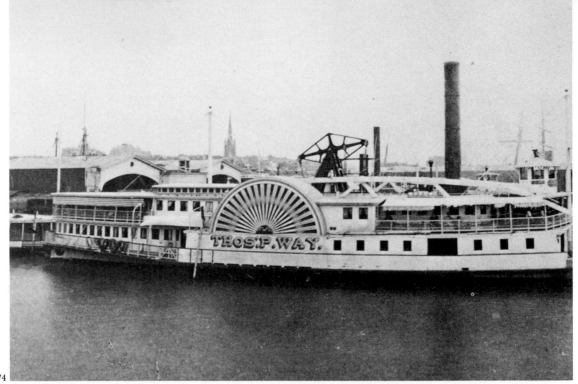

74

75

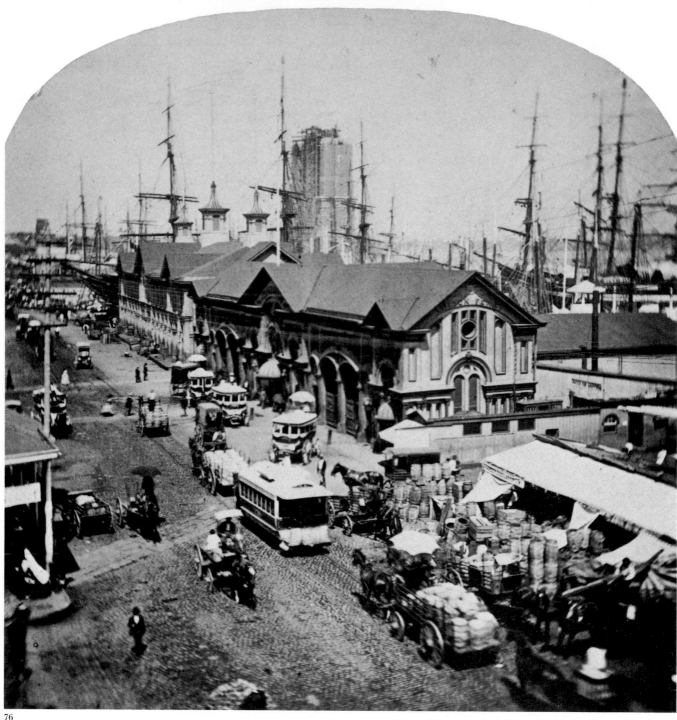

76

76. A good 1875 instantaneous photograph shows Fulton Ferry, Fulton Market and the Brooklyn Bridge tower under construction. Several omnibuses are making connections at the ferry.

77. The building of the Brooklyn Bridge was a boon to photographers; from its unfinished towers they were able to take unprecedented aerial views up and down the river and inland, on both shores of the East River. Here some of the best examples, as well as the famous Beale's Panorama of the Manhattan shore (pages 75–79), are presented. This view looks south along the Manhattan shore. The aerial perspective makes it easier to pick out three-masted schooners, which were the workhorses of coastal shipping in this period. One is docked at Pier 27, across from the steamboat *Sappho*, which

was originally launched as the *Spirea* at Fair Haven, Conn. in 1864. The entire New Haven Steamboat Co. fleet is at Peck Slip, *C. H. Northam* and *Elm City* are in the slip, and the *Continental* is at left. The *Northam* and *Continental* ran opposite each other as day boats in daily service, while the *Elm City* operated as the night boat. The Morrisania Steamboat Co.'s *Harlem* is shown approaching Pier 22 at the end of her commuting run from Harlem.

78. Another view southwest from the bridge tower. Pier 27 is in the foreground, and the New Haven Steamboat Co.'s *C. H. Northam* is at Peck Slip. In the distance, Schermerhorn Row on Fulton Street, and the Fulton Market buildings, are clearly visible. Note the large load of cordwood on the lighter (lower center).

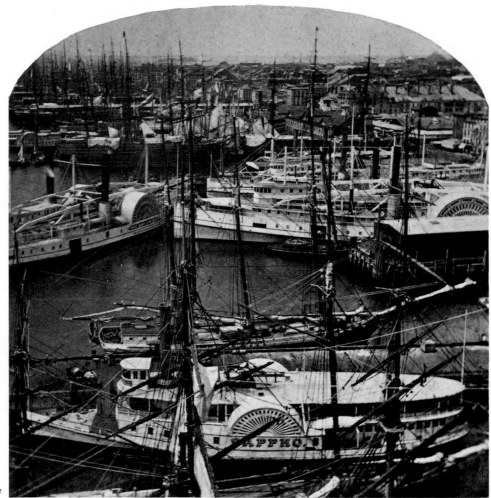

77

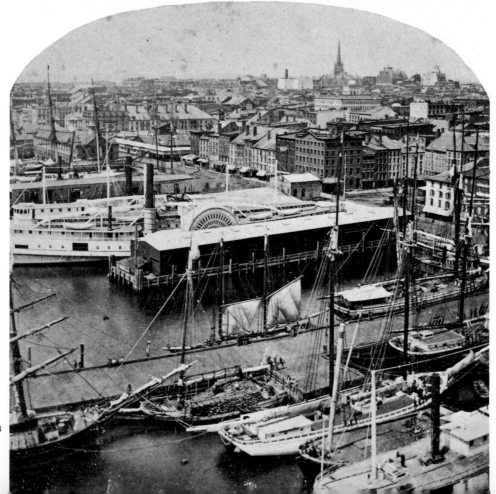

78

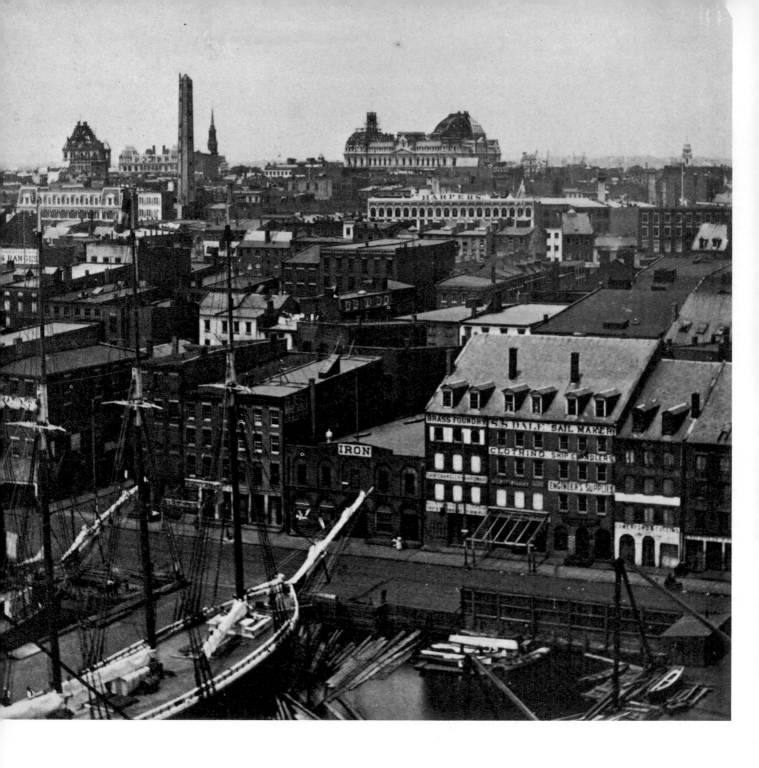

79. This and the next image, both taken looking west from the bridge tower, supply valuable details of the trades directly related to the harbor's business. Signs for iron and brass foundries, engineers' supplies, fire hoses and sail makers, are legible on South Street, and a block beyond there is one for crackers (and probably ship biscuit, the fare purchased for the fo'c'sle). A broad-beamed three-masted schooner is at dock, while timber, some of it rafted, floats freely in the river. The building in construction at the left in the background is the "new" Post Office. In front of it, slightly to the right, is Harper's, the famous publishing house.

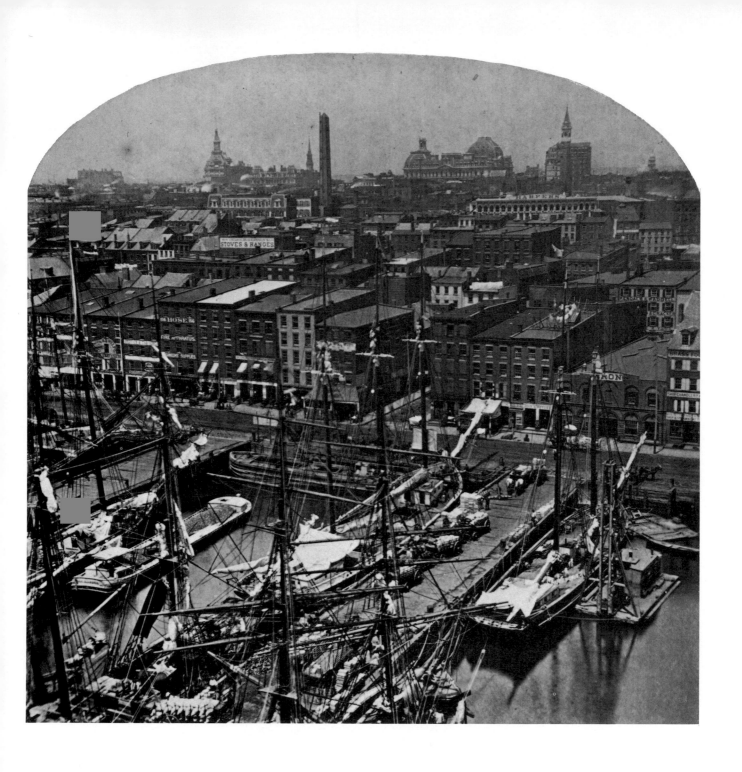

80. This view, taken approximately southwest, is a bit later than the preceding one. The Post Office is complete and to its right there now stands the new Tribune Building. The tall chimney-like structure in the center is a shot tower, used to produce lead shot. Wagons are lined up on Pier 28 waiting their turn to discharge their cargo onto the docked sailing vessels.

The New York Waterfront after the Civil War 59

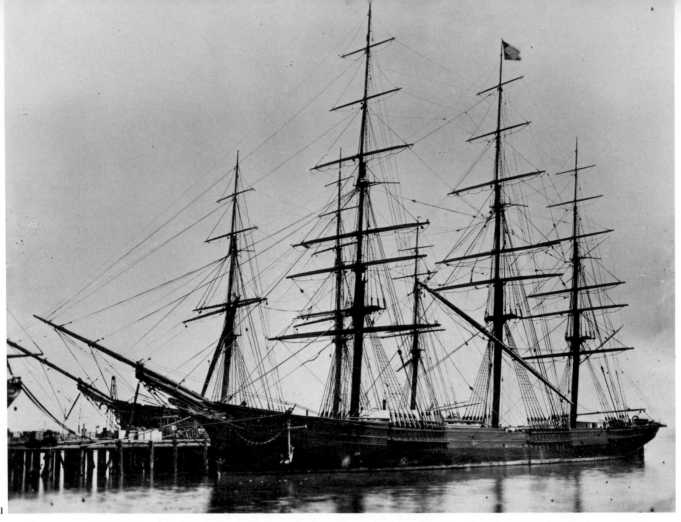

81

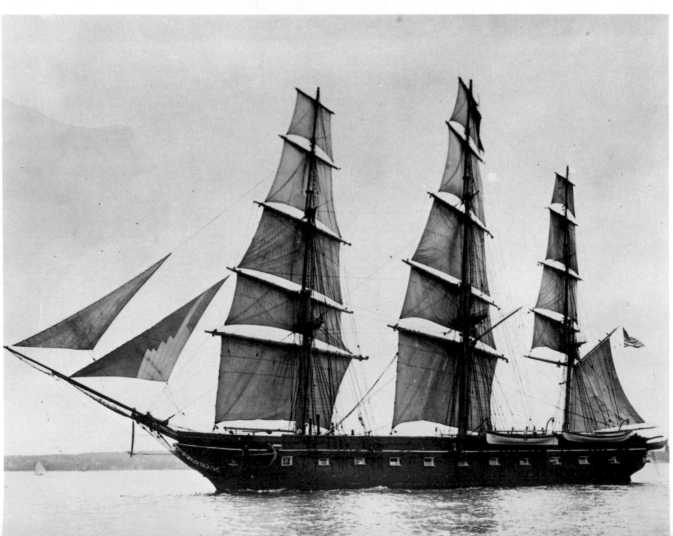

82

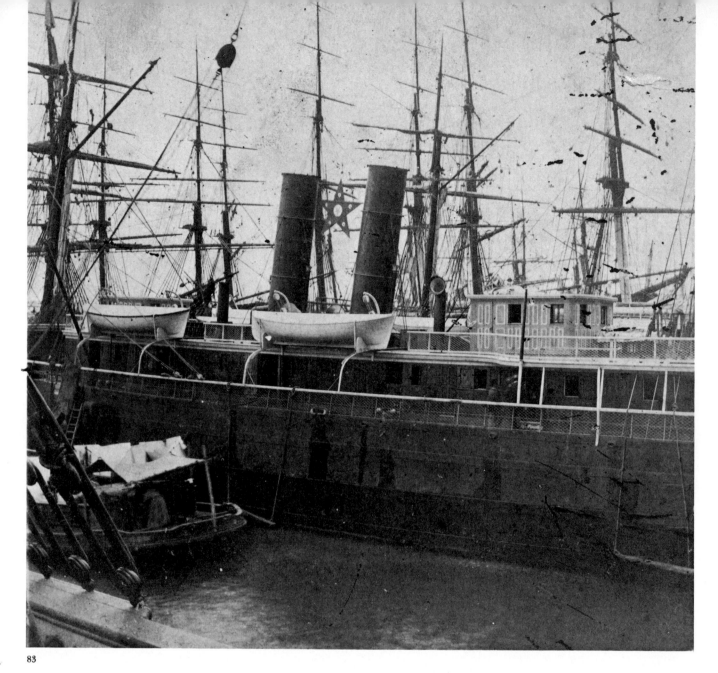

83

81. *Young America* (243′–43′2″–1,961) was the last of the best-known large extreme clippers built by William Webb. An extremely fast and beautiful vessel, one of Webb's finest designs, she was launched in 1853 at his shipyard on the East River between 5th and 7th Streets. *Young America* served 30 arduous years on the San Francisco run, adding up to over 50 passages.

82. New York Nautical Schoolship *St. Mary's* (149′3″–37′4″–958), newly painted and converted from a sloop of war, sails down the Bay toward the Narrows on a training cruise. She was built in 1843–44 at the Washington, D.C. Navy Yard, and served in the Gulf of Mexico during the war with Mexico, when a seaman was hanged for striking an officer and using mutinous language. On April 11, 1848, she joined the Pacific Squadron, remaining with it during the Civil War, protecting Union merchant shipping. After returning from a cruise to Australia and New Zealand in November, 1872, she departed for the East Coast, where she remained in the ordinary until 1874, when she was transferred to New York schoolship duty.

83. Ocean steamships were found mostly at the North River, New Jersey and Brooklyn docks, but a few steamships in the Coastal and West Indies trade were berthed on South Street, where dealers in bananas, pineapples and other tropical fruits met them. The Mallory Line steamship, shown in an 1875 view, docked at Pier 20.

The New York Waterfront after the Civil War 61

84. An unusual marine composition, taken from the deck of an old-time square-rigger packet docked at Pier 21 on the East River in 1875. (Note the long, full poop deck.) The Fulton Ferry building is at the right. Straight across South Street is the office of John E. Stow, a dealer in foreign and domestic fruits, at No. 88.

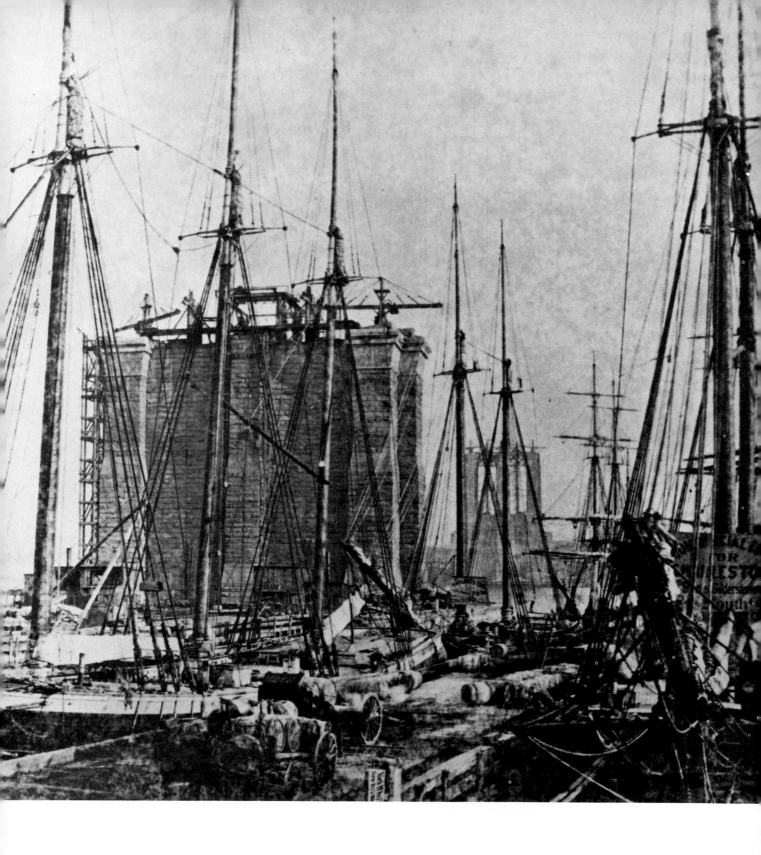

85. Just north of the Brooklyn Bridge, where work is progressing on the piers, were the berths of ships in the coastal trade, such as the Dispatch Line for New Orleans and the Commercial Line of packets for Charleston. Hurlbut's Line, shown here, was established in 1827.

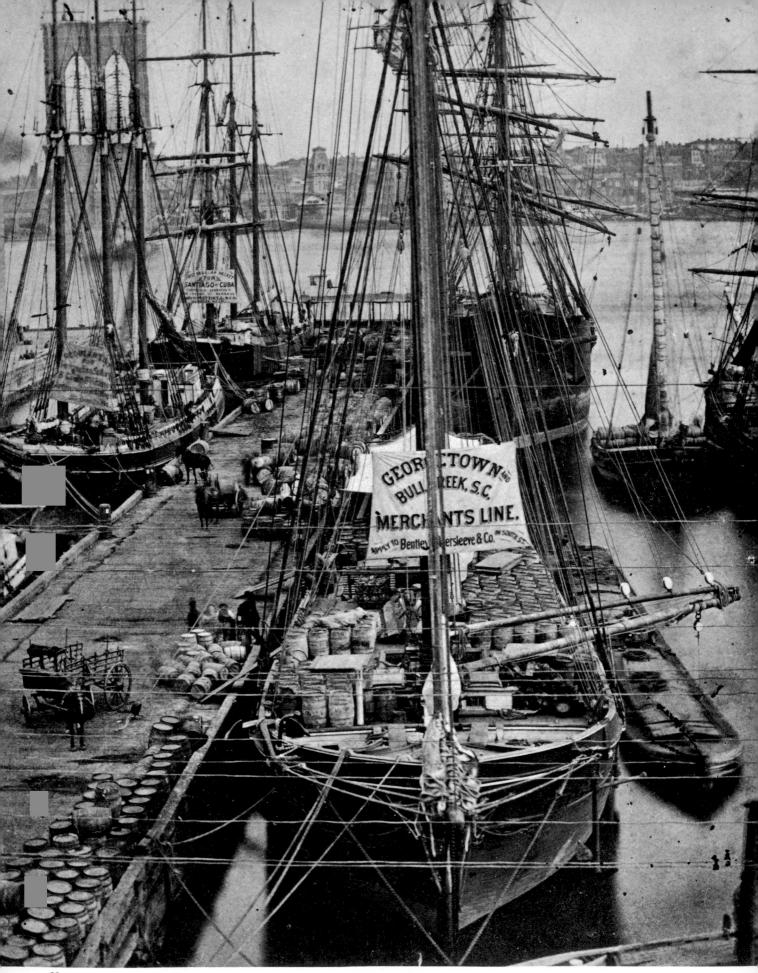

GEORGETOWN AND
BULL CREEK, S.C.
MERCHANTS LINE.
APPLY TO Bentley, Gildersleeve & Co. 99 SOUTH ST.

PER REGULAR PACKET
FOR
SANTIAGO DE CUBA

86

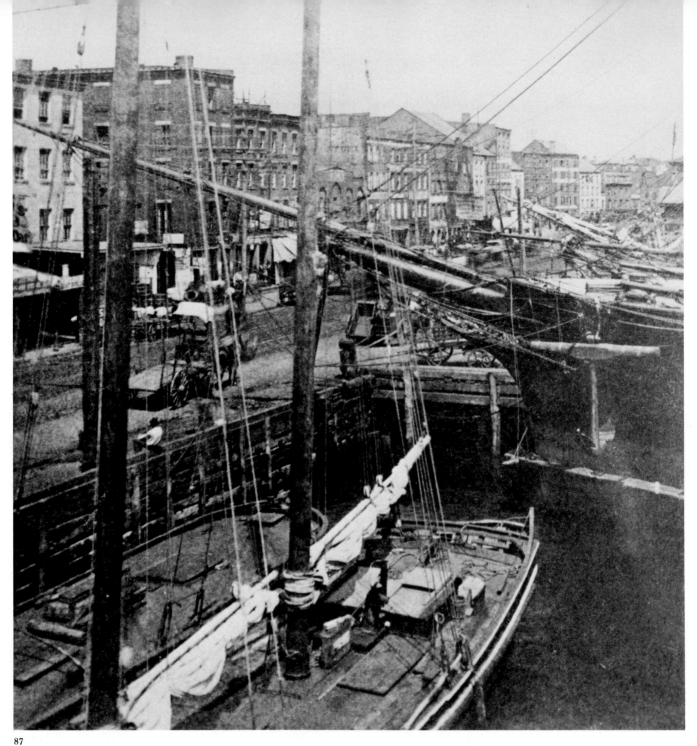

87

86. This stunning view, taken shortly after the previous one, shows the *Ann Eliza*, a schooner of the Merchants Line, operating between New York and the ports of Georgetown and Bull Creek, S.C., as she unloaded her cargo. The barkentine at the head of the pier is announced on its banner as a "Fast Regular Packet for Santiago, Cuba."

87. An unusual angle is presented in this photograph of 1875, looking north along South Street from Pier 27. Staging is set for scraping and painting the hull on the right.

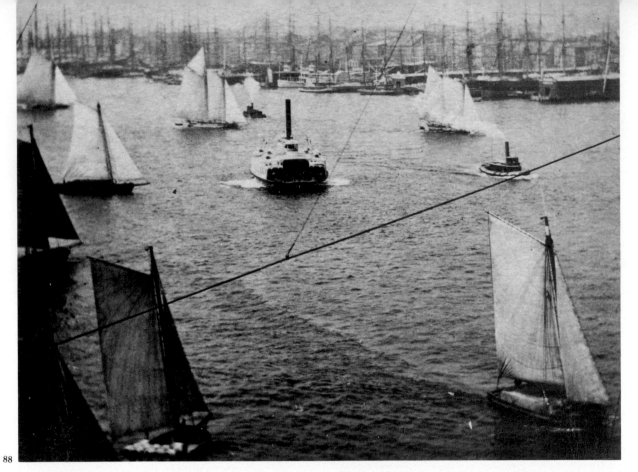

88

89

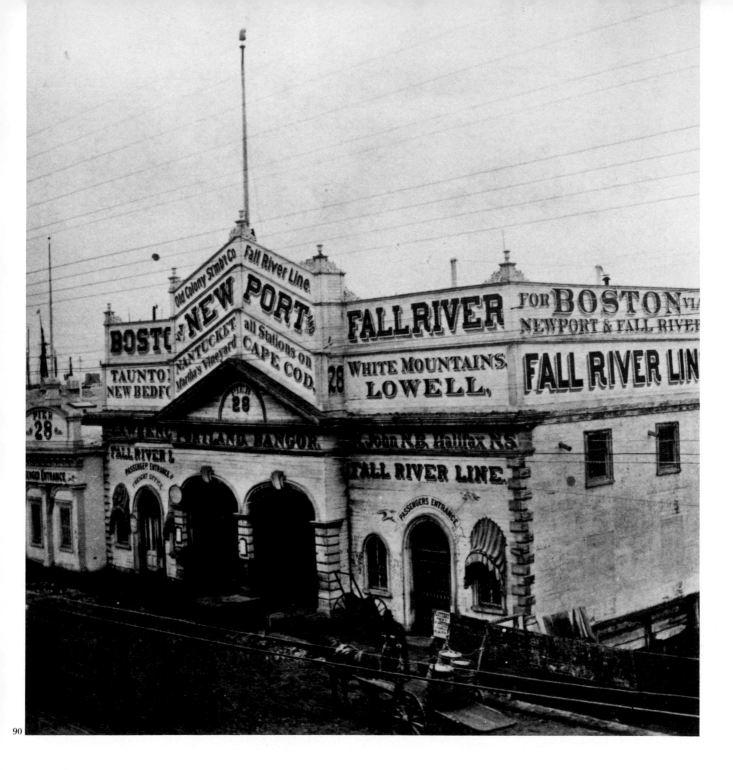

90

88. The relatively narrow East River was quite crowded at times, when lighters, schooners, ferries and tugs all set out at the same moment for their various destinations. This 1875 Anthony picture, taken from the Brooklyn tower of the bridge, suggests that captains of sailing craft needed above-average seamanship in navigating the river and may explain why many of them preferred to be towed through its fierce currents.

89. Two of the most historically important ships that visited South Street were captured in a single picture by an an unknown cameraman on the deck of a Wall Street ferry in 1885. The second large ship in the view is identified by its gangplank cloth as the *Iron Age* (142'–30'–650), the first ironhulled square-rigger (three-masted bark) built in the United States and the first iron sailing vessel built on the Delaware River. She was constructed at the Harlan & Hollingsworth,

Wilmington, Del. yards in 1860. The vessel beyond is the Swallow Line packet *Liverpool* (175'5"–36'5"–1,077). The first three-deck packet to be built, she was launched by Brown & Bell in New York in 1843. She made fast transatlantic passages, and was the showpiece of her time, having the longest continual service of any packet, finishing up with 37 years on her last transatlantic run to New York in November, 1880.

90. The flamboyance of public buildings in the 1870s is startling, especially when their appearance is compared with that of today's anonymous, unmarked and uncommunicative buildings. There was no doubt about the purpose of this building at Pier 28, North River! The Fall River line sailed daily, except Sunday, at 5:00 P.M. In this 1875 view a lottery sign is posted at the passengers' entrance.

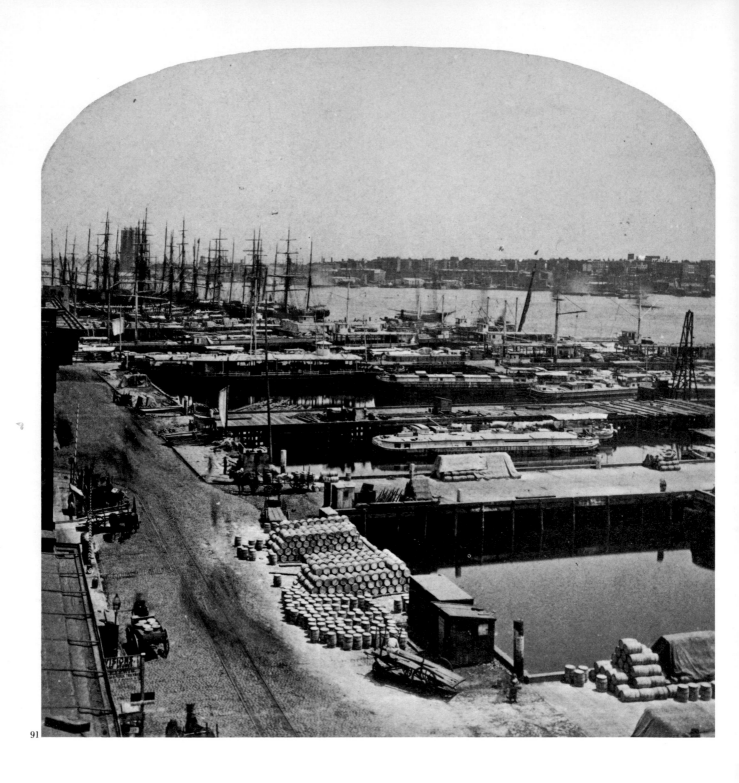

91.

91. Canal boats were by far the cheapest way to move bulk cargoes to or from the hinterlands, although they could not operate when ice closed down the canals. Their importance is obvious from the frequency with which they appear in so many of the pictures of the wharves. A special, large canal basin for them was located on South Street at Coenties Slip, extending south to the Whitehall and South Ferries. This picture gives an excellent overall view of the basin in about 1875, although it surfaced in a print published almost 20 years later by a Philadelphia firm. It is taken from the corner of South and Moore Streets, at Pier 3. Broad Street intersects at the next slip, Coenties Slip, where South Street turns left at a dead end.

92. The process of extending Manhattan Island's shoreline farther out into the East and North Rivers began centuries ago

and is still going on. In this picture of 1875, a large Department of Docks floating derrick works on the construction of the Battery seawall, which expanded the Battery and set a firm boundary to it.

93. The long line of Cunard steamships started service from Liverpool to Boston in 1840. When the company's reach stretched to New York in 1847, its ships had to dock at Jersey City, but later were able to land their passengers on the North River side of Manhattan. The Cunard Pier No. 40 (according to the new numbering) was at the foot of Clarkson Street. Vernon H. Brown & Co., whose office was at 4 Bowling Green, were their agents. This picture was published by William Chase of Baltimore in 1875.

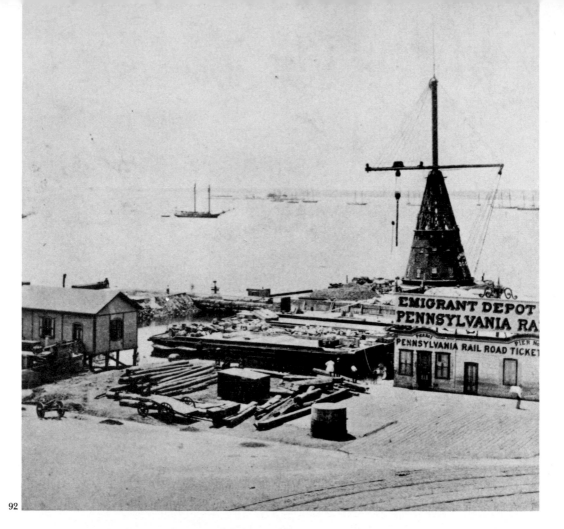

92

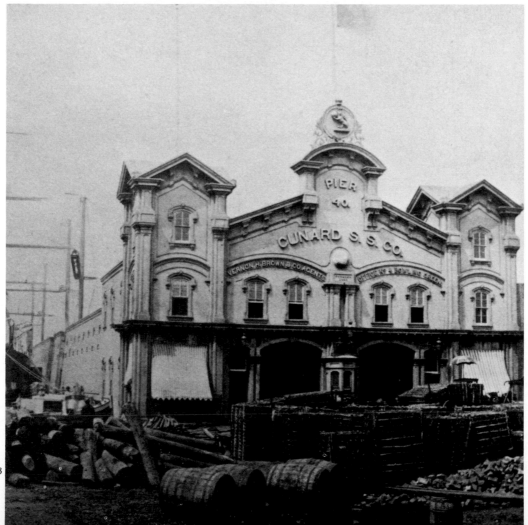

93

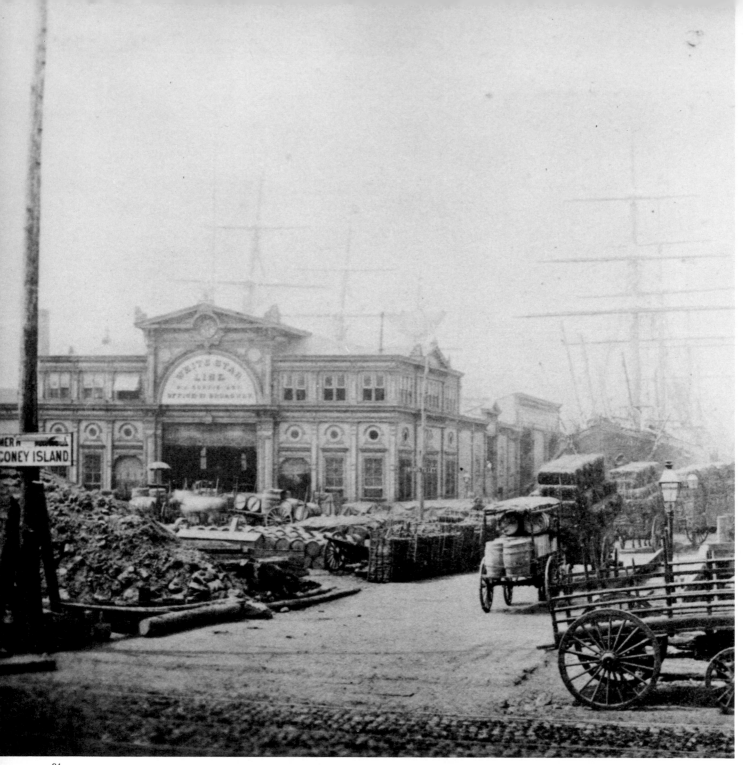

94

94. The White Star Line (the Oceanic Steam Navigation Co.) became an important factor in transatlantic travel soon after it was established by Thomas Henry Ismay in 1869. Its first liners were ship-rigged with Jigger masts, but in 1889 the company became the first to enter liners on the Atlantic which were powered solely by steam. These were the twin-screw ships *Majestic* and *Teutonic*. The ship at the right of the pier is White Star's pioneer vessel, the *Oceanic* (420'–42'–3,808), which made the line's maiden voyage from Liverpool to New York on March 2, 1871. Built by Harland & Wolfe, Ltd., Belfast in 1870, she had four masts, one funnel and an iron hull with single screw driven by compound tandem engines.

She could carry 166 first-class and 1,000 third-class passengers at 14½ knots. The ship was transferred to the Occidental & Oriental Steamship Co. in 1875 (the year William Chase took this photograph) and then operated on the San Francisco–Hong Kong route until 1895. The White Star Line pier was No. 44, at Christopher Street.

95. A portion of West Street, as seen from Pier 42, Pacific Mail Line, facing Canal Street, about 1875. The photograph has a number of interesting details—huge hogsheads, the crude packing cases in the foreground, the planked walk and the Ninth Avenue el in the distance. The two tobacco and "segar" stores were typical of this stretch of West Street.

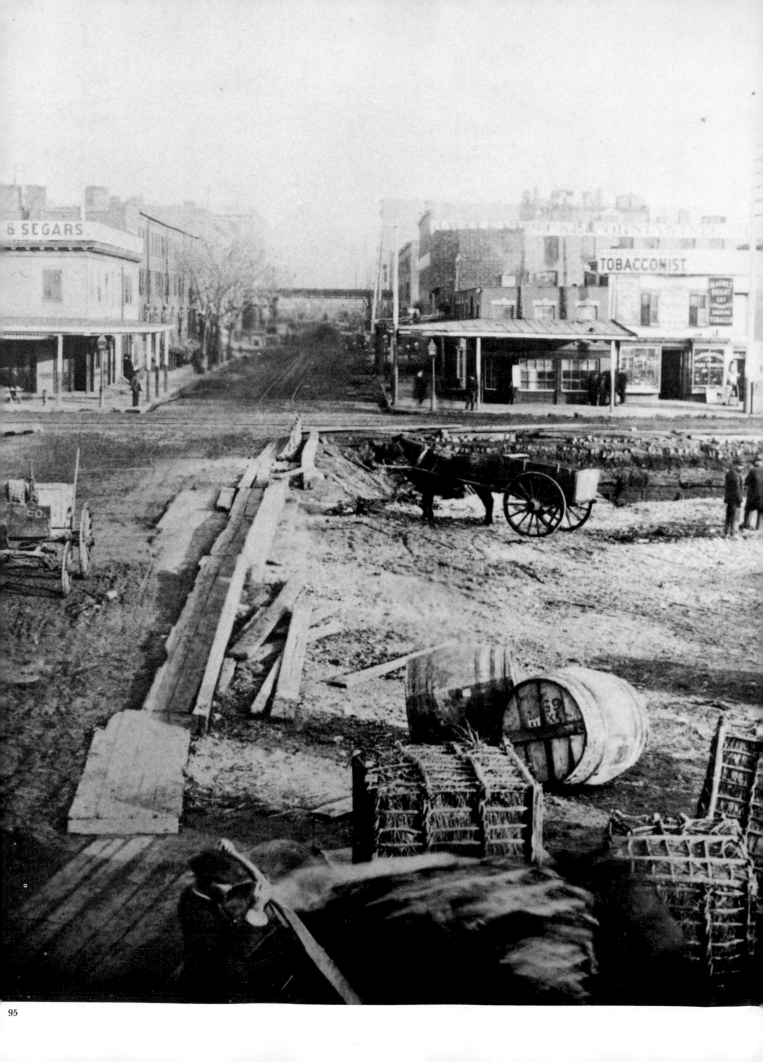

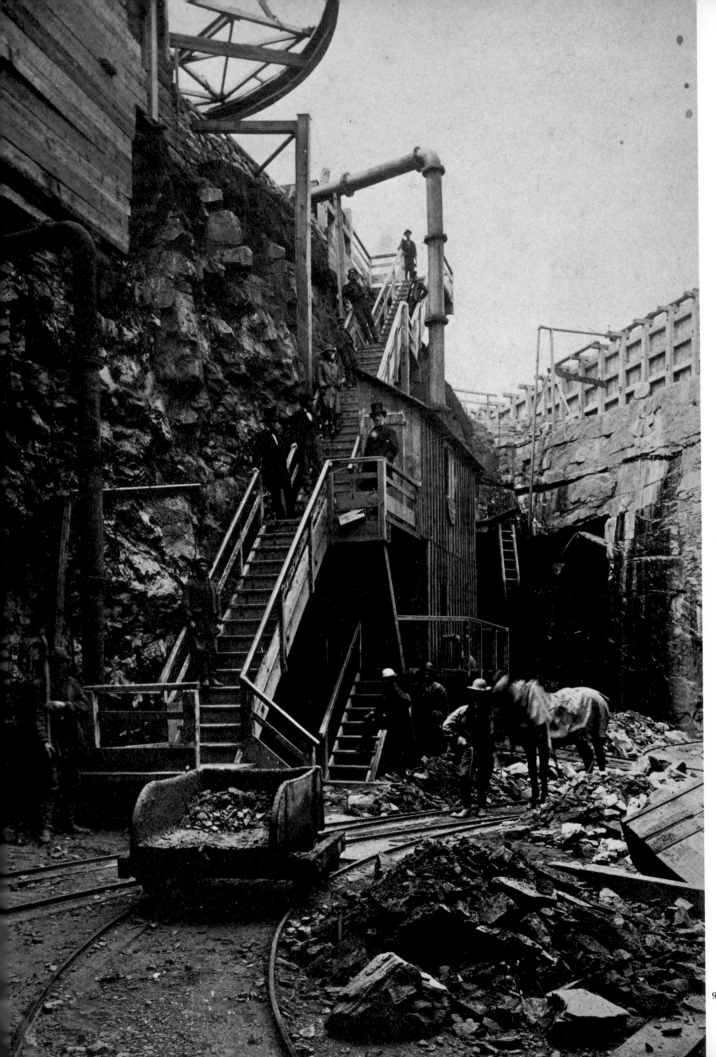

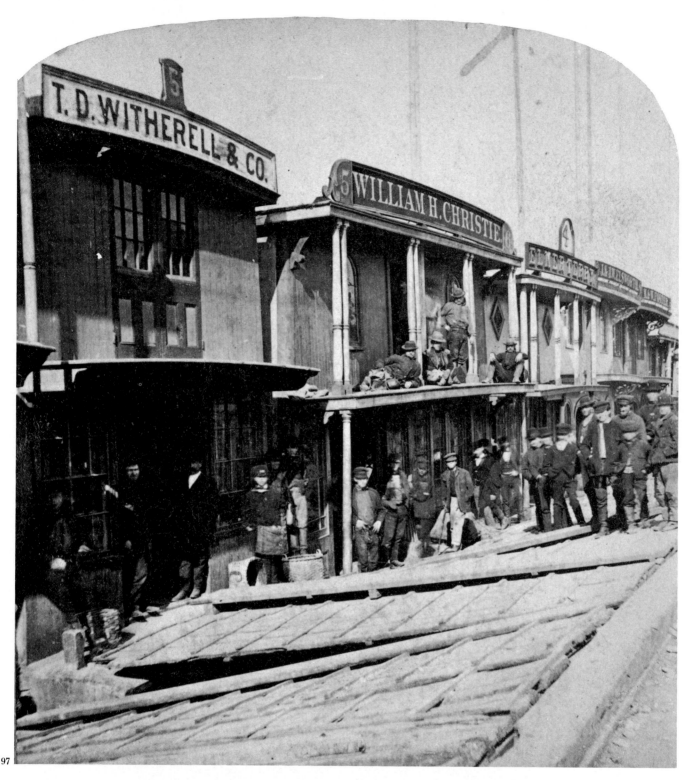

97

96. There is much controversy about how Hell Gate got its name. The section of the East River where it meets Long Island Sound was notorious for violent currents, whirlpools and treacherous rocks which were better suited to striped bass than safe transportation, and these may well have earned it the name. The federal government spent years in the 1870s blasting out rocks to reduce the danger of the area. Much of the work was accomplished by digging a large open pit in the adjacent shore, Hallet's Point, and then mining galleries out from this pit into the rocks for explosive charges. Three acres of rocks were honeycombed in this manner. This picture of 1875 shows the pit.

97. One of the most picturesque sights on the waterfront, seen in this 1875 photograph, was the floating oyster market, a string of oyster barges moored at West 10th Street on the Hudson River. The top decks were used for the offices and storage, while loading and shucking operations took place on the main decks. Saltwater wells built into the holds of the barges held oysters for as extended a storage as was necessary. The oysters were delivered to the barges aboard sailing sloops from famed Long Island oyster beds, as well as from Princess Bay on Staten Island.

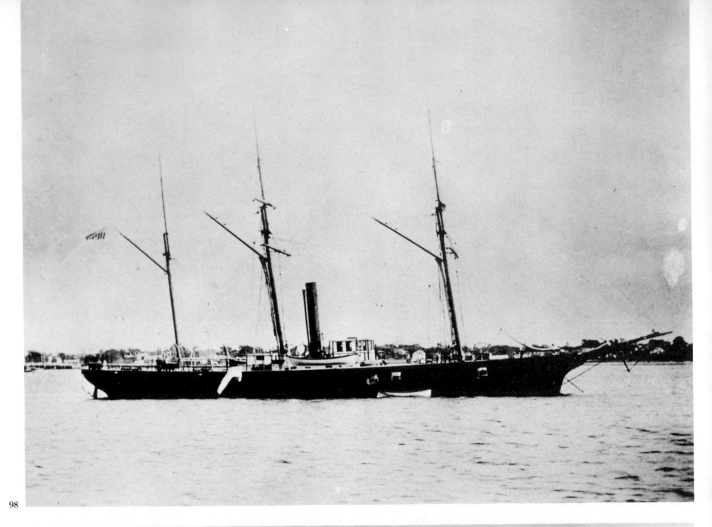

98

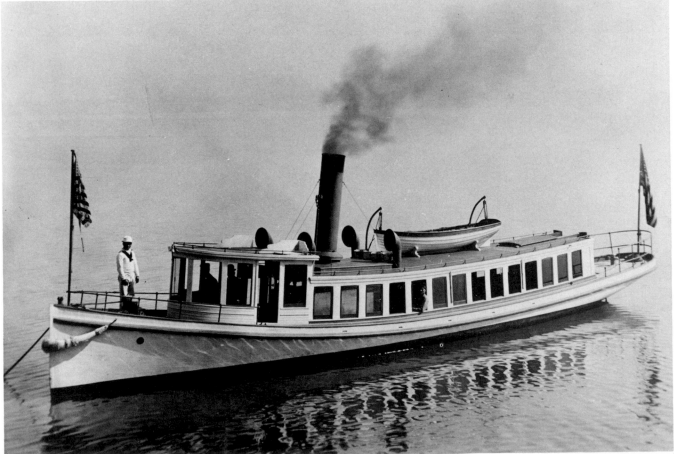

99

BEALE'S NEW YORK HARBOR PANORAMA [Nos. 100–104]

Before a panoramic camera with a rotating lens was manufactured, it was customary for photographers to prepare panoramic pictures by pasting together a series of pictures taken in different directions from a high vantage point. When sufficient care was taken, the illusion of a single, continuous photograph was reasonably well achieved. The most remarkable nineteenth-century panorama of New York, known as "Beale's New York Harbor Panorama," was published in 1876. This was produced in five panels, with the camera placed on top of the Brooklyn tower of the Brooklyn Bridge. The day was very clear, so that even details many miles away in New Jersey are fairly distinct. The entire five panels are presented here to give a better idea of the sweep of the waterfront south of the bridge, as well as details north of the bridge which were otherwise almost totally neglected by photographers.

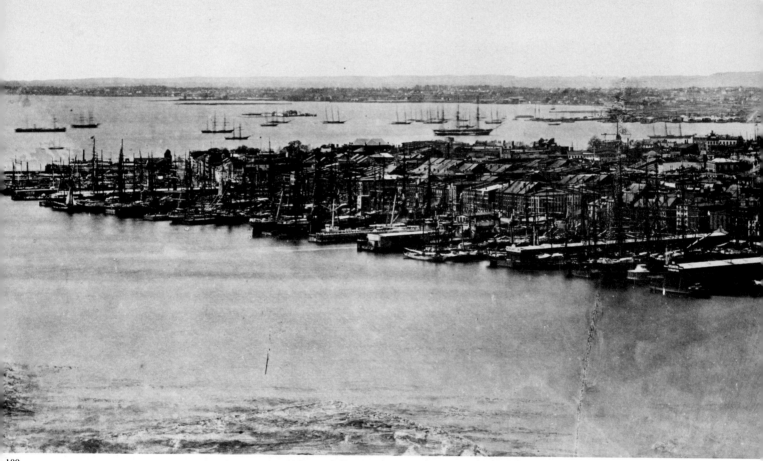

100

98. The "long arm of the law" was provided on the high seas by the ships of the Revenue Cutter Service, the forerunner of today's Coast Guard. The *Grant*, one of the revenue cutters, was stationed in New York and ranged as far north as Portsmouth, N.H. and as far south as Cape Henlopen, Del. Later she served in the Northwest Pacific with the Bering Sea Patrol. She was the first vessel in the United States to make practical use of radio for communication, on November 1, 1903. In this picture, taken in 1876, she is anchored in Gravesend Bay, Brooklyn.

99. Local harbor cutters were also on station to hold down marine crimes. The *Alert*, which operated in and around New York and later was transferred to duty off North Carolina, was built in New York in 1876 for the modest cost of $2,095. She was sold in 1896.

100. No. 1. Ellis and Bedloe's Islands are to the left of center in the Upper Bay. (The Statue of Liberty's fate had yet to be decided by a subscription drive to pay for its erection.) The Department of Docks' floating derrick is visible at the Hudson River side of the Battery. To its left, a large naval steam frigate lies at anchor in the Hudson. Some modernization of South Street is evident in two full-length covered piers with prominent identification signs at their heads—Morgan Line, Pier 18, and C. A. Mallory & Co., Pier 20.

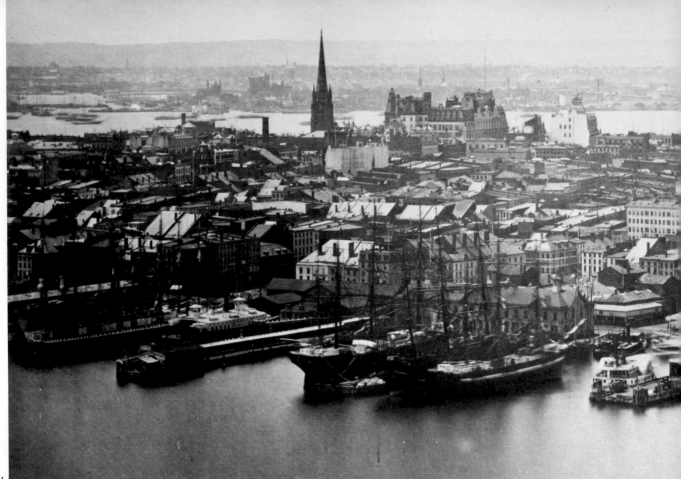

101

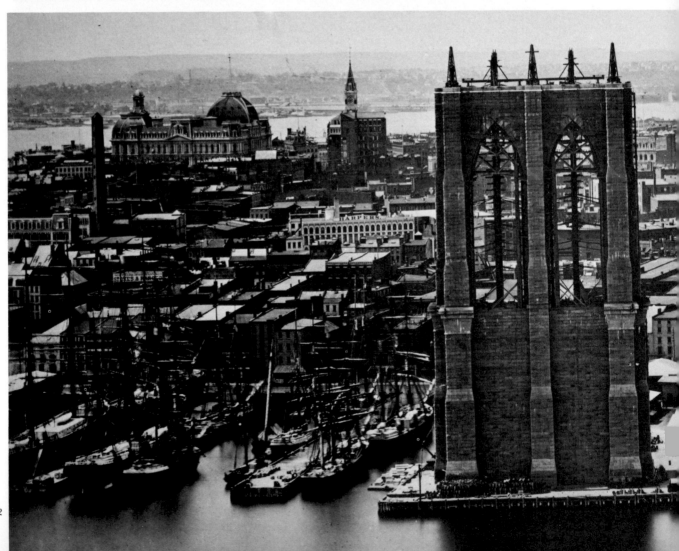

102

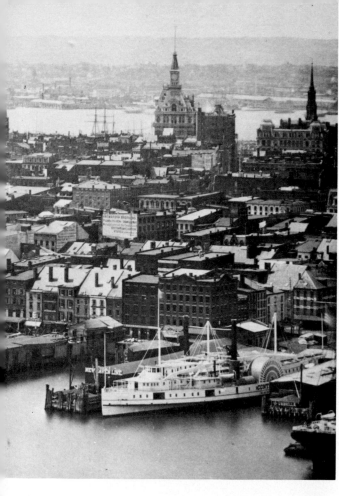

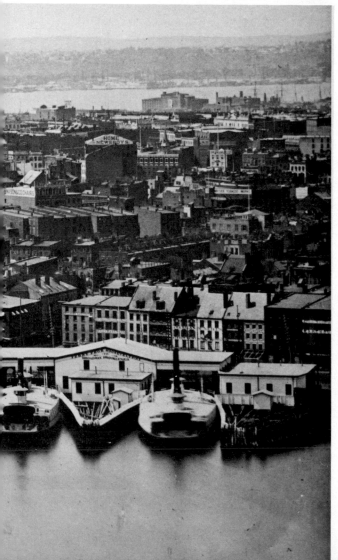

101. No. 2. The Fulton Ferry is toward the left. At the right, the steamer *Continental* is docked at the New Haven Line pier. The Trinity Church steeple is in the left background. The tallest office building is the new Western Union Telegraph Building on Broadway. At the extreme right is the graceful spire of St. Paul's Church.

102. No. 3. The Manhattan pier of the Brooklyn Bridge is nearing completion after about three and a half years of work. Supports are still visible inside its arches. Piers 27 and 28 are to the left, Roosevelt Ferry to the right. The major structures left of the bridge pier are the shot tower, the new Post Office and the new Tribune Building on Park Row.

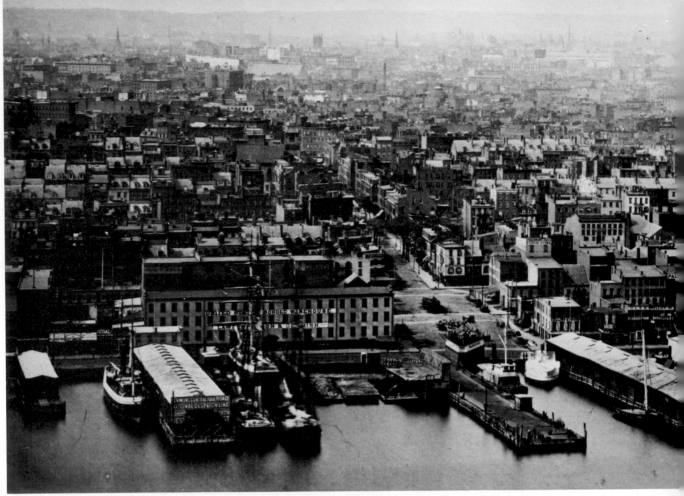

103

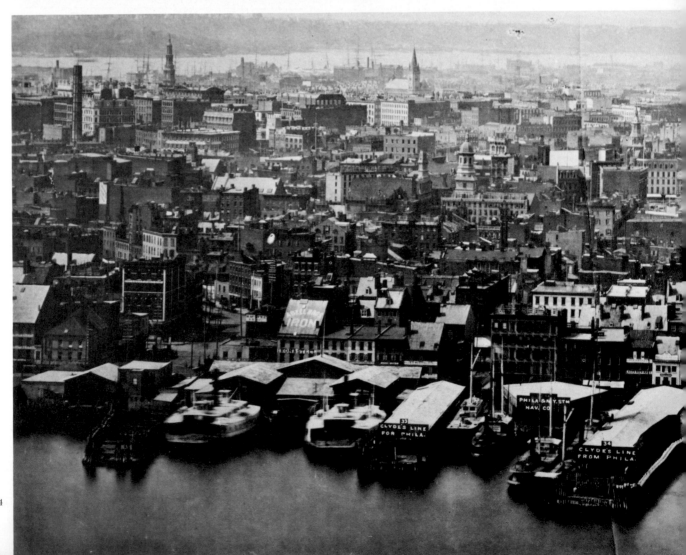

104

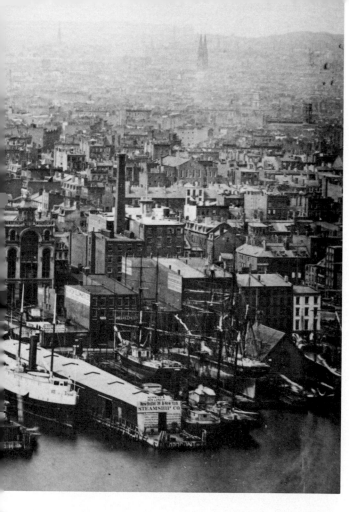

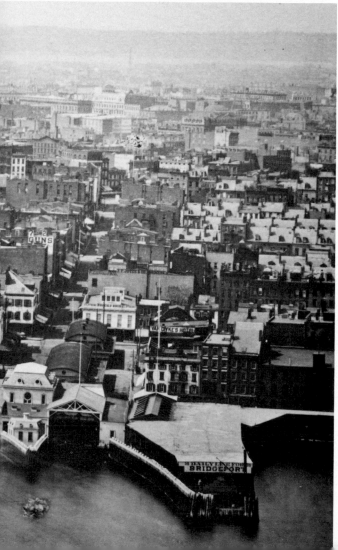

103. No. 4. This panel documents the Clyde Line that ran to Philadelphia and the Daily Line for Bridgeport, Conn. Signs on shore show that the area had a good share of ironworks and machine shops which undoubtedly were fed business by ships and shipyards. The German Lager Bier Haus supplied large schooners of beer and free lunch to the waterfront workers. To the left of the Van Dyke's Hotel building is Brooks Brothers, which had a store in this area long before the Civil War, furnishing clothes to sailors and also to Long Islanders who came to Manhattan to shop.

104. No. 5. More docks of steamboat lines that connected with New England ports appear here: the Vermont Central Railroad, National Despatch Line at Pier 36; the Portland Steamers at Pier 38; the New Bedford & New York Steamship Co. and Norwich and New London Line at Pier 39. Directly to the right of Pier 39 are the N.Y. Screw Dock Drydocks, occupied by a two-masted and a three-masted bark. Just to the right of that is the "Floating Bethel" of the Seamen's Friends Society. Again, scattered signs tell of the shore-based activities that supported the ships—a shipwright, a shipsmith, plumber, coal supplier and a United States Bonded warehouse.

The New York Waterfront after the Civil War 79

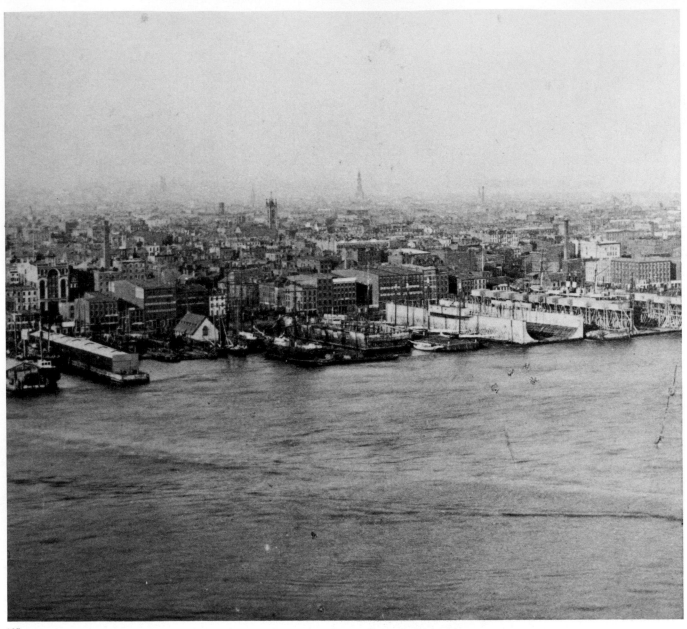

105

105. Beale's Panorama is, in effect, extended northward by the stereoscopic view shown here. Besides the Hydrostatic Lifting Dock (hydraulic dock) and the New York Screw Dock Co. docks south of the Floating Bethel, there are shown, north of the Bethel, the Sectional Dry Dock south of Pier 41 and the New York Floating Dry Dock north of Pier 41. Next, between Pike Slip and Rutgers Slip (which is not clearly shown at the extreme right), are the Big Balance Dry Dock and the Large Screw Dry Dock, which has an early screw steamer in dry dock. The Big Balance Dry Dock was built in 1854 by William Webb in Williamsburgh. There was trouble launching it and it was not worked free until the next day. It was in this dock that the *City of Boston* (page 42) toppled while being raised on May 18, 1882, suffering serious hull damage. The area shown in this view was feverishly busy in clipper-ship days. Two of

Donald McKay's famous clippers were dry-docked here. The *Stag Hound* had its hull caulked and coppered in the Pike Street Sectional Dock, while the *Great Republic* underwent hull work in the Big Balance Dry Dock.

106. A view of 1877 shows a waterboat delivering water. Note its intake and discharge pipes.

107. The "Floating Bethel" or, more accurately, the Floating Church of Our Saviour for Seamen, was located at Pike Street from 1870 until 1910. The Bethel, the successor of an earlier floating chapel (1844–70) also berthed at Pike Street, was built and operated by the agency known today as the Seamen's Church Institute of New York. It was an early attempt to provide a chapel in which the seaman would feel at home and to befriend him while he was onshore. The steamboat *Shadyside* is shown along Pier 41.

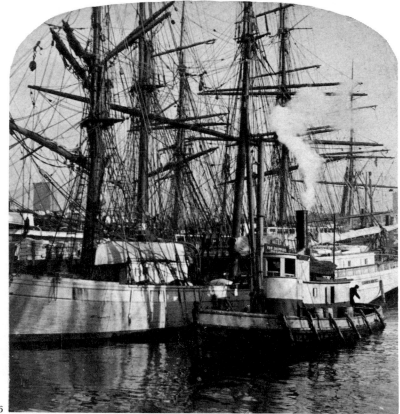

106

107

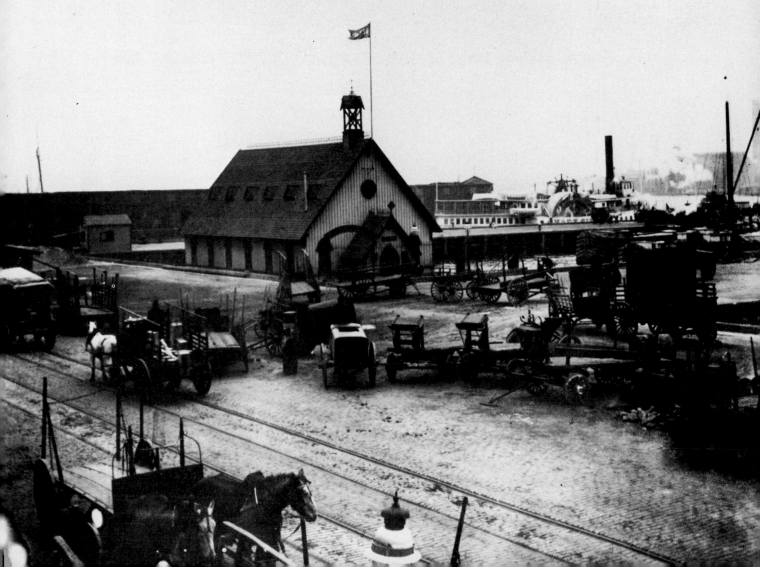

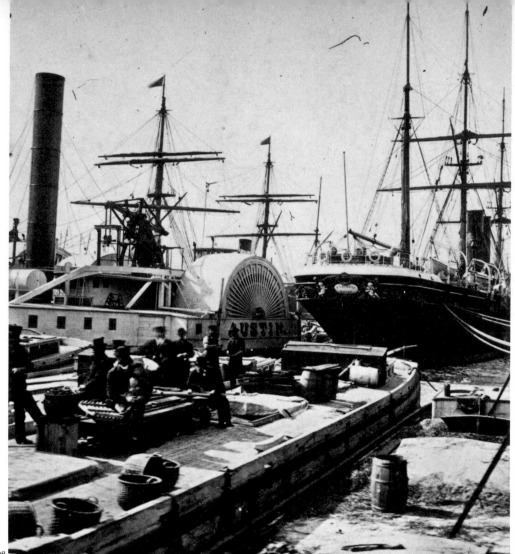

108

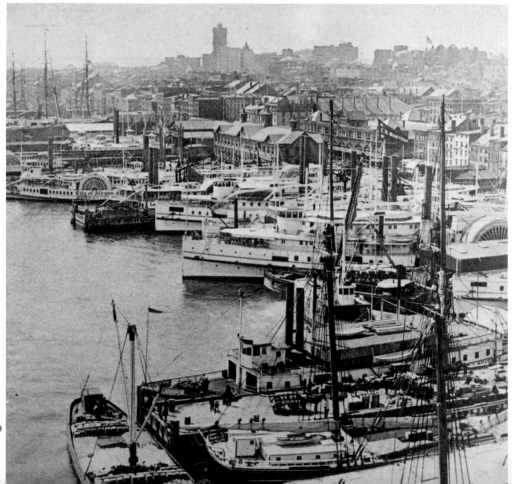

109

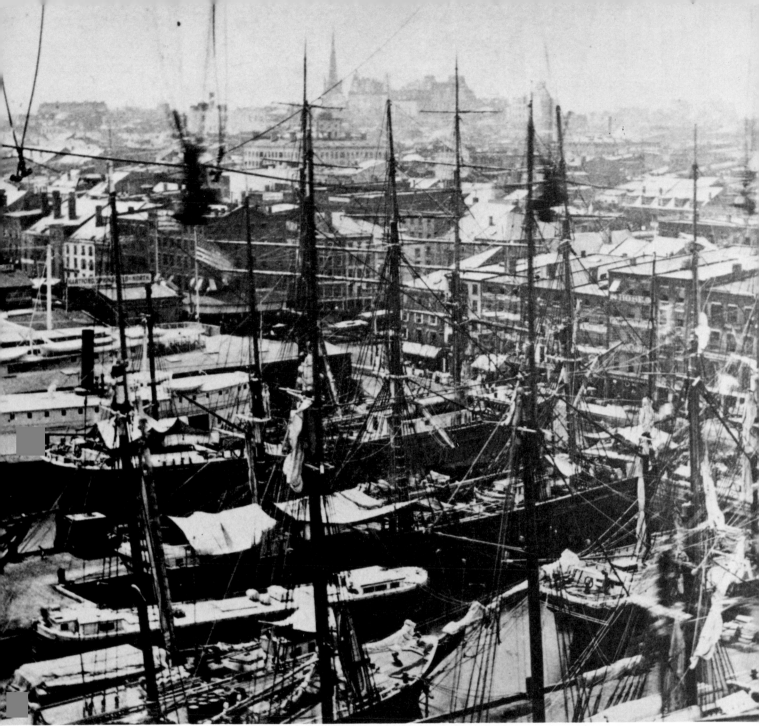

110

108. An interesting hodgepodge was caught in 1876 at Pier 42 on the North River at the foot of Morton Street. Barges with diverse cargoes are being unloaded in the foreground, evidently having been brought down the Hudson by the towboat *Austin*, a wooden-hulled craft of 521 tons built in Hoboken in 1853 and operated until 1900. Home port for the *Austin* was Albany. At the right rear is the French Line steamer *St. Laurent* (355′–43′9″–3,400) launched April 10, 1866, at St. Nazaire, France. Originally laid down as a paddle steamer with iron hull, she was changed to single-screw propulsion. Her second funnel was added when she was re-engined in 1875. After some years of service between France and New York, she was transferred to the route between France and Panama. She was scrapped in Italy in 1902.

109. A few years later, the wet-plate era of photography ended and many of the firms that had formerly issued stereoscopic views no longer produced them. But new publishers moved in, most noticeably Benjamin W. Kilburn of Littleton, N.H. who was fascinated by the waterfront. His view of South

Street from the bridge in 1879 shows significant changes. Steam is more prevalent, and the lighter at the lower left is an old sailing vessel converted for towing only. Particularly notable here is the sternwheeler *Wilber A. Heisley* at Pier 27, one of a very few of this type to operate in New York Harbor. The *C. H. Northam* has been rebuilt and improved after burning to the waterline on November 27, 1877. *Elm City* and *Continental* complete the roster of the New Haven Steamboat Co. in Peck Slip. Down at Pier 23, across from Beekman Street, the *City of Albany* is docked. She ran to Stamford and Norwalk, Conn. The Morrisania Steamboat Co.'s *Morrisania* is at the left along Pier 22.

110. Another view from the Brooklyn Bridge, taken about a year later, shows cables dangling from the construction work. Sailing vessels are still present in reassuring numbers, filling every available space along piers 27 and 28. The Springfield Line pier for steamers to Hartford, Springfield and other northern ports is in the distance.

The New York Waterfront after the Civil War 83

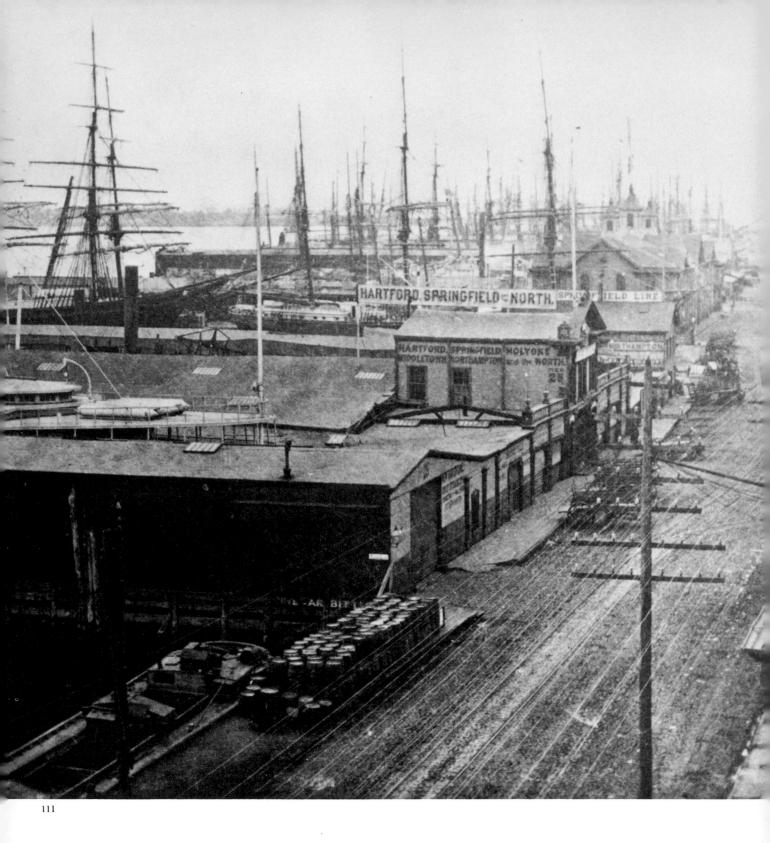

111

111. A good detail of the steamboat docks of the Springfield Line at Pier 25 on the East River, and Peck Slip, where boats left for Springfield and other northern ports.

112. Charles Bierstadt of Niagara Falls, N.Y., who hailed from the seaport town of New Bedford, Mass., decided to add some stereoscopic views of New York to his line of views in about 1880. He brought a fresh eye to the waterfront, presenting new viewpoints of old subjects. Here is a close-up he took of Coenties Slip and its bevy of barges. To the left is the large paddle-wheel towboat *Anna* (146'–25'–201 gross tons), whose

home port was Albany, N.Y., where she was built in 1854. The Murray Line of Barges of Troy advertises its services on a banner at the right. The screw-type tugboats at the pier head began to take over most towing work in the late 1870s.

113. A bit more of the flavor of old New York's architecture and street traffic near the East River is contained in this photograph of 1880, looking west on Peck Slip from Front to Water Streets, with the Second Avenue el on Pearl Street in the distance.

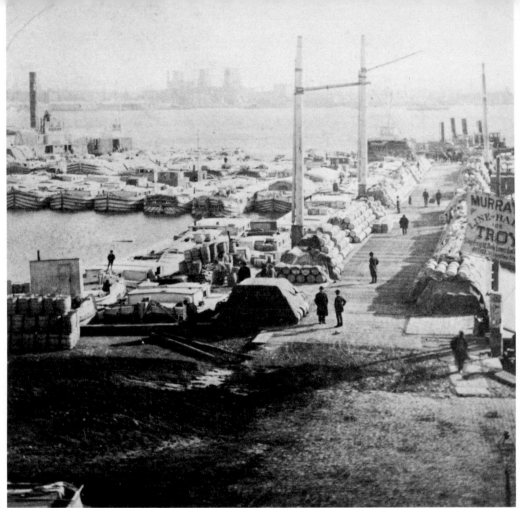

112

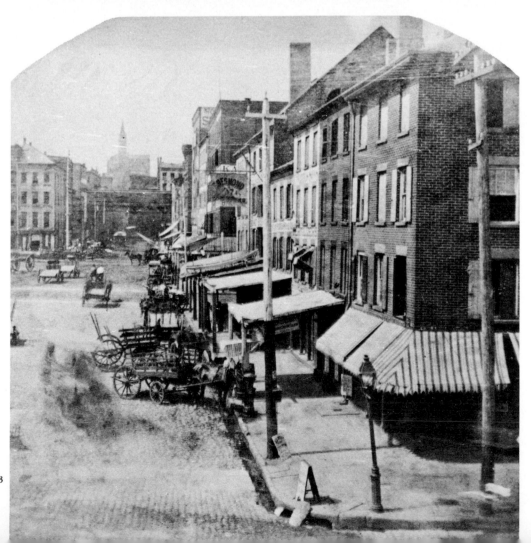

113

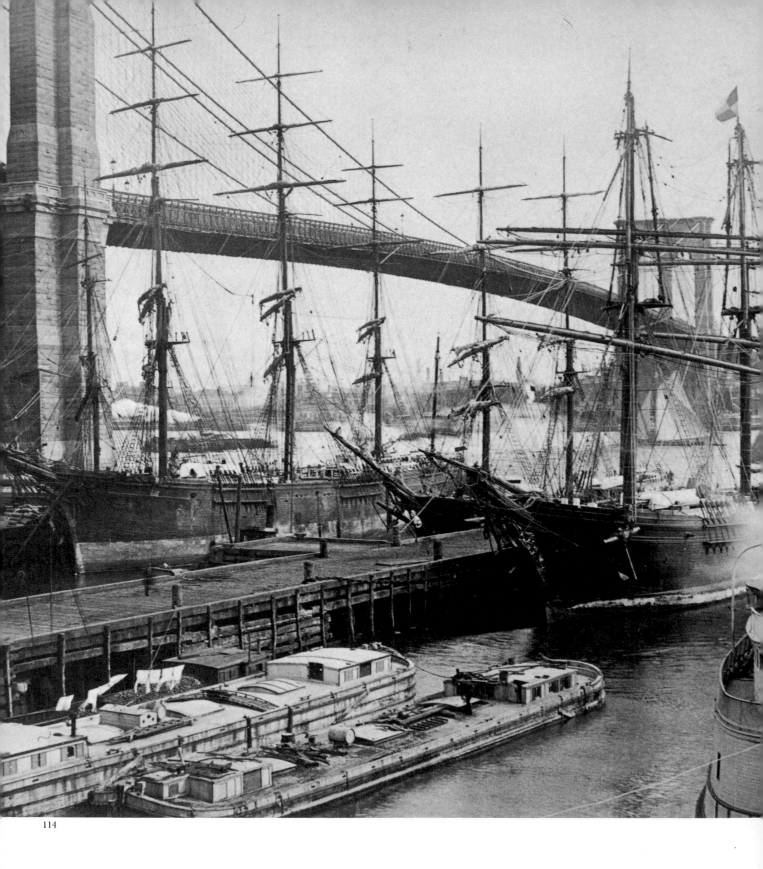

114

114. One of the grand, loftily sparred "Down Easters" was captured by B. W. Kilburn in 1883 at Pier No. 28. She is taking on water from the Croton Water Works Co. water boat. Closer, on the far side of Pier 27, there is a three-masted bark with a figurehead. On this side of the pier is a vessel with her fore and topgallant masts and spars lowered to allow safe passage under the bridge. It is laundry day on the barge.

115. Ben Kilburn returned frequently to New York to take new pictures. Here is his unusual 1883 view of South Street seen through the rigging of a ship. Broad Street is the next intersection.

116. A Kilburn view of 1885 shows Coenties Slip from Front Street. A steam locomotive on the Third Avenue el swings its cars around an S curve en route to South Ferry.

86 The New York Waterfront after the Civil War

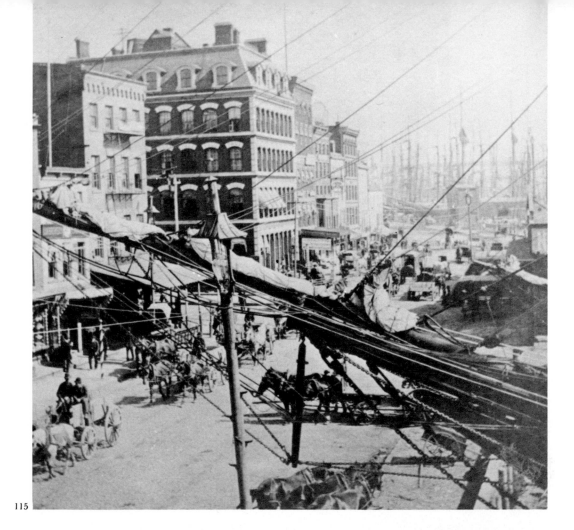

115

116

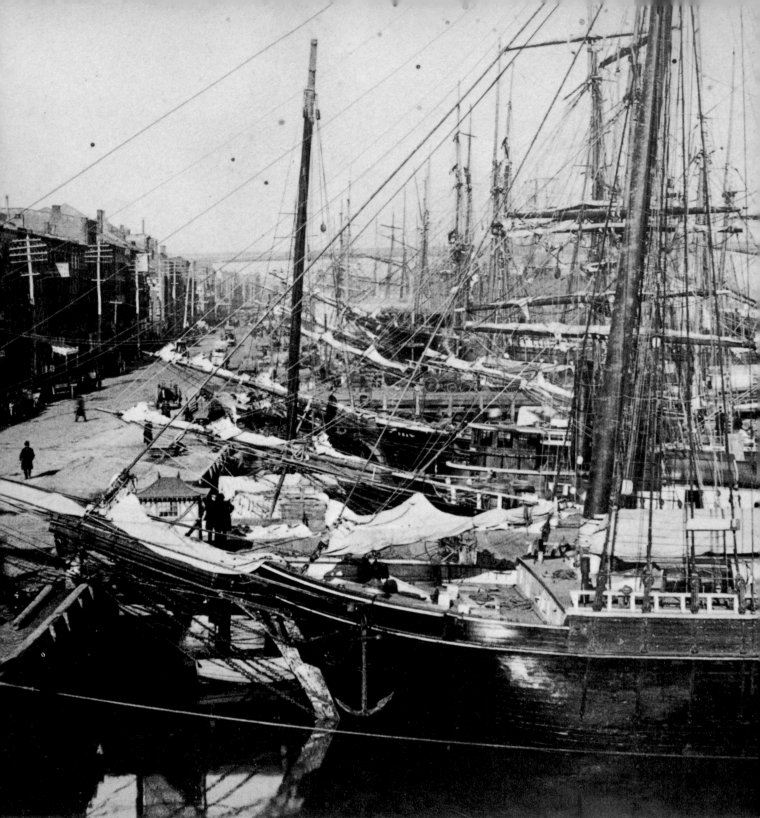

117

117. One of Kilburn's best photographs looks north from Pier 11, Old Slip and South Street. Note the raised deck schooner in the foreground. Sail still flourishes in 1885.

118. A view of 1885 shows the New Haven Steamboat Co.'s *Elm City* (280'–760) passing under the Brooklyn Bridge on the New Haven run. Built by Samuel Sneeden in New York in 1865, she ran on the night line for New Haven, Hartford and Springfield, leaving Pier 25 on the East River at 11:00 P.M., and

arriving in New Haven in time for the early morning train. She was abandoned in 1897.

119. The Fulton Market, early in a morning in 1885, was shown in a Bierstadt view, crowded with market pickup wagons. The new Fulton Market building is at the left. Two sailors on the jibboom of the second sailing ship reef the flying and outer jibsails.

88 *The New York Waterfront after the Civil War*

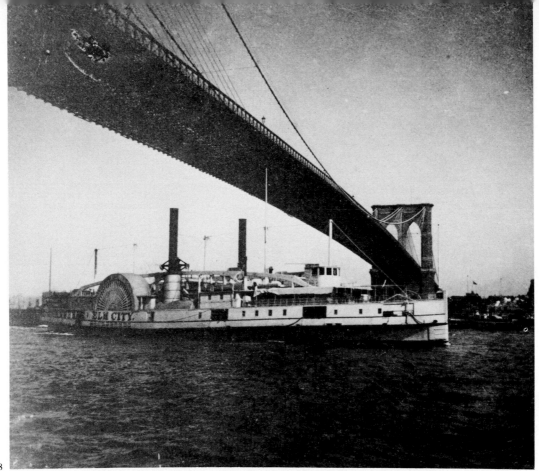

118

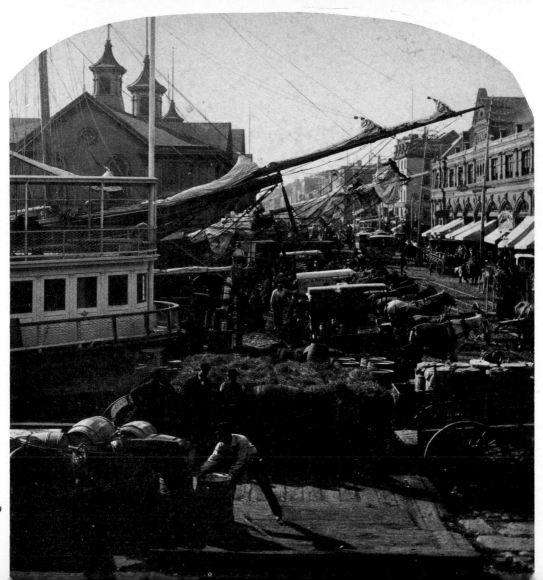

119

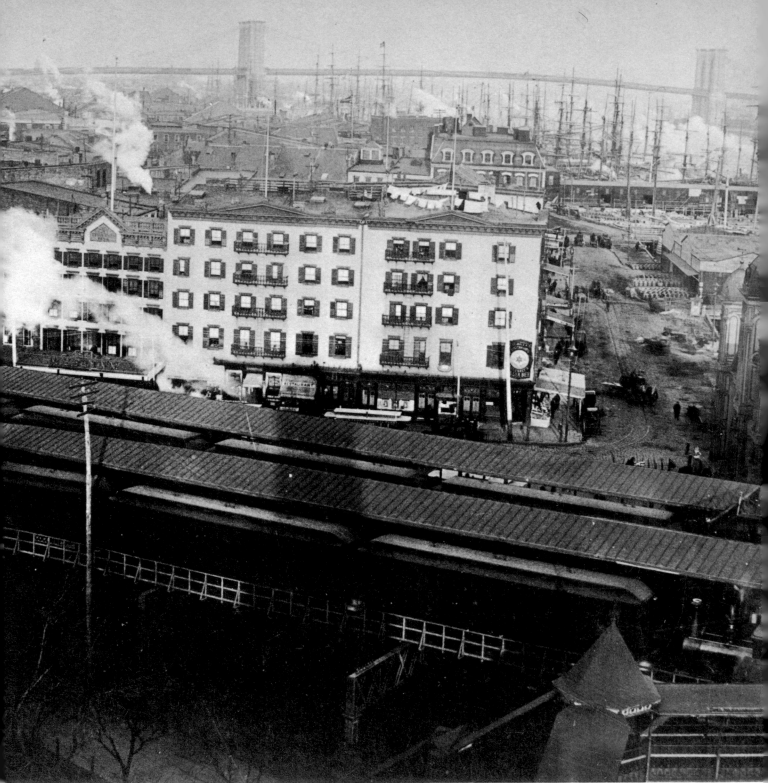

120.

120. This panorama was taken from the corner of Whitehall and South Streets at South Ferry by Kilburn in 1885. The long shed to the extreme right is on Pier 6, Coenties Slip. In the foreground, the steam locomotives and cars of the Third and Ninth Avenue elevated lines await the signal for their return north.

121. South and Broad Streets in 1885. The ship with the towering masts is the *Pegasus* (314'–42'3"–3,564), a medium clipper with four masts, fully rigged, and an iron hull. She was owned by Charles W. Corsar of Liverpool, and had a sister ship, the *Reliance*. All Corsar vessels carried a flying horse for a figurehead, and the name "Corsar" emblazoned on all can-

vas. The *Pegasus* and *Reliance* featured midship bridges, and were the first ships to have their officers' quarters amidship. The *Pegasus* went aground in 1912 and was towed free, only to be condemned and broken up.

122. An interesting detail of the new brick Fulton Market building is included at the left in this 1885 view. It had insets of sculptured animals' heads. To the right an ice wagon leaves Pier 22, between the older market building and the ferry, whose sign reads, "The only Reliable Freight Line to Astoria, Harlem." Another sign advises that the Norwalk steamer is now at Pier 27.

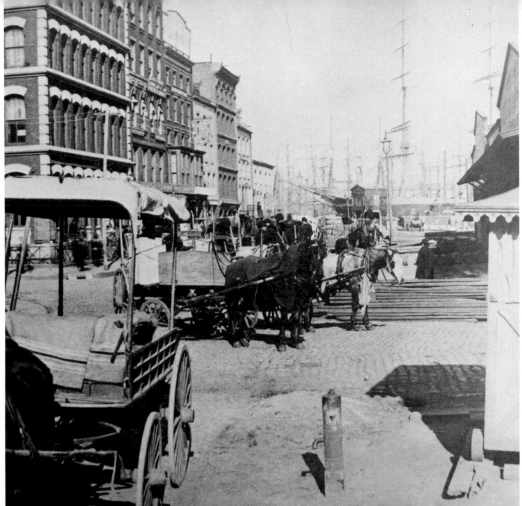

121

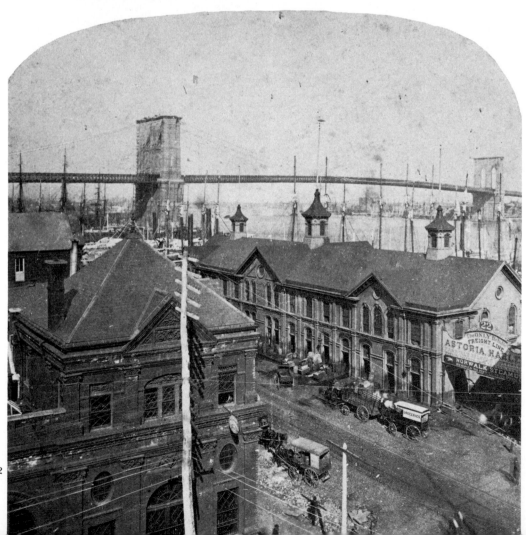

122

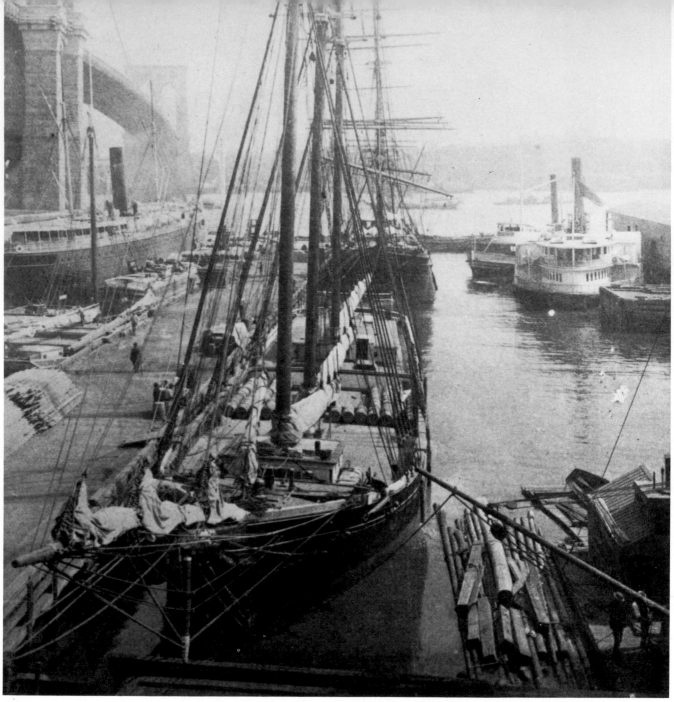

123

123. An 1885 view of shipping near the bridge shows the details of the deck of the three-masted schooner, with barrels stowed on their sides, and of the pile driver to its right. A screw-type coastal steamer is also present. The river steamboat at the right is the *Sylvan Glen* of the Harlem & New York Navigation Co.

124. In this 1885 Kilburn view, as an anxious merchant watches a steam tug ease his vessel into a berth at Maiden Lane, the Union Ferry Company's *Mineola*, built in Brooklyn in 1868, heads for the Fulton Ferry slip.

125. The full-rigged German ship *Sleibrecht*, (56.1 meters–8.9 meters–1,337), ready to cast off towline off Sandy Hook, was built at Quebec in 1877 by J. E. Gingrass.

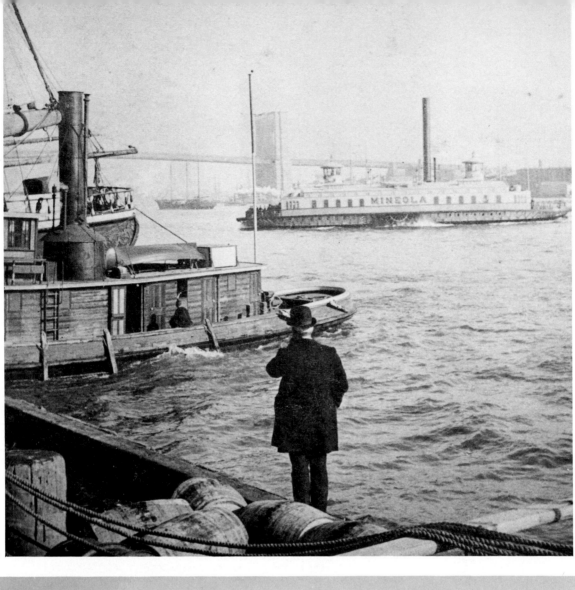

124

125

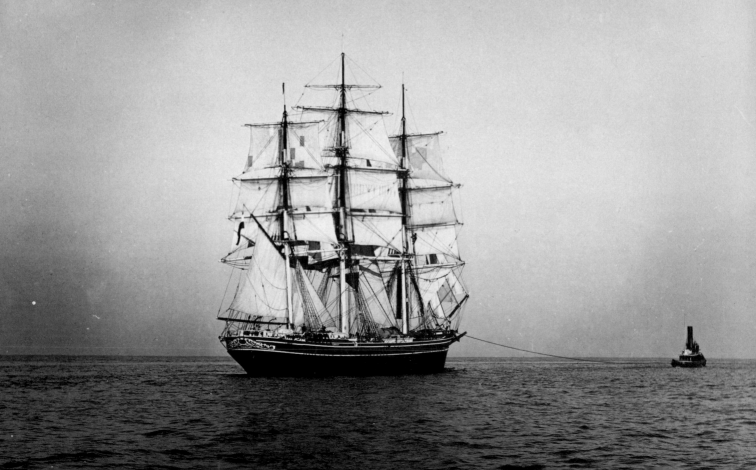

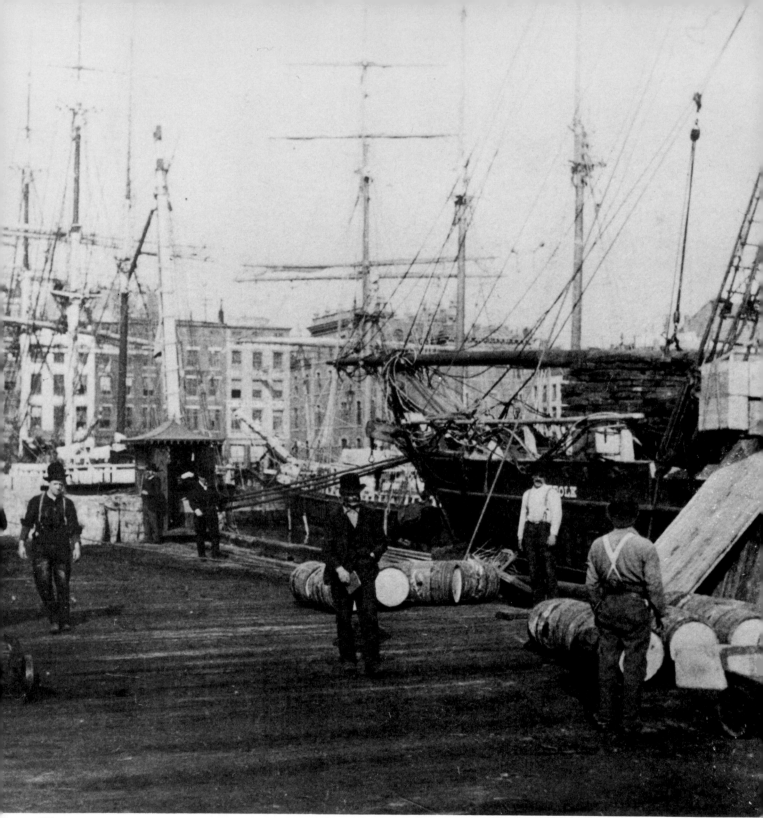

126

126. On South Street, many of the piers remained open. At Pier 11 in 1888, the British full-rigged *Norfolk*, (1,324 tons) discharges cargo. Constructed in 1856 by E. & H. O. Briggs, South Boston, Mass. as the *Asa Eldridge* for the Henry S. Hallet Co., she made ten Cape Horn passages to California, and four around-the-world passages. She was renamed after being purchased by British interests in 1873.

127. By 1885, many of the piers along West Street were modern and substantial structures. The Pacific Mail Steamship Company, Pier 42 on the North River, at Canal Street (extreme left), is a good example. This company was founded in 1847 to operate steamships from New York to Aspinwall (Colon) in Panama, and then on to the West Coast from Panama to San Francisco. At one point, this line ranked first in operating steamship tonnage. The photograph is by Kilburn.

128. The America's Cup Races of 1885 at New York drew an unusual amount of attention. The New York Yacht Club course for the race was off Sandy Hook, within easy distance for excursion boats. The defender was the *Puritan*, shown above. The British challenger was the *Genesta*.

127

128

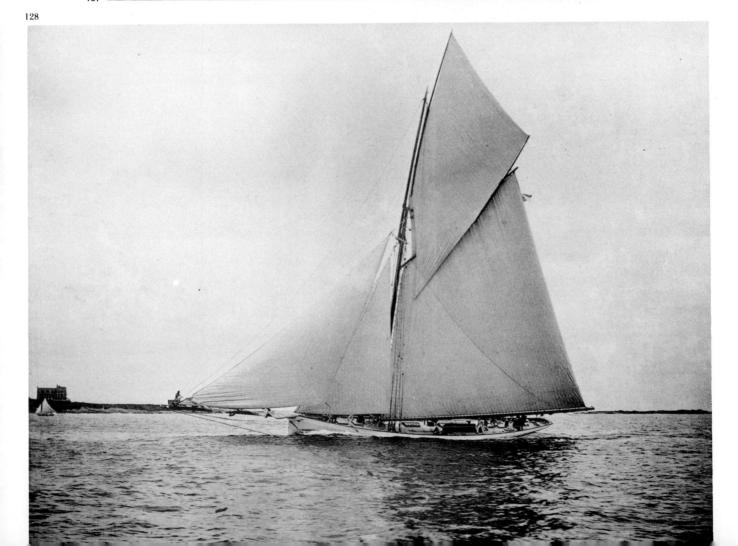

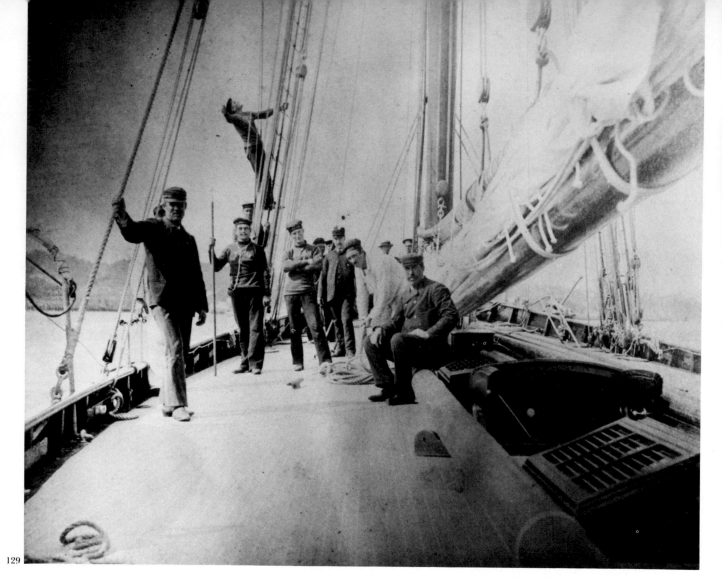

129

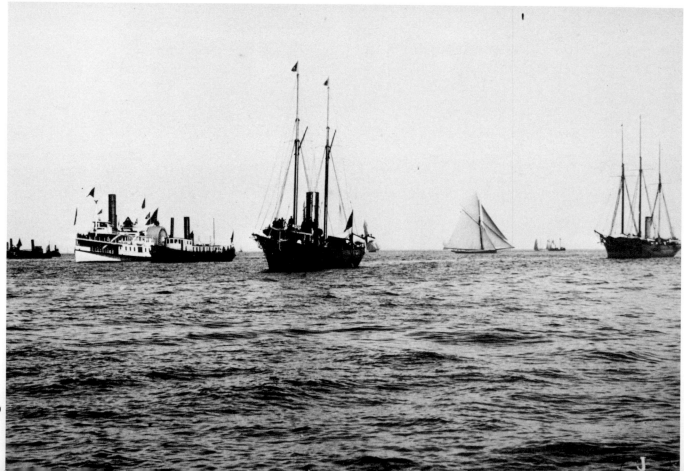

130

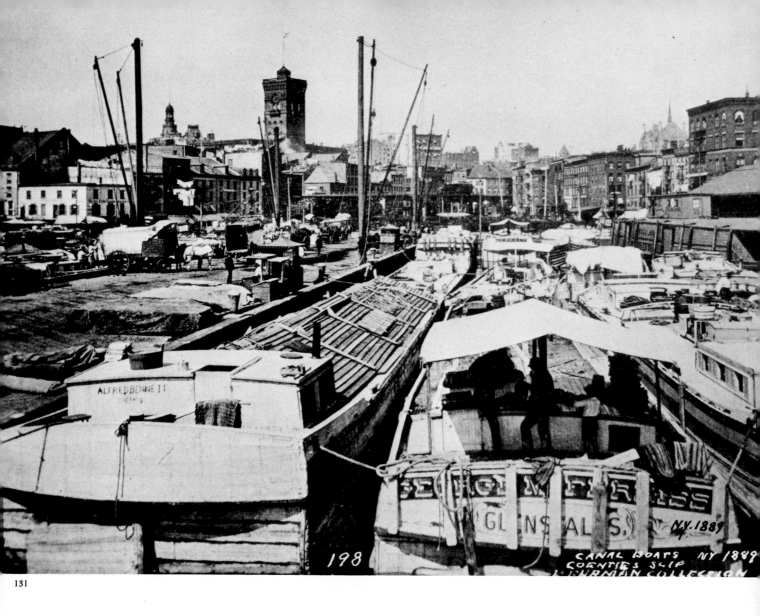

131

129. The captain and crew were photographed aboard the 1885 America's Cup defender *Puritan* while she was anchored off the New York Yacht Club Station at Stapleton, Staten Island.

130. Private yachts, excursion boats and tugs steamed out to watch the 1885 America's Cup Race. In the second race of the defense of the cup the *Puritan* is leading the *Genesta* in a turn around the buoy, which is framed between J. P. Morgan's famous yacht *Corsair* and another large yacht of the New York Yacht Club. Four unsuccessful attempts were made to race. The first, third and fourth failed for lack of wind, and in the second race the *Puritan* fouled the *Genesta*, causing

damage to both yachts. The first decisive race was staged on Monday, September 14 over the 38-mile inside course, starting at Buoy 18 off Bay Ridge, Brooklyn. *Puritan* won this race as well as the second, which was 20 miles to the leeward from Scotland Lightship and return, thus succcessfully defending the cup.

131. "A long way from home," the canaler's lament, comes to mind here at Coenties Slip in 1889. The *Alfred Bennett* of Buffalo nestles alongside the *George M. Ferriss* of Glens Falls. The tall brick tower in the background is part of the Produce Exchange.

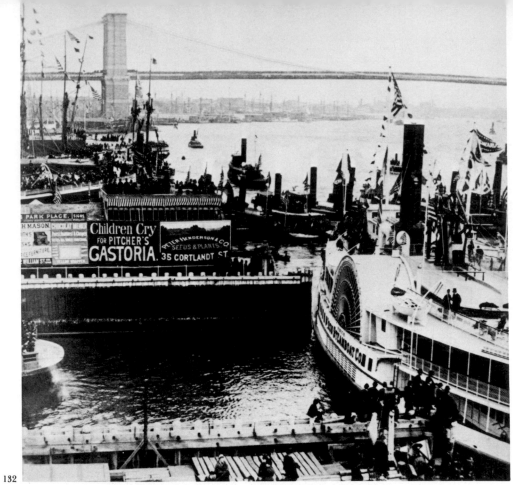

132

133

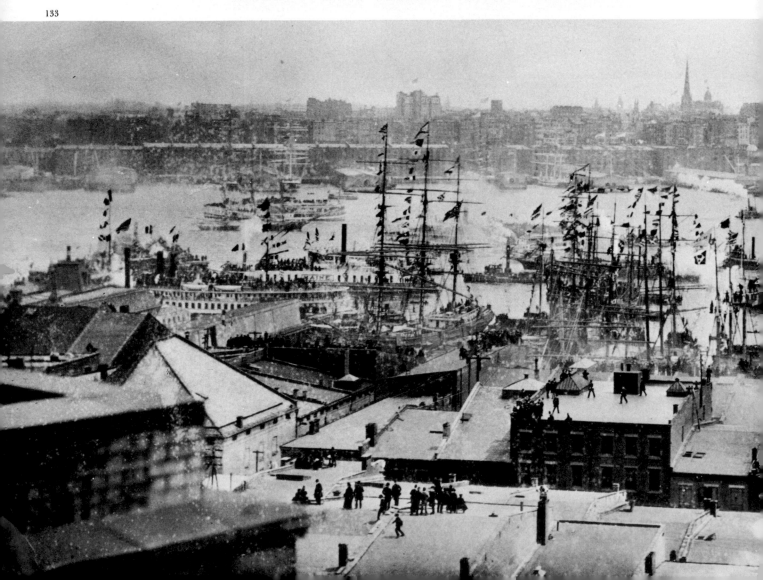

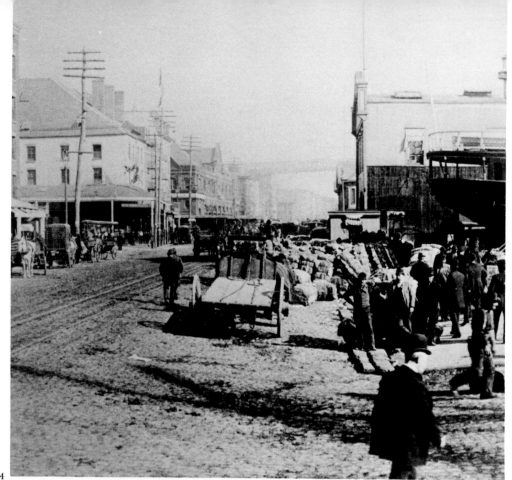

134

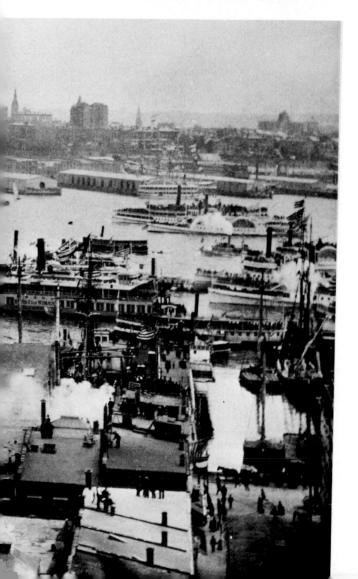

132. A celebration was held at New York on April 29, 1889, marking the centennial of George Washington's inauguration in the city. Here, the *Sirius* of the Iron Steamboat Co. and a small fleet of tugs await the arrival of President Benjamin Harrison. The Kilburn view shows people lining the upper pedestrian walk and the roadway of the Brooklyn Bridge to see the Presidential party.

133. Possibly the most exciting photograph of the riverfront activities of the 1889 Centennial Celebration is this wide-angle shot showing the fleet on the river, and spectators on rooftops and other vantage points greeting President Harrison. The *Monmouth* (far left) and the *Erastus Wiman* (right) acted with the *Sirius* as escort vessels.

134. In 1890 Kilburn captured a subject ignored by other photographers, the Cotton Depot on South Street, south of Burling Slip.

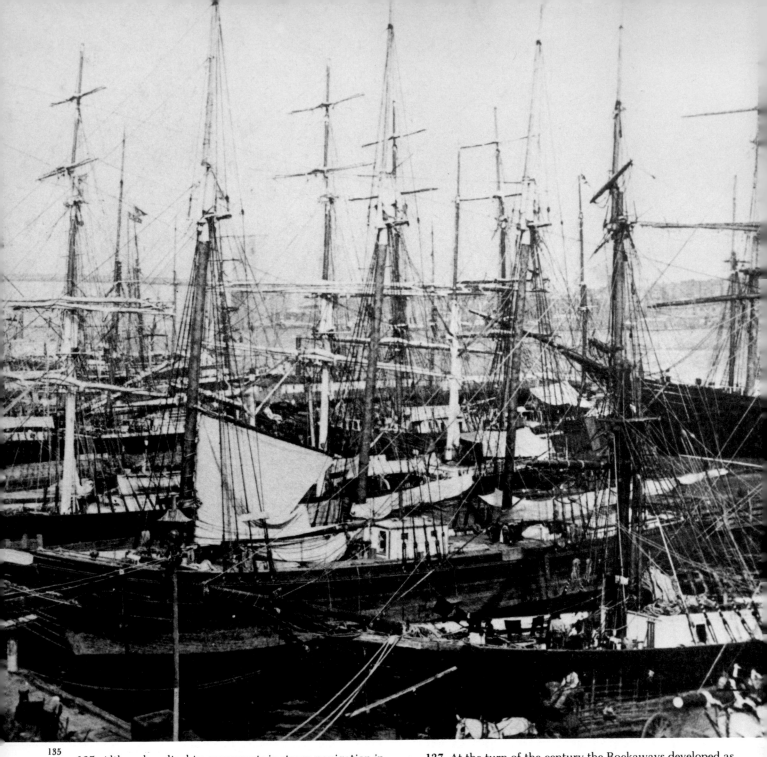

135

135. Although radical improvements in steam navigation in the 1890s further weakened the competitive position of sail, there were enough sailing vessels at South Street up to the end of the century to delight any photographer. L. G. Strand, of Worcester, Mass., published this 1890 view of square-riggers and schooners taken at South Street from Pier 17, at Pine Street.

136. The noted amateur photographer Alice Austen, of Staten Island, gets the credit for this well-composed photo of the bow of the *Sea Witch* (197′–37′8″–1,233) at South Street. The ship, a fast, full-rigged design not classified as a clipper, was built in 1872 by Robert E. Jackson of East Boston for William F. Weld & Co. of Boston. She made three voyages around the Horn in the New York–San Francisco–Liverpool circuit. From 1876 to 1901 she sailed to Australia and Far Eastern ports. Then she was sold to the North Alaska Salmon Co. She was lost in 1906 off Cape Flattery after 34 years of service.

137. At the turn of the century the Rockaways developed as a summer pleasure resort for the masses, with tent cities, bungalows and amusement parks—all of which depended on large excursion boats for transportation. The side-wheeler *Grand Republic*, seen in a photograph of 1890 published by Strohmeyer & Wyman, played an important role in this business for many years. She was built in Brooklyn in 1878 for the Knickerbocker Steamboat Co. as a summer excursion boat only, i.e., without any heating equipment. However, she was chartered for New York–Hartford service in the winter of 1884 as a replacement boat. But her home port was New York and she was normally on the summer Rockaway run. She finally burned opposite 158th Street during winter lay-up, and her walking beam showed above the water for many years. She was a sister ship to the ill-fated *General Slocum* (page 109).

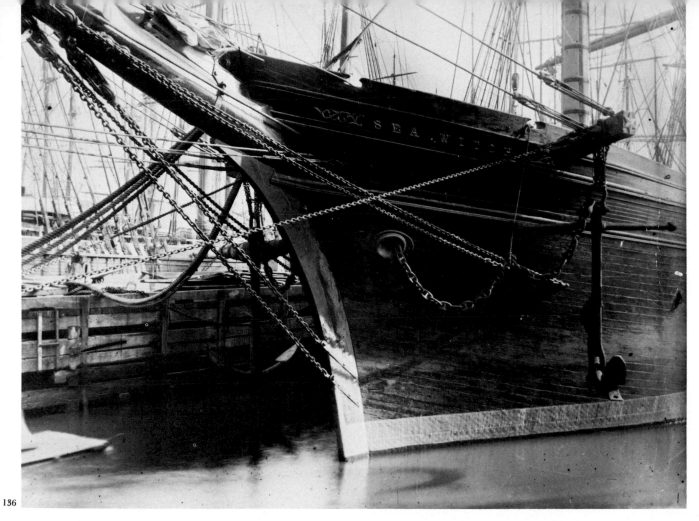

136

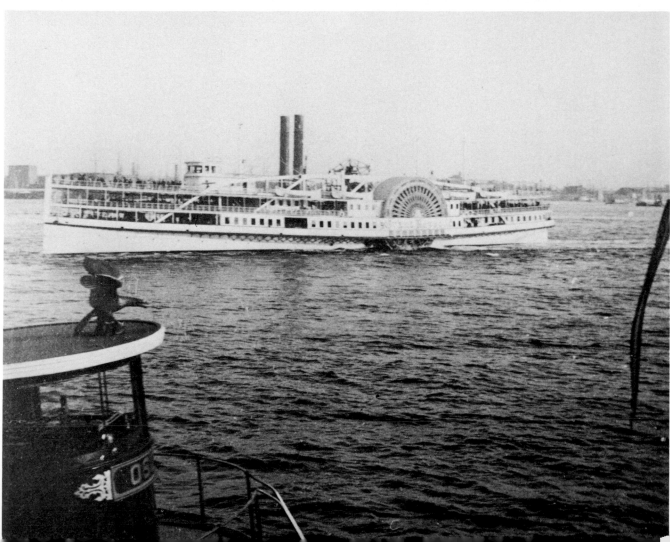

137

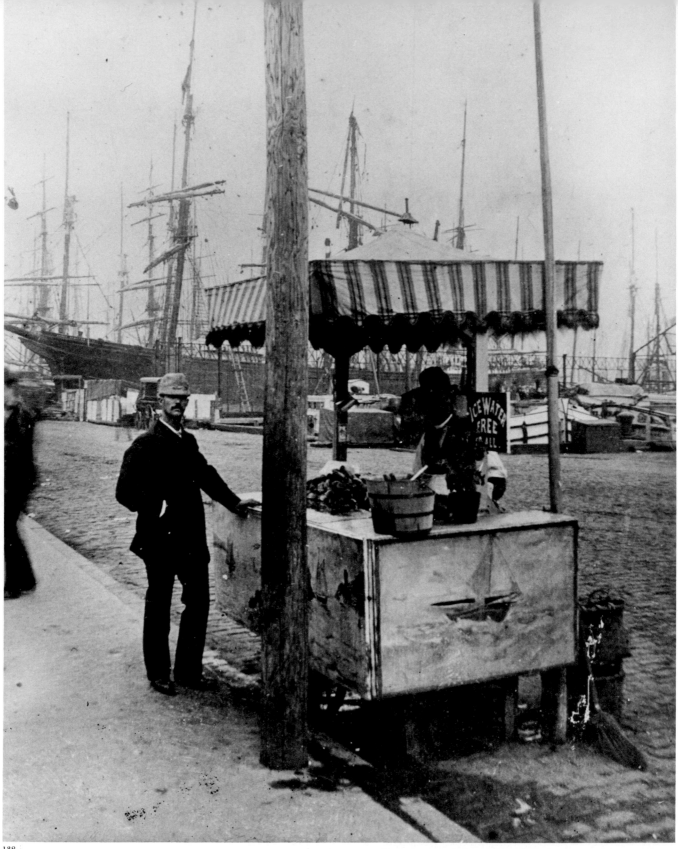

138

138. A dash of local color—and some folk art as well—appears in this genre study of an open-air oyster stand, published in 1890 by Webster & Albee, Rochester, N.Y. The proprietor, stationed at South Street and Wall Street Ferry, offers free ice water to all. In the background is the large British bark *Frank Stafford*.

139. This, one of the finest pictures ever taken at South Street, is believed to be the work of Loeffler of Staten Island, 1890. The iron ship, with its flowing figurehead, jibboom and martingale hinged back toward the deck, remains to be identified. It is docked at Cuylers Alley.

102 *The New York Waterfront after the Civil War*

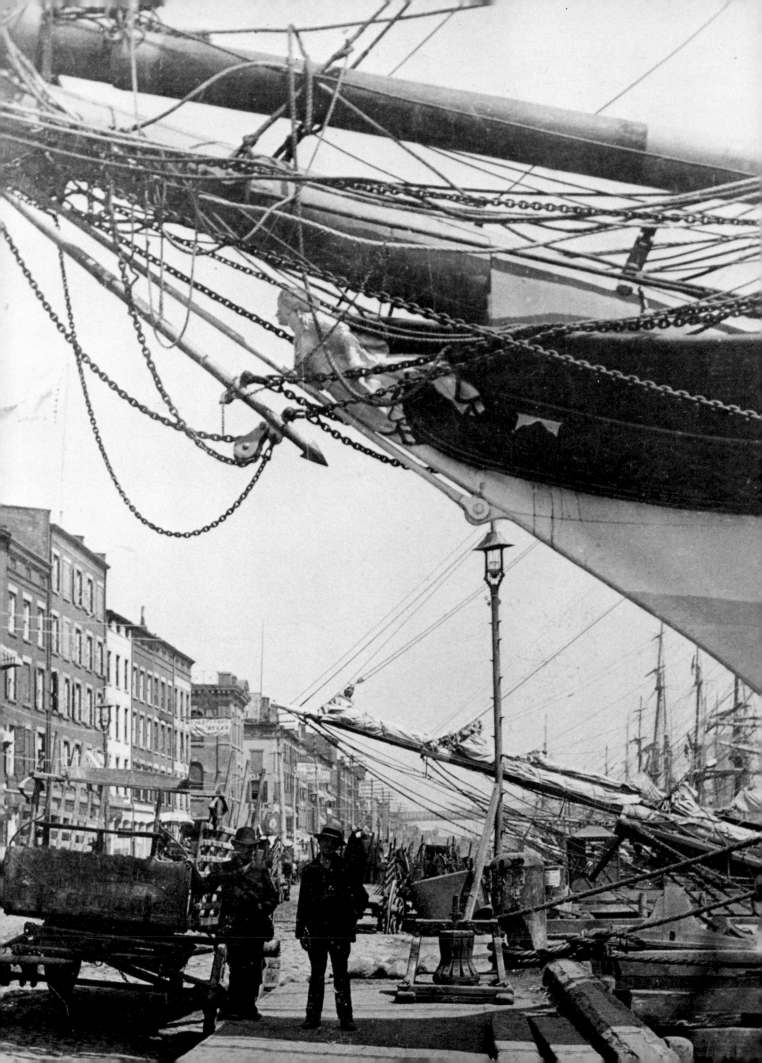

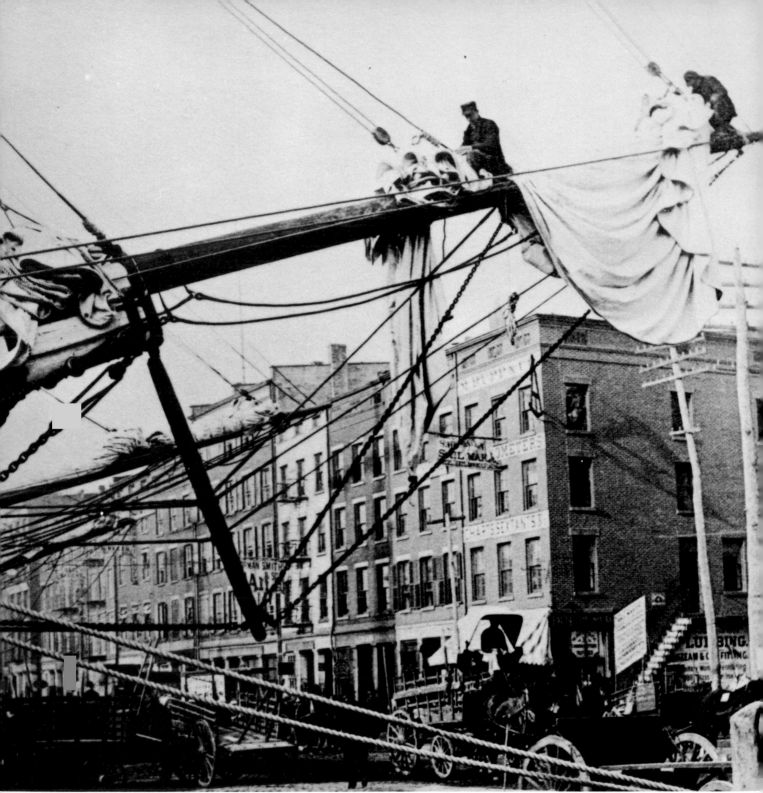

140.

140. In 1891 Kilburn took a good close-up of sailors securing flying and outer jibs while overhanging the roadway at Old Slip and South Street. The famous old nautical instrument house of M. Rupp & Co. is identified by the large sextant displayed on the corner of the building at the intersection.

141. Kilburn also snapped this photograph of the *Cape York* in 1891, just a year after she was launched at Barclays for the Lyles, who were long active in the East Indian sugar trade.

She was a 2,128-ton four-masted steel bark.

142. Did the bowsprits sweep across the streets? Just about! Pedestrians and horse drivers had to be alert on the water side of South Street. This is at Pier 10, south of Old Slip, caught by Kilburn in 1891. Note the figurehead on the second vessel, a man with his right arm outstretched and his hand pointing, seen between two of the men at the right. The signs of sailmakers and others are at the left.

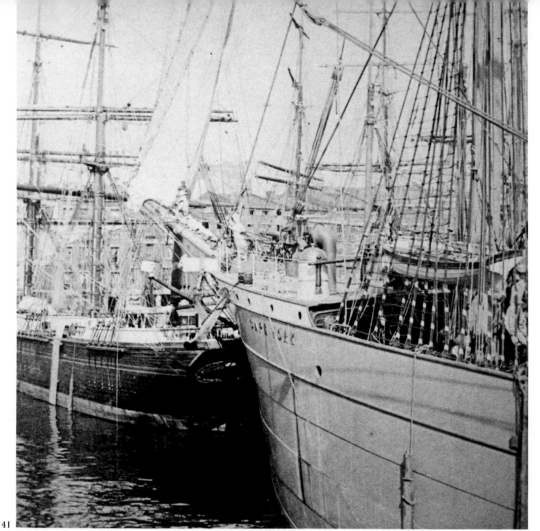

141

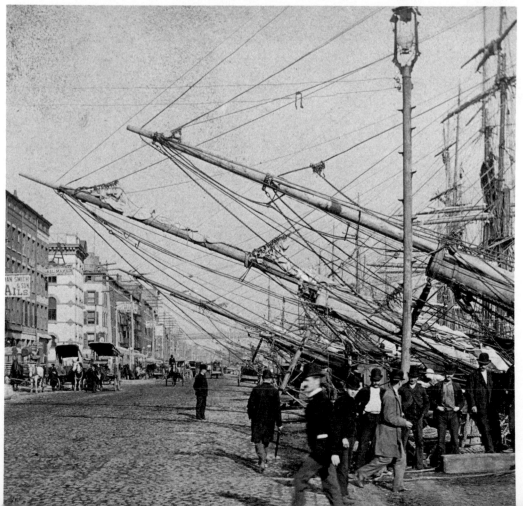

142

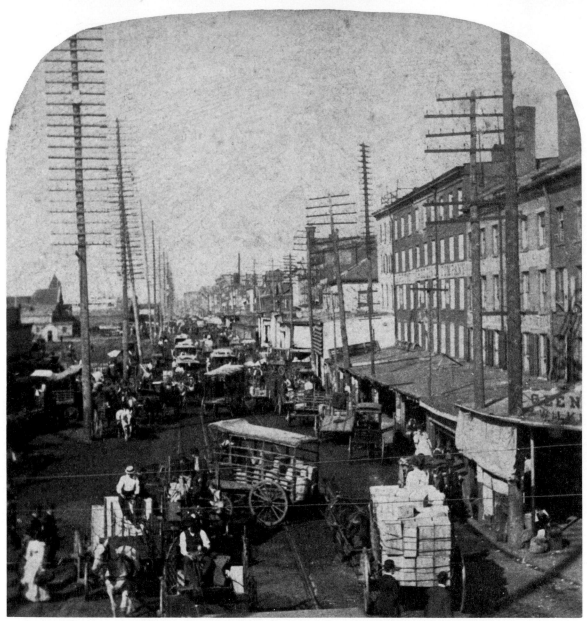

143

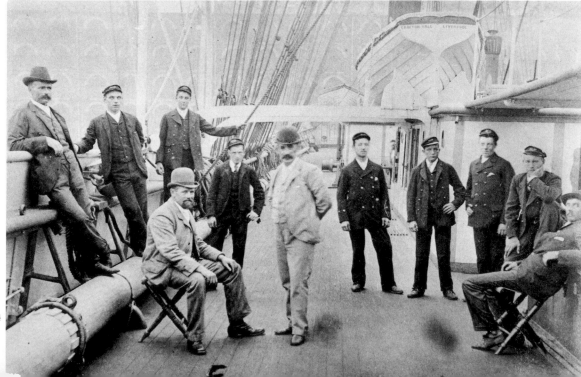

144

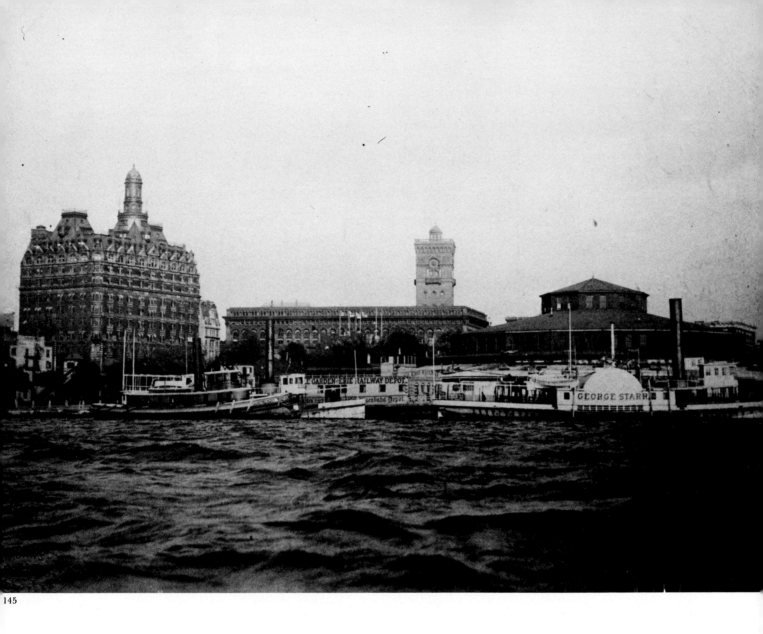

145

143. In 1892 West Street's shoreside buildings look pretty much as they did in 1860, but the traffic has become a serious problem and the Christmas-tree telegraph and telephone poles cry out for replacement by underground cables. Strohmeyer & Wyman published this view, taken near Washington Market.

144. In almost every large port there were photographers who specialized in taking pictures of ships to order. These advertising photographs were usually handed out to favored customers and other business connections.

145. An 1892 panorama of the Battery area from the Hudson includes two paddle-wheel towboats and an early screw tug alongside the floating Castle Garden Erie Railway Depot. The *George Starr*, formerly the *Virginia Seymour*, was among the towboats that earned extra income on Sundays by taking fishing parties off Sandy Hook and Long Branch, N.J. The high funnels on these old towboats were needed because they depended on a natural draft, obtainable with a tall stack, for their boilers. The building at the left is No. 1 Broadway, the Washington Building. The long building with a tower in the center is the Produce Exchange, facing Bowling Green. Castle Garden is at the right.

The New York Waterfront after the Civil War 107

146

146. An 1893 view of the East River shipping looks over the deck of the bark, with plenty of detail of the rigging. Another bark is tied up on the opposite side of the dock, and a Royal Baking Powder wagon on the dock suggests that one of the barks is carrying a mixed cargo, probably to some port not served by steamships. This photograph was published by the Keystone View Co., destined to become the largest and last mass-producer of paper stereoscopic views.

147. In 1895 the steamboat *General Slocum* was photographed while docked alongside a picnic area on the lower Hudson River. She was built in 1891 by the Devine Burtis, Jr., Shipyard, Brooklyn, N.Y., for the Knickerbocker Steamship Co.

148. The *General Slocum* caught fire in the East River on June 15, 1904. Her passengers, mostly women and children from a German Lutheran neighborhood on the Lower. East Side of Manhattan, were forced to jump overboard. Despite the efforts of a tugboat that rushed to help, 1,030 perished in the worst disaster of the type ever to strike New York. Most of the survivors in the victims' families moved to other parts of the city to help forget their loss. The hull of the *Slocum*, seen in an H. C. White view, was brought to Robbins Ship Yard in Brooklyn and was later sold and used as a coal barge, the *Maryland*, along the East coast.

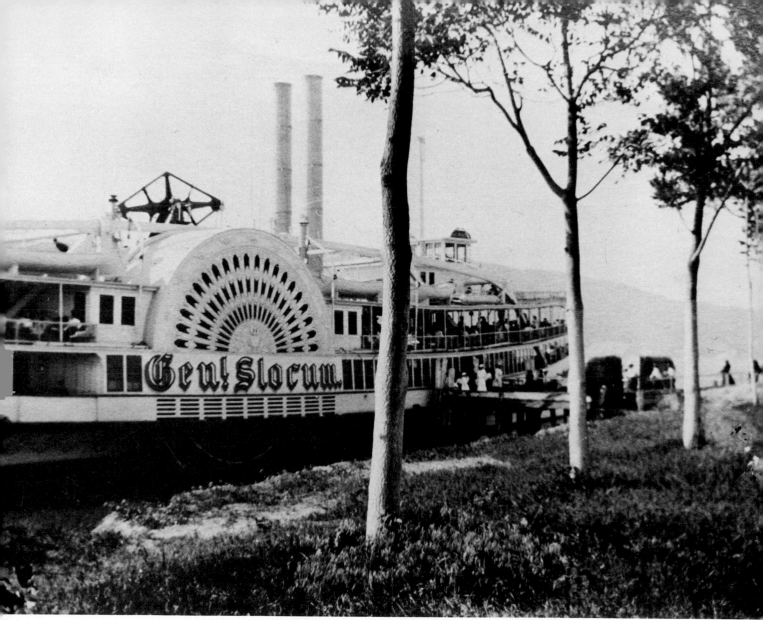

147

148

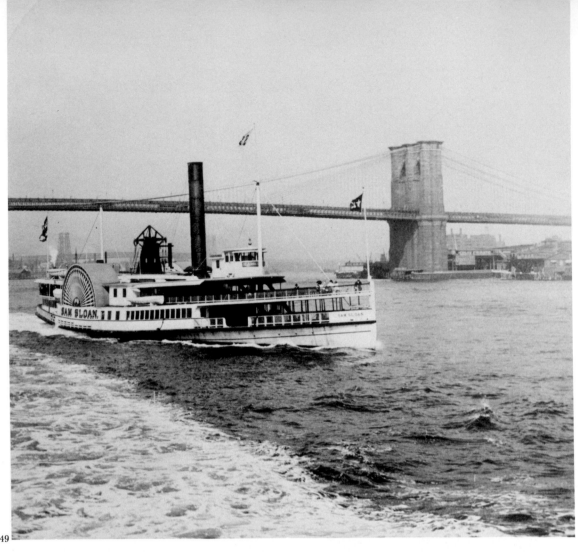

149

150

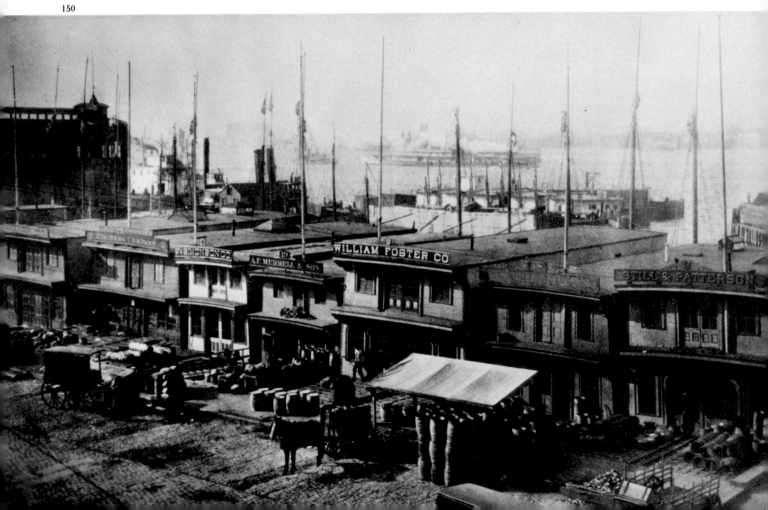

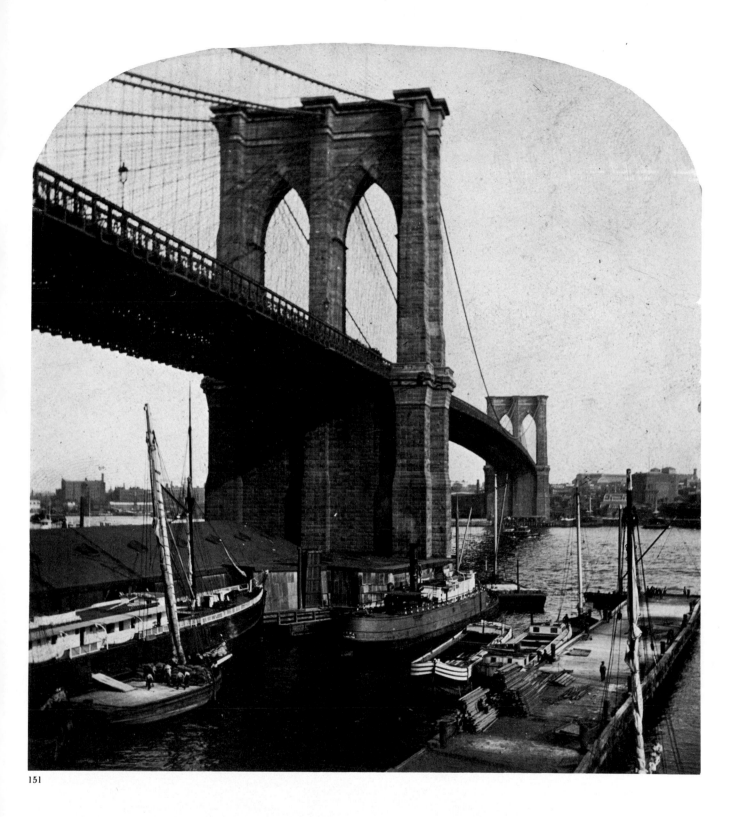

151

149. The Starin line of excursion boats did a huge business in New York for many years. One of its most dependable vessels was the *Sam Sloan* (216′–28′4″–531), with a wooden hull and a vertical-beam engine, constructed as the *Thomas Collyer* in 1864 by Thomas Collyer and Co. in New York. George Starin purchased her and, after having her rebuilt, renamed her after his friend, the president of the Delaware, Lackawana & Western Railroad. She ran on excursions and charters under Starin's flag for about 28 years. William H. Rau took this photograph in 1895.

150. The oyster barges still stood at West Washington Market at the turn of the century. At the left, just above their roofs, the twin stacks of a large Hudson River screw-type tugboat are visible. In the stream, the Hudson River Day Line's three-stacker *New York* is bound downriver for her berth at Desbrosses Street.

151. It is 1896. A Keystone view shows that sailing craft are now scarce at Piers 28 and 29. Two lighters are loading a Clyde Line steamer at Pier 29, and another one, a later type of steam lighter, lies alongside the bridge tower.

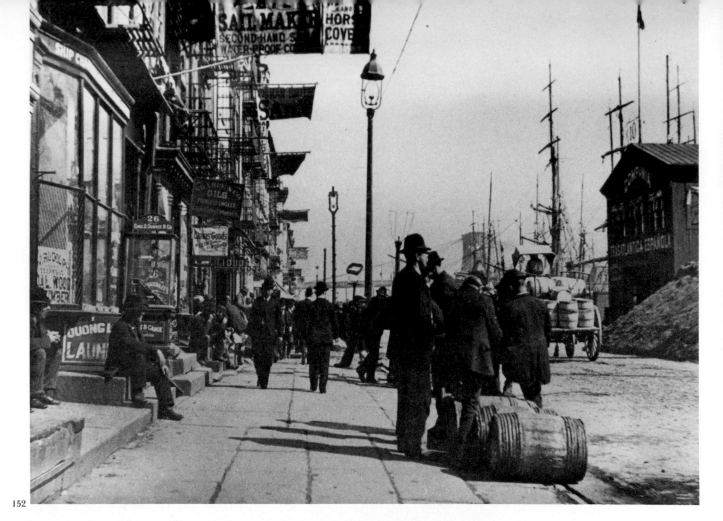

152

153

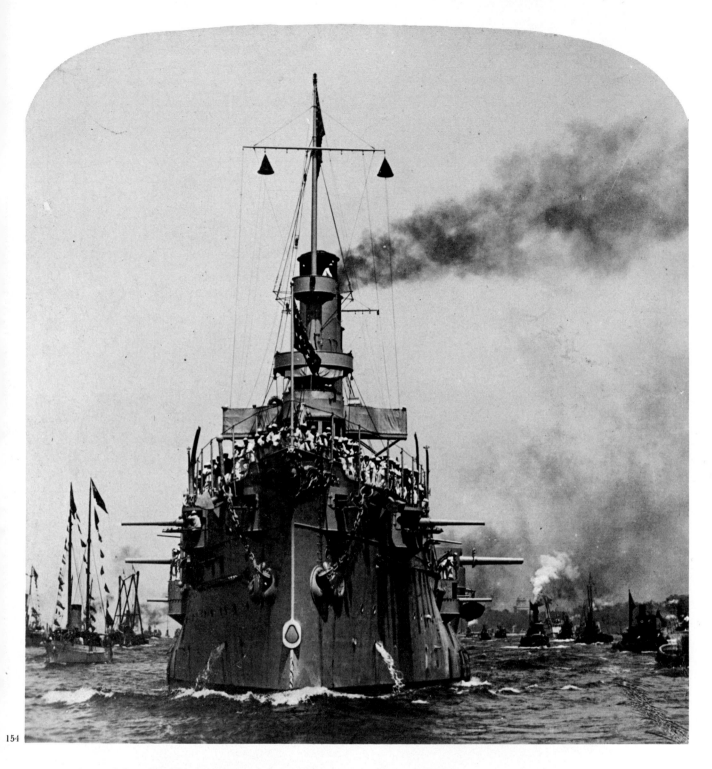

154

152. High-speed dry-plate films encouraged close-up instantaneous photographs. This one of 1898, actually taken for a lantern slide, shows South Street from a vantage point below Pier 10, the terminal of the Compañía Transatlántica Española line for Havana.

153. Compared to the Civil War, the Spanish-American War had little effect on New York harbor. The Bay and the Lower Hudson River, however, were chosen for the gala naval review, part of the Dewey Celebration in 1899, honoring the admiral who conquered the Spanish fleet at Manila. The spectator fleet for the Dewey Celebration Naval Parade up the Hudson included the *J. S. Warden* (153′6″–27′3″–347), a wooden-hulled side-wheeler with vertical-beam engines, built as the *Eliza Hancock* by M. S. Allison in Jersey City in 1863.

After Civil War service under charter to the Quartermaster Corps, she worked Atlantic harbors and river routes from Boston to Jacksonville for over 50 years. The Knickerbocker Steamboat Co.'s *Grand Republic* is upstream beyond her. The photograph was published by J. F. Jarvis.

154. In this view of the Dewey Celebration published by R. V. Young, the armored cruiser *Brooklyn* (400′6″–64′8″–9,215), the flagship of Admiral Schley, heads the parade. Built in 1896, she was then Commodore Schley's flagship in the battle of Santiago, July 3, 1898. Although she was the fastest ship of the American vessels engaged, capable of over 21 knots, she suffered the only casualties on the American side—one killed and one wounded.

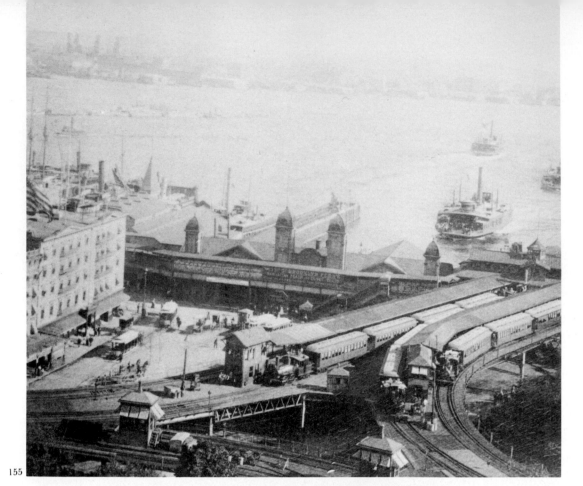

155

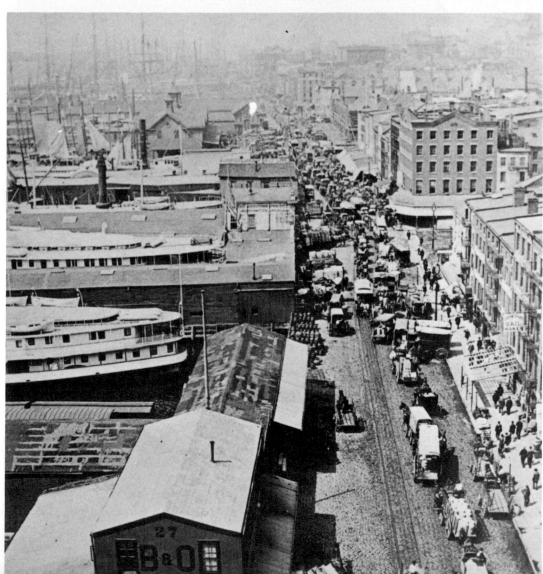

156

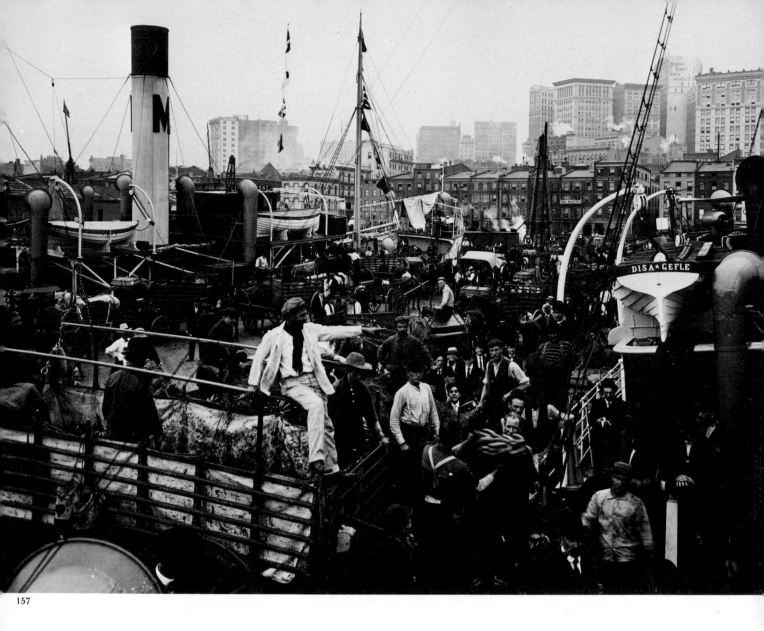

157

155. In 1898 Kilburn took this photograph of ferryboats and steam trains at South Ferry. All four of the Manhattan Railway Companies' elevated lines started from South Ferry at this time. The tracks on the left were used by the Second and Third Avenue Lines, which shared a common route as far as Chatham Square. On the right are the tracks used by the Sixth and Ninth Avenue Lines, which were shared to a point just above Battery Place. The el steam engines were never turned, running boiler-first uptown and coal-bunker-first downtown. The locomotive was always at the front of the train.

156. A classic traffic jam, horse-and-wagon style, extends on South Street from above Peck Slip to below Fulton Ferry.

157. After 1898, picture postcards were legal in the United States, requiring a new catalog of pictures in an oblong format. One taken for the Detroit Photographic Co. is shown here—the banana dock at Pier 13 on the East River, opposite Gouverneurs Lane. The Standard Fruit Co. operated this pier and No. 14. The Cuneo Importing Company's banana wagon is in the foreground. Old Slip House is visible at the left.

The New York Waterfront after the Civil War 115

THE NEW YORK NAVAL SHIPYARD (BROOKLYN NAVY YARD)

In 1799, by Appropriation Act (Statute No. 621), Congress authorized $40,000 of original funds for the purchase of 42 acres of land for establishment of the Navy Yard. In 1800 the only naval facilities in New York were two wharves at Market Street and the East River, south of the Manhattan Bridge. The 44-gun frigate *President*, constructed in 1800 by Forman Cheesman on the East River, near the present location of the Williamsburg Bridge, was the first major naval vessel built in New York. The New York Naval Shipyard was established on February 23, 1801, on the site of a privately owned shipyard in which merchant ships had been built 20 years previously. President John Adams directed the purchase of this site along with five other sites for navy yards. Lieutenant Jonathon Thorn was the first Commandant of the Yard. The shipyard first rose to importance in the War of 1812, when it outfitted and armed more than 100 ships for the sea struggle with Great Britain. The first vessel constructed in the Yard was the U.S.S. *Ohio*. The noted New York shipbuilder Henry Eckford designed the *Ohio* while the equally famed shipbuilder Isaac Webb supervised its construction. Its keel was laid in 1817 and launching took place on May 30, 1820. Three of the greatest naval architects and shipbuilders of America were trained by Isaac Webb while serving their apprenticeships in his shipyard—his son William H. Webb, Donald McKay and Samuel Pook. In 1841 construction commenced on the first dry dock, built of solid granite blocks on wooden piles. Ship construction during the Civil War consisted mainly of nine-gun steam sloops of war and eight-gun side-wheel double-enders, along with refitting and arming many vessels for blockade and transport duty. On October 18, 1888, the keel was laid for the ill-fated battleship *Maine* with launching taking place on November 18, 1890. The *Maine* was destroyed by an external explosion in Havana Harbor on the evening of February 15, 1898, killing 268 of her crew, an event that sparked the Spanish-American War. During the First World War, the shipyard was active in repairs and new construction. It reached its top capacity during the Second World War, when a peak working force of 69,128 civilian employees repaired 5,000 ships, converted 250 other ships and constructed 3 large battleships, 5 large aircraft carriers and 8 landing ships. The Navy abandoned the yard in 1966.

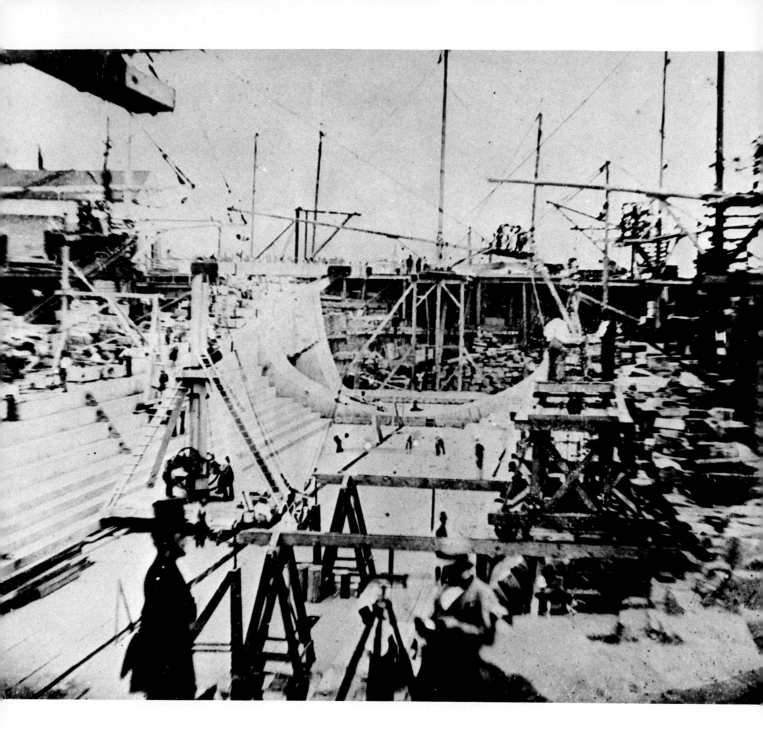

158. The first dry dock at the Brooklyn Navy Yard. This unique image is from a daguerreotype made during construction of the dry dock in 1846, and is the earliest photograph presented in this book. It was once owned by civil engineer William Jarvis McAlpin, who supervised the dry dock's construction, and was acquired by the Navy Department in 1914, when Rear Admiral E. H. C. Leutze, U.S.N. Retired, presented it to Secretary of the Navy Daniels.

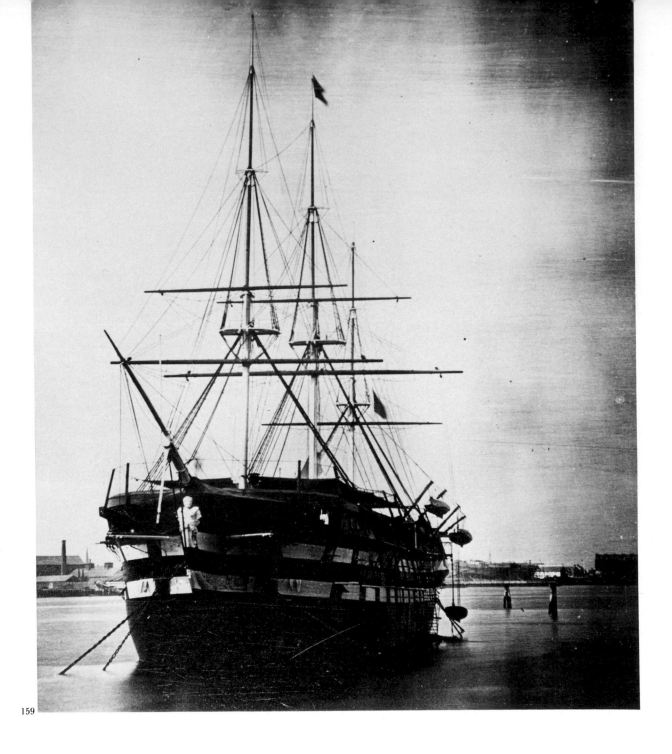

159

159. The U.S.S. *Ohio* was daguerreotyped in Boston in 1856 by Southworth & Hawes for their large parlor stereoscope. The *Ohio*, a 74-gun ship of the line (197'–53'–2,757) was the first vessel to be constructed in the Brooklyn Navy Yard. Built under the supervision of Isaac Webb after the designs of the renowned Henry Eckford, Superintendent of the Yard, she proved to be an excellent sea boat and the fastest sailing ship ever built in this class in the U.S. Navy, differing from the frigates in her size, armament and the combination of two covered gun decks with a spar deck. She became the flagship for Commodore Isaac Hull in the Mediterreanean Squadron, and later served in both the Atlantic and Pacific Squadrons. She was sold at Boston on September 27, 1883. The image of the daguerreotype is reversed.

160. The receiving ship *North Carolina* (196'3"–53'6"–2,633) was photographed at the Brooklyn Navy Yard. She was laid down in 1818 and launched on September 7, 1820, at the Philadelphia Navy Yard. With her 74 guns, she was one of the most powerful naval vessels afloat in her day, and served in the Mediterranean as flagship for Commodore John Rogers from 1825 through 1827. She later was the flagship of the squadron assigned to the west coast of South America. Because of her huge size and great draught, only ports in the Mediterranean, the west cost of South America and the United States could accommodate her. She was sold by the Navy in 1867.

161. Manning the pumps aboard the ship of the line *North Carolina* in the Brooklyn Navy Yard, September, 1861.

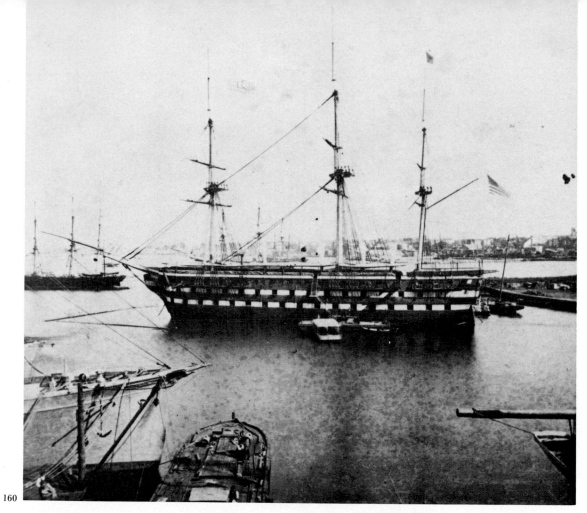

160

161

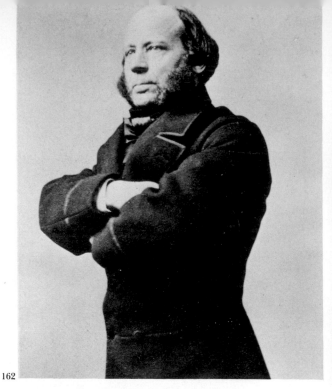

162

163

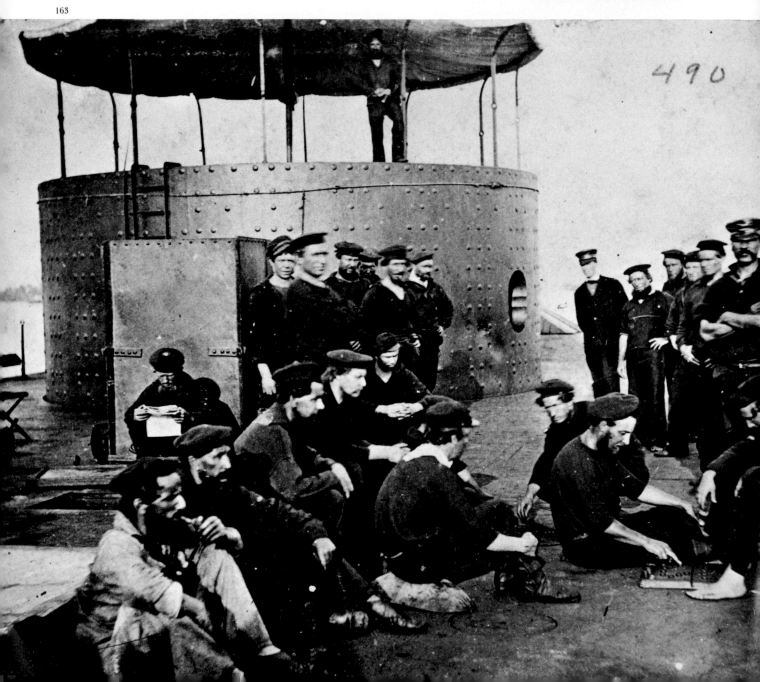

490

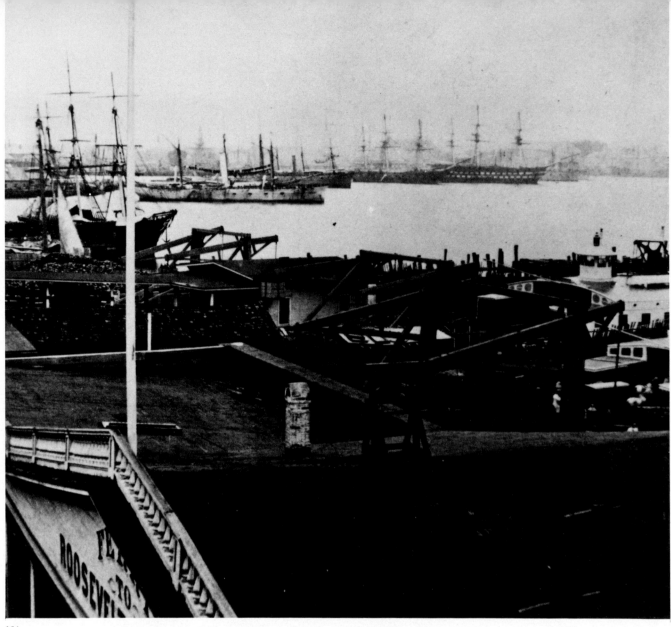

164

162. The great Swedish-born marine engineer John Ericsson (1803–89) arrived in New York in 1839 to promote the screw propeller as a means of ship propulsion superior to the paddles in use. He designed and supervised the construction of the famed Civil War ironclad *Monitor*.

163. The crew of the ironclad U.S.S. *Monitor* (179′6″– 41′6″–776) relaxing on the deck. The ship was constructed by John Ericsson at the Continental Iron Works, East River, Greenpoint, N.Y. Her round turret was made of eight thicknesses of iron bolted together, and her side was protected by five inches of plating. The turret was turned by machinery below the waterline so that she had a complete sweep with her two 11-inch Dahlgren guns without being forced to change

her position or maneuver. The *Monitor* engaged the *Merrimac* in an historic battle on the morning of March 9, 1862, at Hampton Roads, Va., near Fortress Monroe. By holding off the *Merrimac*, she saved the Union blockading fleet from destruction. The news of the battle revolutionized the world's navies, causing the replacement of wooden ships by ironclads. The *Monitor* later sank. The wreck was recently located but after examination scientists determined that she was too fragile to be recovered.

164. This view of the Brooklyn Navy Yard was taken for Anthony from Roosevelt Ferry in 1863. The *North Carolina* is in the distance. The closest naval vessel is a screw-type gunboat of the class used by the Navy for blockade duty.

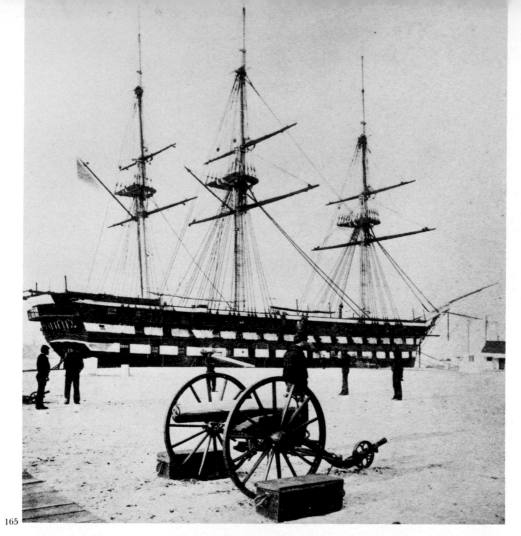

165

166

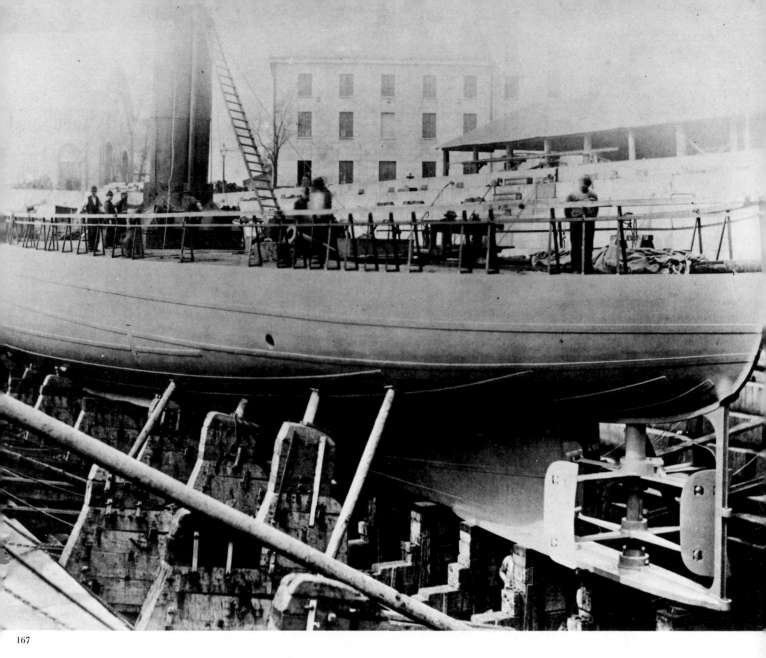

167

165. The 74-gun *Vermont* (196'3"–53'6"–2,633) lies in the Brooklyn Navy Yard in 1868. The sister ship of the *North Carolina*, she was the last ship of the line in the U.S. Navy. Construction work on her was started in 1818, but was halted because of a lack of appropriations and was not resumed until nearly 27 years later. Launching took place on September 15,1845.

166. This deck scene aboard the steam-screw frigate U.S.S. *Colorado* (288'6"–52'6"–3,425) was photographed by C. W. Woodward at the Brooklyn Navy Yard in 1868. Launching took place at the Norfolk Navy Yard on June 19, 1856. The ship was decommissioned, but returned to active duty six times during her 28 years of naval service, operating with blockading squadrons during the Civil War and later serving as flaship for the European and Asiatic Squadrons.

167. The U.S.S. *Alarm*, an iron torpedo boat, is fitted out in No. 1 Drydock. Launched November 13, 1873 in the Brooklyn Navy Yard, it was commissioned in 1874. Built to the design of Admiral D. D. Porter for the experimental use of the Bureau of Ordnance, the *Alarm* had a long, pointed ramming blow and utilized the unusual "Fowler Wheel," seen here at bottom right, instead of the conventional propeller, for propulsion.

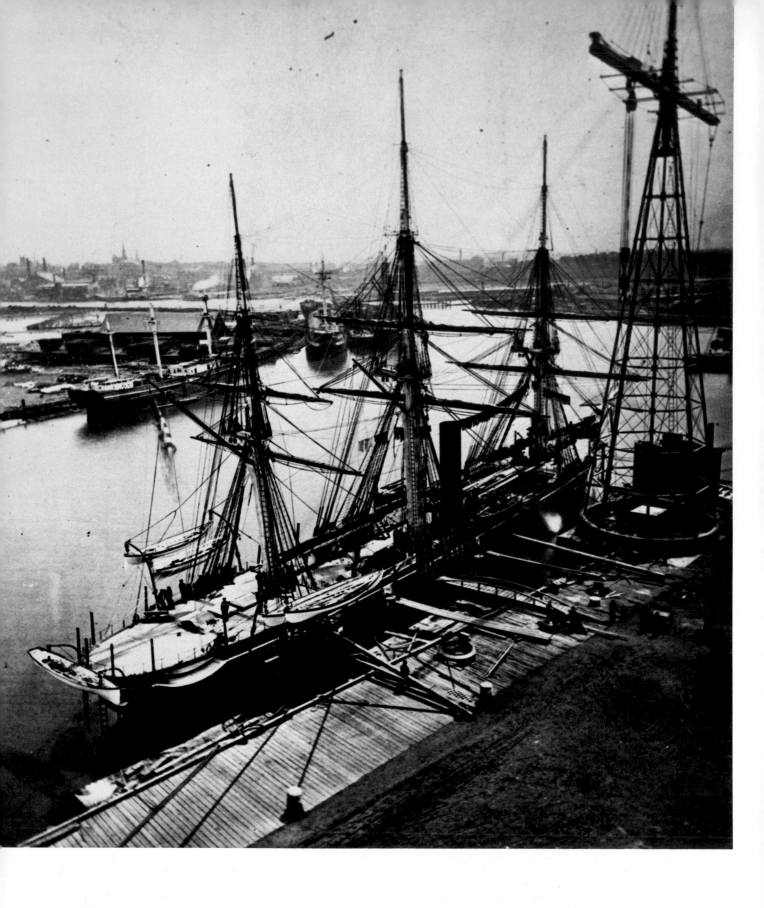

168. An 1876 view shows the U.S.S. *Swatara* (216′–37′–536), a wooden ship with screw propulsion and ship rig, launched on May 23, 1865, as she is being refitted in the Brooklyn Navy Yard on her return from Australia and the Pacific.

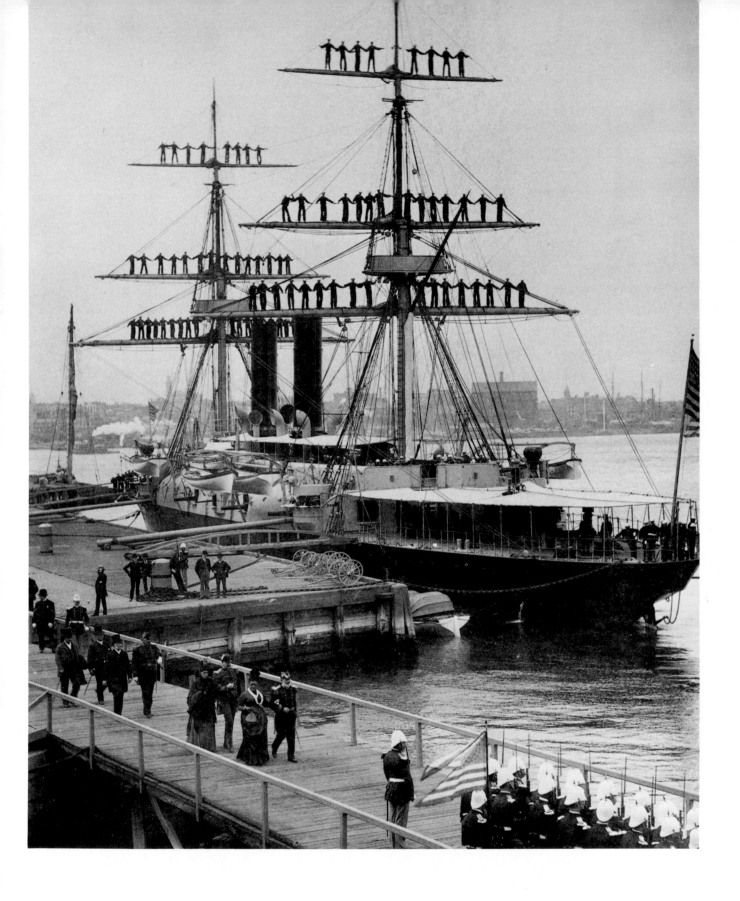

169. Sailors manned the yards of the U.S.S. *Atlanta* in the Navy Yard in May, 1887, in honor of the visit of Queen Kapiolani of the Hawaiian Islands. The Queen, consort of King Kalakaua who reigned 1875–91, is being escorted down a gangway and approaches a Marine honor guard. The *Atlanta* (283'3″–42'–3,189) was a protected cruiser launched October 9, 1884 at John Roach & Sons Ship Yard, Chester, Pa.

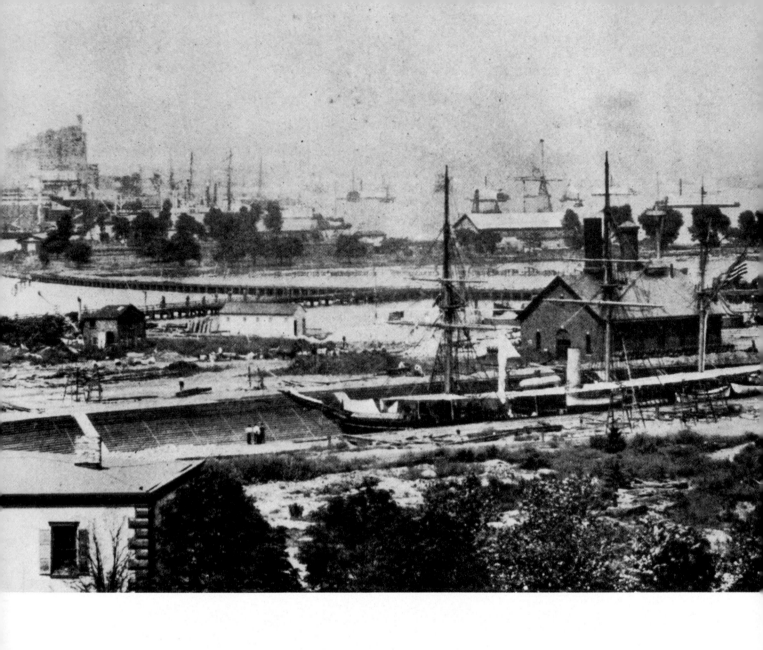

170. An old-style U.S. Navy screw steamer lies in No. 1 Dry Dock, Brooklyn Navy Yard, for overhaul. Also shown is Cob Island (Cob Dock), an artificial island created mostly from cobblestones that were used as ballast in sailing vessels and were dumped into the bay at the end of a voyage. The island was used for berthing after being cribbed up.

THE BROOKLYN WATERFRONT

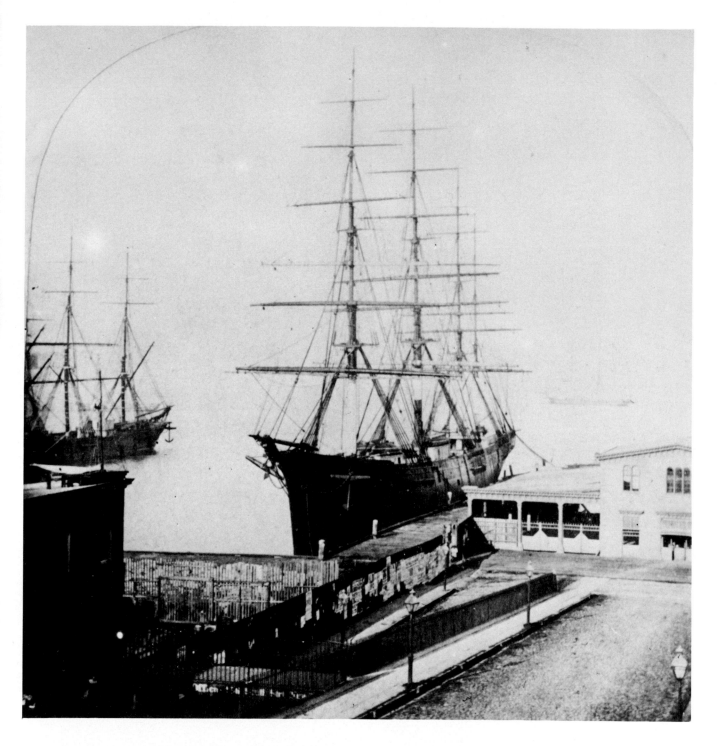

171. The clipper ship *Great Republic*, the largest extreme clipper ever built, lies alongside the Montague Street terminal of the Wall Street Ferry in Brooklyn in 1857. She was designed by Donald McKay and launched in his East Boston yard on October 4, 1853. While tied up at the foot of Dover Street on the East River for loading, the ship was severely damaged by fire on December 26, 1853, and was scuttled. Her hull was raised and sold to Capt. N. B. Palmer, and she was rebuilt by Sneeden & Whitlock in Greenport, Long Island. The sail plan and her mast and spar dimensions were reduced in the reconstruction. She was then purchased by A. A. Low & Brother and reregistered at 3,357 tons, as against an original 4,555 tons. She remained the largest merchant ship afloat, and was employed as a troop transport in the Civil War. Returned to civilian use, she still attracted attention while at San Francisco. She was renamed the *Denmark* while sailing under the British flag, and foundered in a hurricane off Bermuda in 1872.

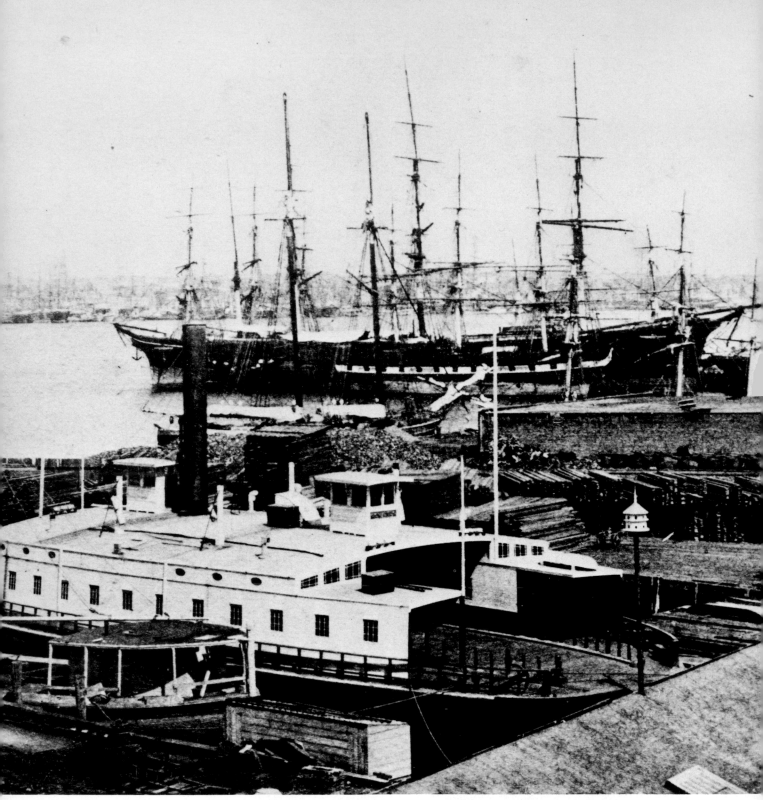

172

172. The Union Ferry Company's *Republic* is shown in the repair yard in an 1861 Hoyer view. In the background, the *Great Republic* is docked at Pier 14, East River, Brooklyn, dwarfing the 200-foot packet of the 1840–50 period beside it.

173. The Bierstadt Brothers of New Bedford visited New York City and the Hudson Valley in 1860, and took some excellent negatives for their line of stereoscopic views. Among them is what seems to be the earliest view of the sailing ships at Pier 18, near Remsen Street, taken from the Montague

Street ferry terminal. Governors Island is in the distance.

174. Brooklyn got a fair share of the ship construction during and after the Civil War. An 1864 Anthony view shows Henry Steers' Greenpoint yard, as the sidewheeler *Arizona*'s hull nears completion. Owned by the Pacific Mail Steamship Co., the *Arizona* (323'7"–44'7"–2,793) sailed between New York and Panama, later operating from San Francisco to Panama and other West Coast ports.

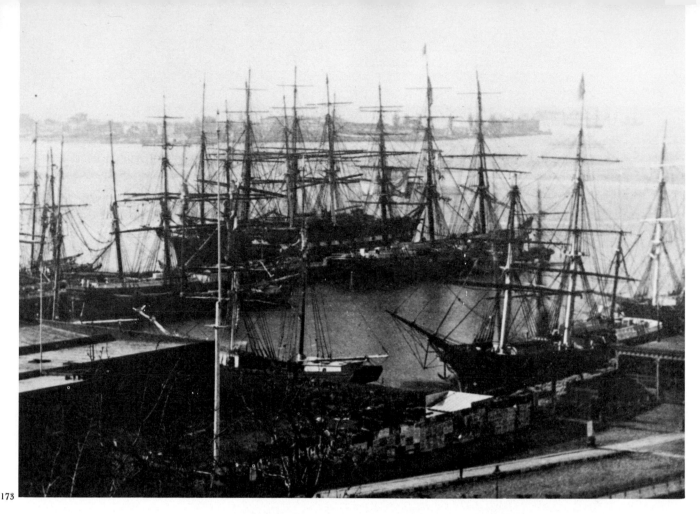

173

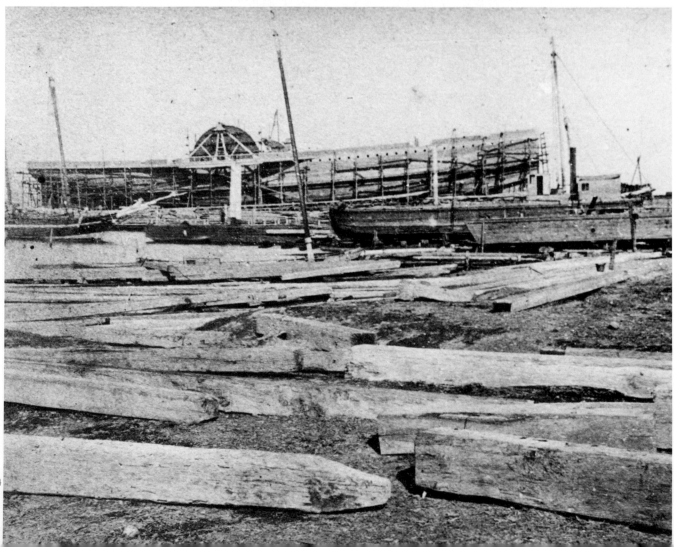

174

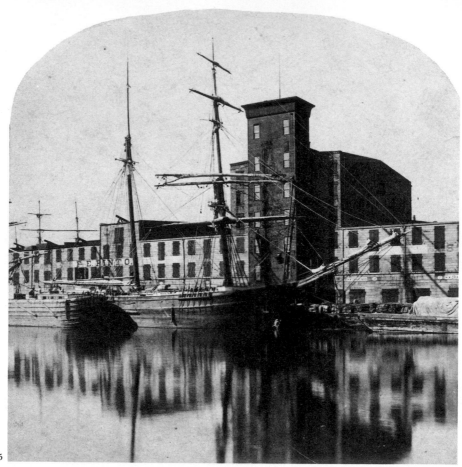

175

176

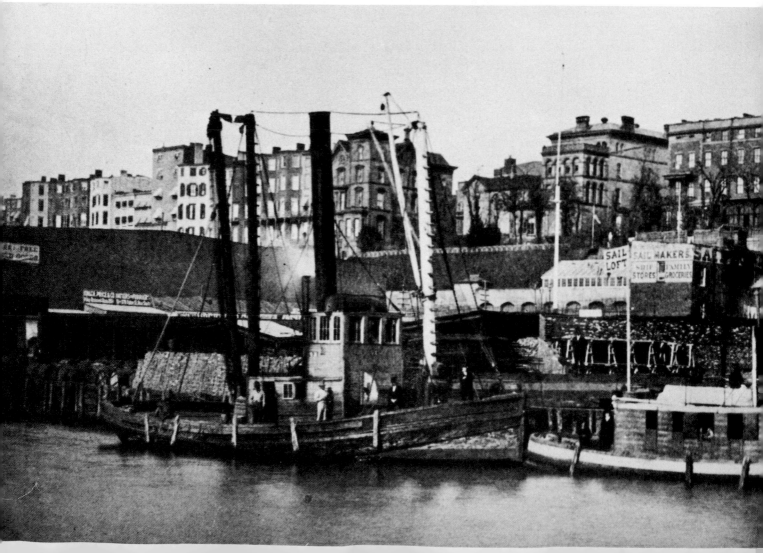

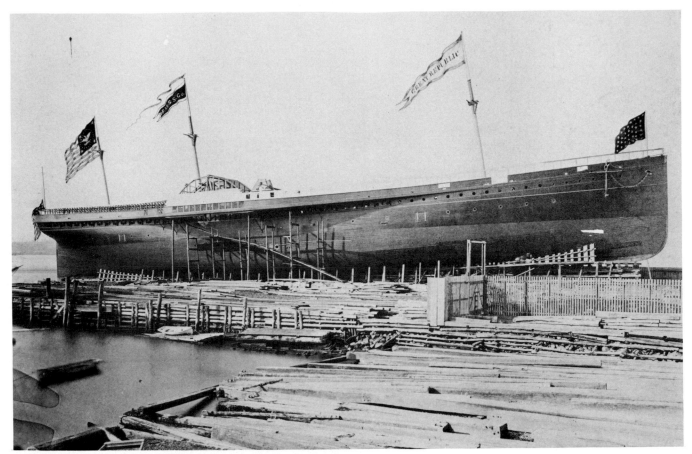

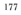

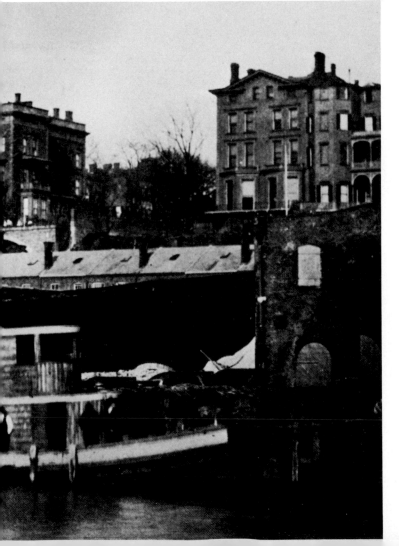

175. An Anthony photograph of 1872 includes some of the large warehouses that helped establish Brooklyn as a major factor in coastal and foreign shipping. A brigantine (hermaphrodite brig), with a large barge alongside, is tied up to the dock of F. E. Pinto.

176. An 1874 view of Brooklyn waterfront south of Montague Street shows Brooklyn Heights. The Montague Street arch is visible over the stack of the steam tug, and signs advertise sail makers.

177. The Pacific Mail Steamship Co.'s wooden sidewheeler *Great Republic* (360'3"–47"4"–3,822) is readied for launching at Henry Steers shipyard in Greenpoint. Designed with a double vertical-beam engine for San Francisco–Far East service, she did the run for only a few years before going into coastal service out of San Francisco. (The flags and pennants were hand-painted on the original photograph of 1866.)

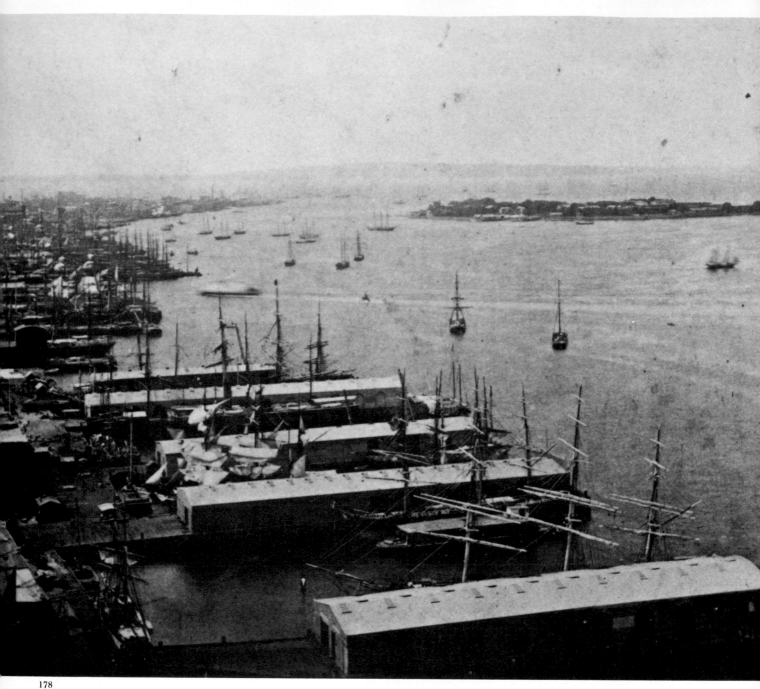

178

178. Part of the Brooklyn waterfront, looking from a vantage point at Fulton Street, in an 1875 Kilburn photograph. Pier 4 is in the foreground; Piers 2 and 3 are enclosed Martin Stores. The Lamport & Holt Steamship Line for Brazil and River Plate ports operated from Pier 2. (Pier numbers given are the contemporary designations.)

179. In an 1880 view from Pier 33, Main Street, Brooklyn, looking toward the dry-dock area between Market and

Rutgers Slip on the Manhattan side of the East River, a square-rigger is visible in the big Balance Dry Dock. The Large Screw Dry Dock can be seen to the right. Three riggers are shown at work on the yards of the square-rigger in the foreground.

180. Ben Kilburn captured this 1875 scene of the Brooklyn waterfront from the Fulton Ferry terminal, looking south toward Governors Island. Sail is very prominent in this view.

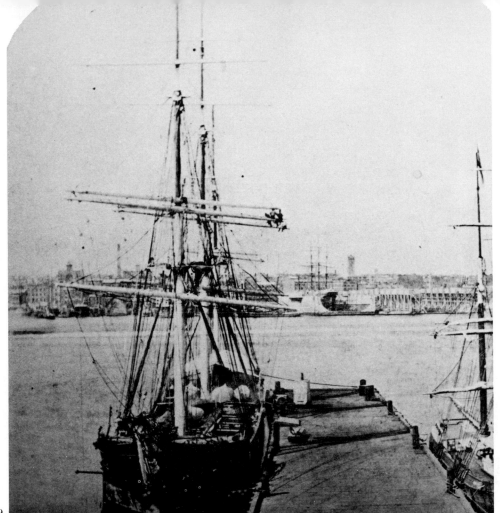

179

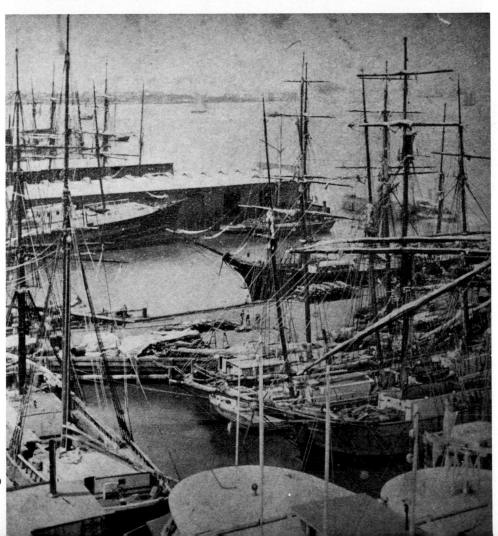

180

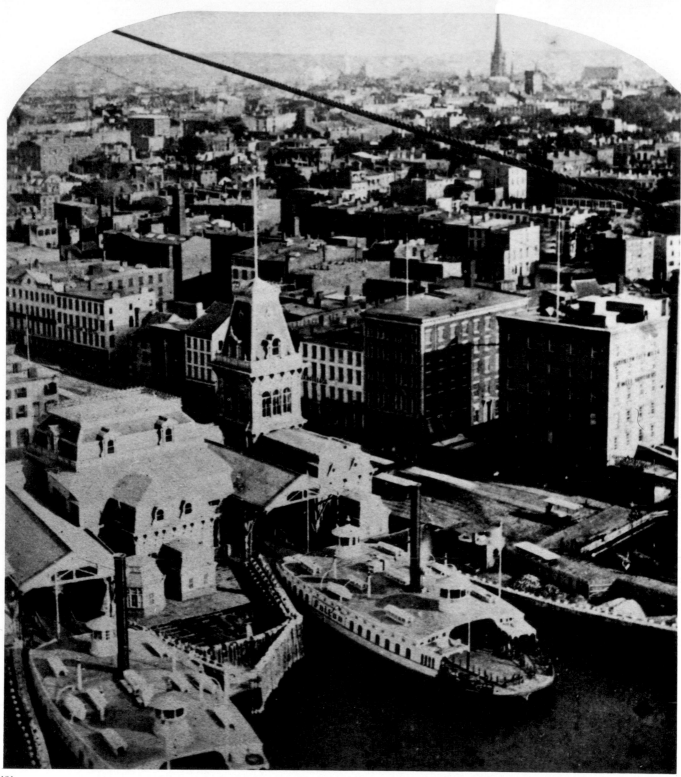

181

181. An 1875 panorama includes the Fulton Street Ferry terminal with the ferryboat *Fulton* in the slip on the right. The Fulton Street el, starting at the terminal, was not constructed until a later date.

182. Kilburn photographed East River traffic from the Brooklyn Bridge in 1883. A tug shepherds a small two-masted schooner and a large three-masted one towards the Upper Bay. Governors Island is ahead, the Manhattan shore is on the right.

183. Small two-masted schooners managed to survive the competition of larger sail and steam vessels. Here three of them, along with one three-master, are framed by the Brooklyn Bridge. The Fulton Ferry, on the left, is approaching its Brooklyn terminal in this 1885 Kilburn photograph.

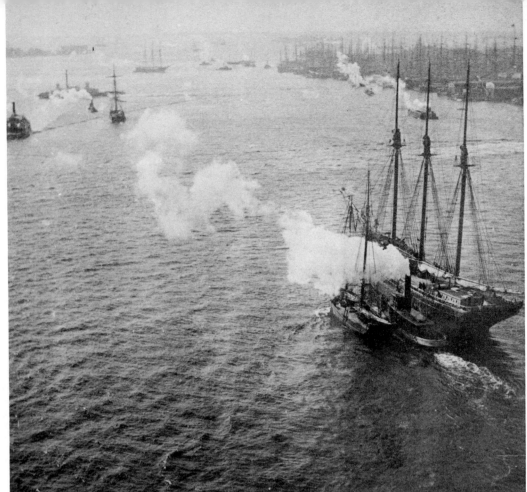

182

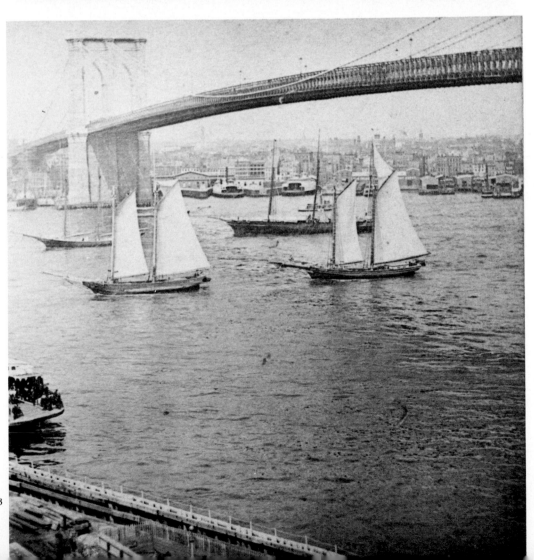

183

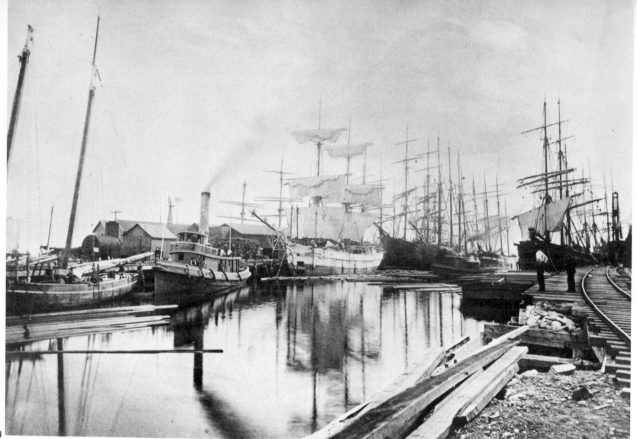

184

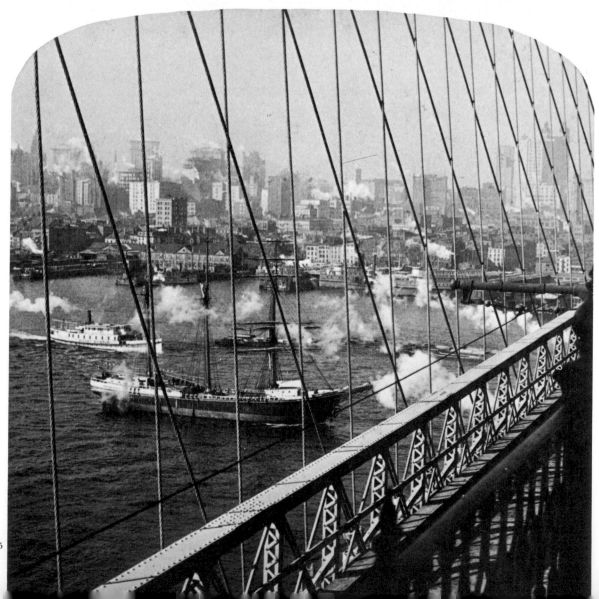

185

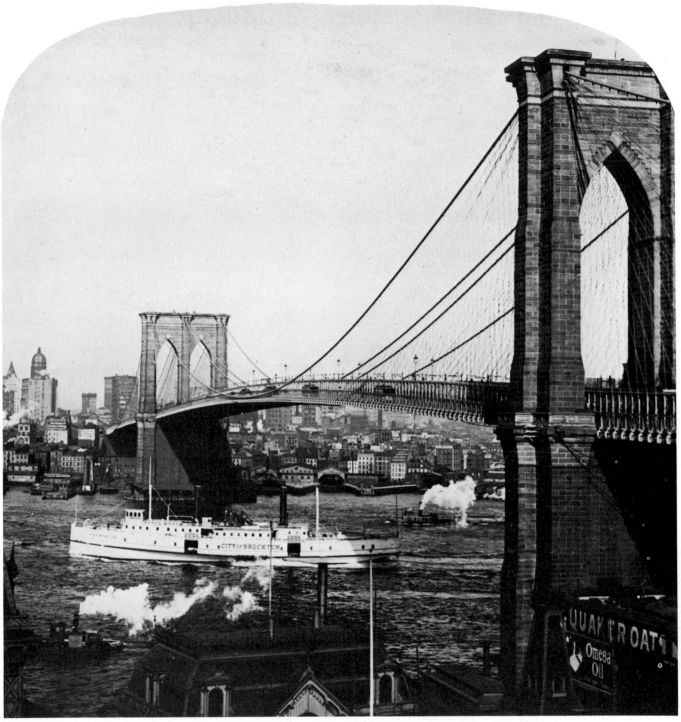

186

184. In an 1887 Brooklyn view from 26th Street looking toward Gowanus Creek, a white square-rigger, its sails unfurled to dry, lies aft of the tugboat. An open port used in handling timber and lumber cargo is visible at the waterline near the bow.

185. In 1900 Underwood & Underwood published this dramatic picture of the East River from the Brooklyn Bridge looking toward Manhattan. Astern the barkentine heading

upstream under tow, one of the two Fulton Market Fish Monger's Association boats steams up the river to rendezvous with fishing schooners coming in with their catch off Harts Island and Port Morris, N.Y.

186. A favorite photograph of many collectors is this view of the *City of Brockton*, framed by the Brooklyn Bridge as she heads down the East River to her New York pier.

THE NEW JERSEY WATERFRONT

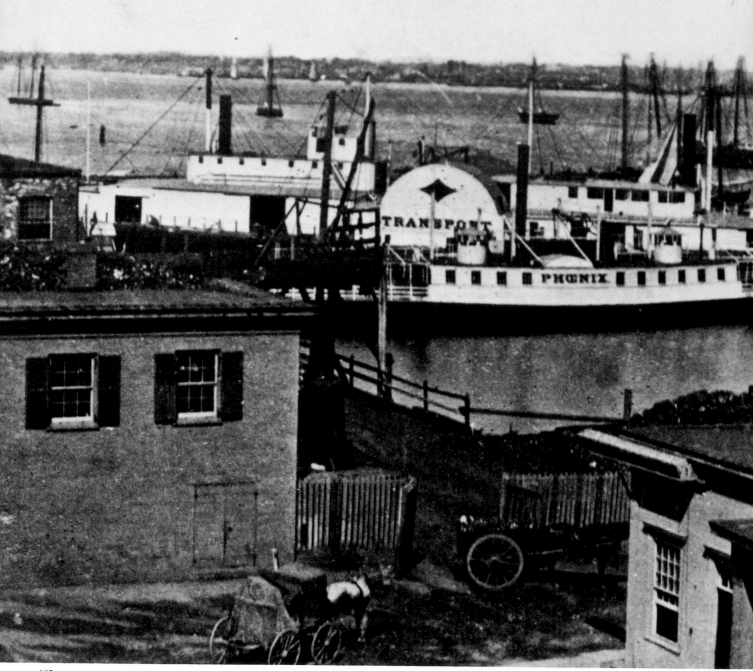

187. Looking toward New York from Hoboken, in a view published by George W. Thorne in 1863. In the foreground are the ferryboat *Phoenix* and the train ferry *Transport*. The *Phoenix*, formerly the *Fair Queen*, was renamed after she was built in 1851. She had originally been put in service in April, 1825, replacing the horsepowered ferries that ran between Hoboken and Canal Street in Manhattan. She also initiated night service across the river in the summer of 1856. The *Transport*, launched in 1845 at Hoboken, was perhaps the first train ferry in the world and was used to interchange freight cars between the Morris & Essex Railroad at Hoboken and the Camden & Amboy Railroad at South Amboy, N.J.

188. Vast quantities of Pennsylvania coal were shipped to New York harbor for use in the city and for transshipment to New England ports. One route was the Morris Canal, which connected with the Lehigh Canal at Easton, Pa., ran across New Jersey to Newark on the Passaic River, then went on to Jersey City. An Anthony view of 1868 shows some of the canal barges at the Morris Canal Basin, Long Dock, Jersey City.

189. An 1865 view from New Jersey Railway (later Pennsylvania R.R.) terminal at Exchange Place, Jersey City, N.J. Looking across the Hudson toward Manhattan, the terminal of the Hoboken Ferry is to the right. A large group of square-riggers occupies Piers 25 and 28, from Barclay to Murray Street. Next is Pavonia Ferry at Chambers Street. On the far left two Narrangansett Steamship Co. steamboats are berthed at Pier 30.

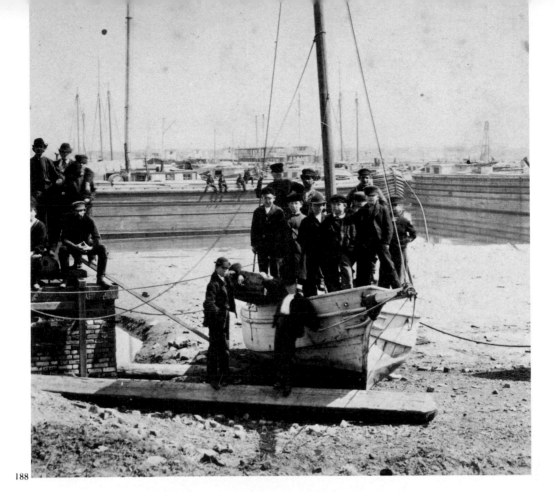

188

189

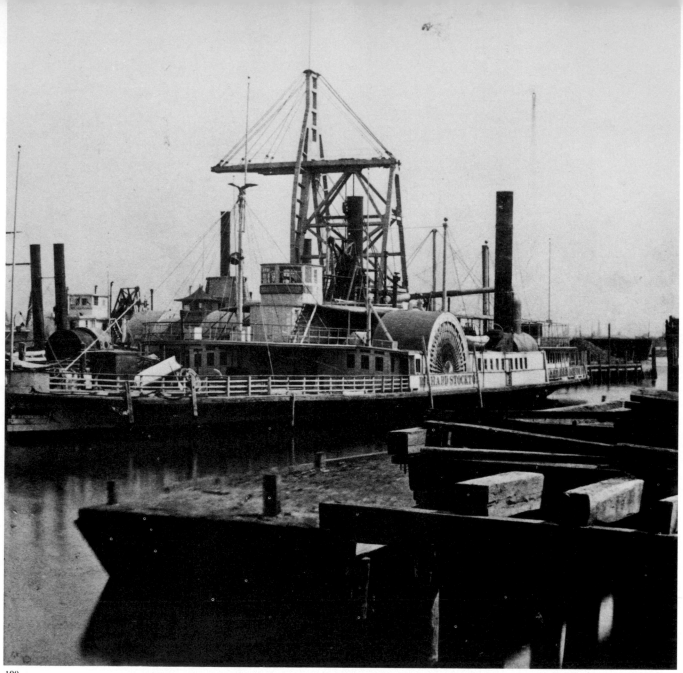

190

190. Docked at Jersey City is one of the early iron-hulled steamboats, the *Richard Stockton* (270′–20′8″–651), designed by Robert L. Stevens and built in 1852 by Harlan & Hollingsworth, Wilmington, Del. Owned by the Camden & Amboy Railroad, she ran on the Delaware River between Bordentown, N.J. and Philadelphia to complete the route from New York to Philadelphia, which was serviced by rail in New Jersey as far as Bordentown. In 1859 she was on the northern part of the route, carrying passengers from New York to South Amboy. This Anthony view was taken in 1868.

191. In 1870 G. W. Pach took this photograph of people admiring the sights of New York harbor from the deck of the Cunard Liner *Russia*, berthed at Cunard Dock in Jersey City. Built in Glasgow in 1867, the fast vessel won the Blue Ribbon for the New York-to-Queenstown crossing in June, 1867. She was one of the last Cunard Liners to have a clipper bow and a figurehead.

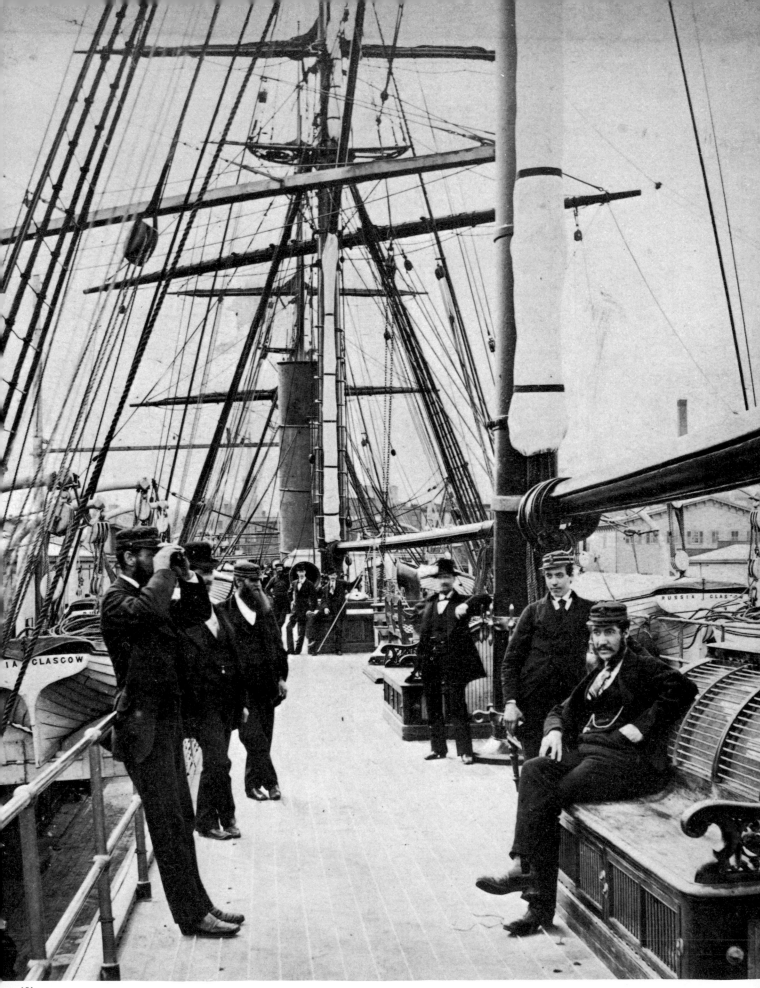

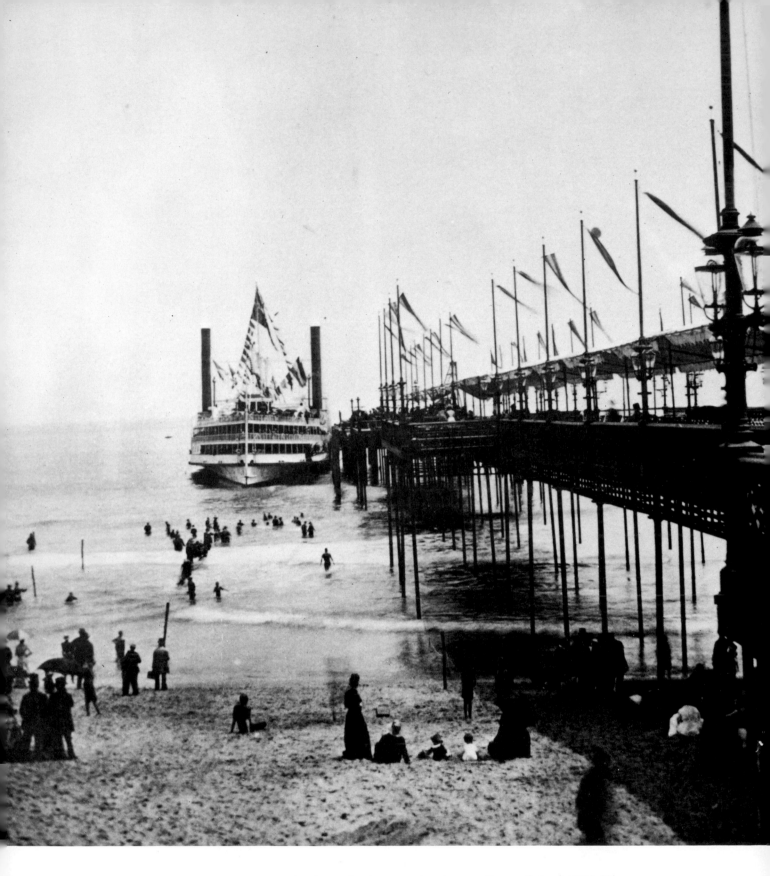

192. In 1875, G. W. Pach caught the excursion steamer *Plymouth Rock* (330'–38'–1,752), tied up to the Ocean Pier, Long Branch, N.J., ready for her return to New York. She had a wooden hull and was built by Jeremiah Simonson of New York for Cornelius Vanderbilt in 1854. One of the first steamboats especially noted for a luxurious interior decor, she was, for a time, employed by the Stonington Steamship Co. on the New York–Stonington run. Purchased by the Narragansett Steamship Co., she was completely refitted under the personal attention of James Fiske, Jr., for Long Branch service.

LONG ISLAND

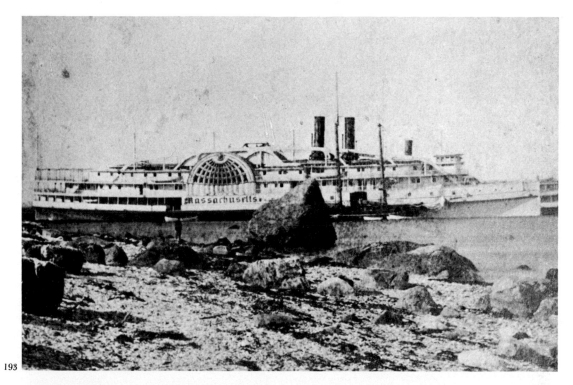

193

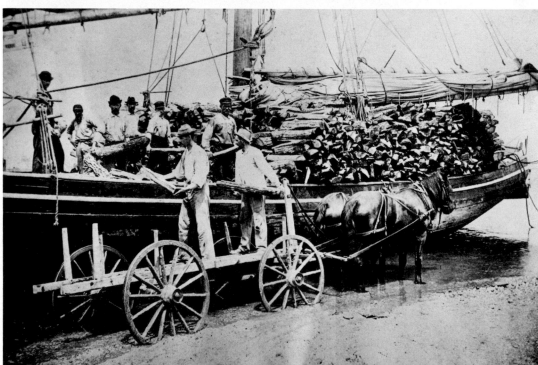

194

193. The steamboat *Massachusetts* (325′–46′) ran aground at Rocky Point on the North Shore of Long Island in the fall of 1877. Part of her cargo is seen being removed to help float her; bales of cotton are onshore to the left. The operation was successful, and she suffered negligible damage. She was launched in 1877 and, along with the *Rhode Island*, instituted service for the New Providence Line on May 7, 1877.

194. Loading a schooner on Long Island. The *Mary Alice*, beached at low tide at Miller Place, is piled high with cordwood destined for brickyards at Haverstraw on the Hudson. She was owned by Captain Daniel Davis of Mount Sinai, Long Island whose family had operated a boat yard there since 1639.

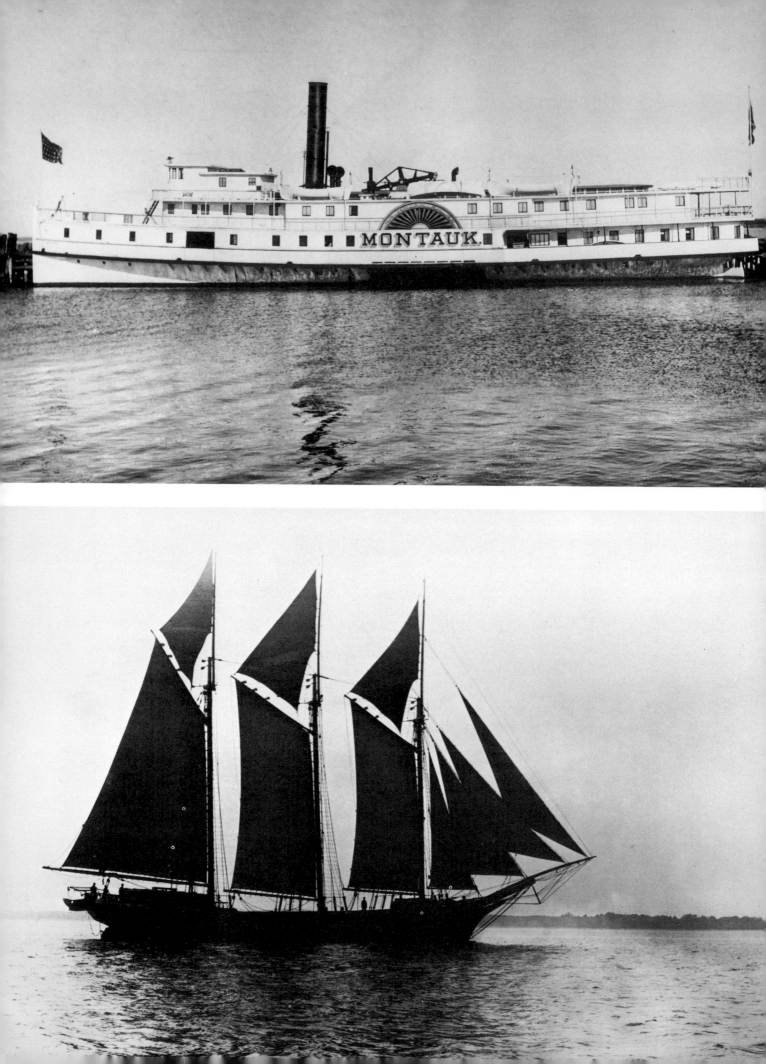

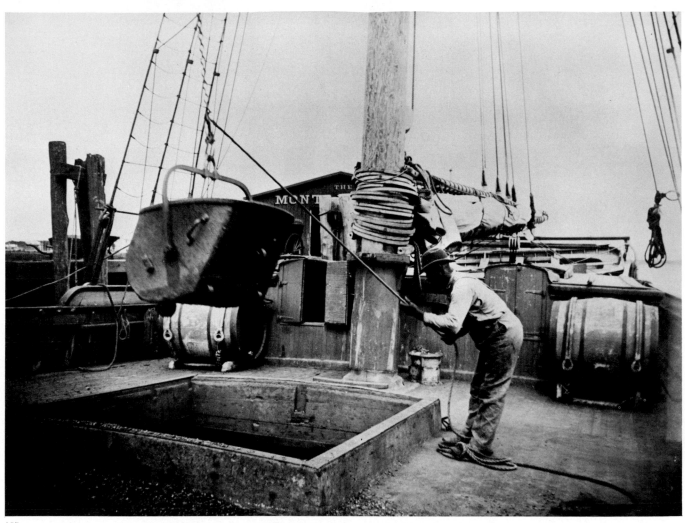

197

195. As the Long Island Railroad extended and improved its service along the North Shore, it drove the steamboats that had connected resorts and ports with New York out of business. One of the lines to resist the railroad most successfully was the Montauk Steamboat Co., which began business in 1886. With three beautiful steel steamboats, it proved a popular route to Peconic Bay ports for passengers and shippers. One of the boats, the *Montauk*, is shown here docked at Sag Harbor in 1890. The Long Island Railroad finally bought the steamboat line and kept it running for some years.

196. As long as the bays were not closed by ice, schooners delivered coal from coal pockets at Rondout, on the Hudson, and at New York. Here the three-masted *Montauk* approaches Sag Harbor with a cargo of coal in 1890.

197. Her hatch open, the *Montauk* unloads her coal, bucket by bucket, at the Montauk Steamboat Co. dock in Sag Harbor in 1890. It was a slow process, but time and labor were cheap.

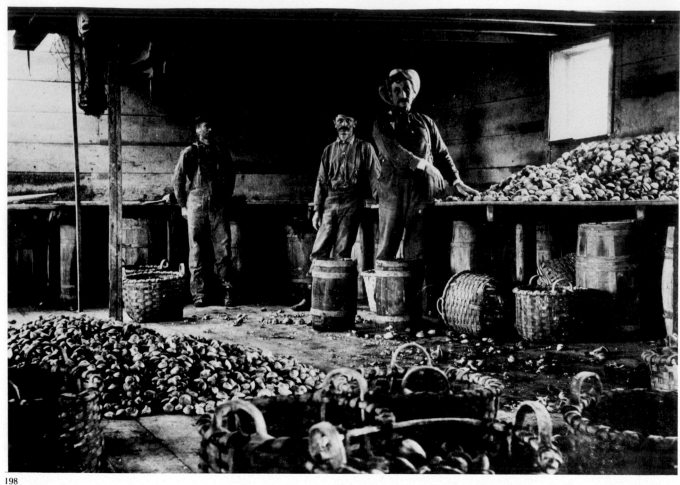

198

198. While connoisseurs preferred to have their oysters delivered to the table on the half shell, it was more economical to shuck the oysters where they were dredged and ship the meats, packed on ice, to New York and inland markets. Here is a shucking operation at John Cochrane & Sons Oyster House at Oakdale, on the South Shore.

199. The South Shore of Long Island was sandy for virtually its entire length, but it proved fatal for countless ships which ran or were driven ashore and broke up in its pounding surf. Here the battered hulk of the once-beautiful *Peter Rickmers* (321'–44'4"–2,926 gross tons) breaks up after going ashore on April 31, 1908, at Zachs Inlet, Jones Beach. She was outward-bound from New York to Rangoon, with over 117,000 cases of kerosene aboard—two five-gallon cans to a case. The steel ship

had been constructed by Russel & Co. at Port Glasgow, Scotland in 1889. Her four skysail yards were crossed above double topgallants because of her loftiness. In her 20-year career in the Asiatic trade, she set some fast times: 123 days from New York to Hiogo in 1898; 106 days from New York to Hong Kong in 1900; and 104 days from New York to Singapore in 1905, carrying close to 120,000 cases on each run.

200. The steel four-masted Norwegian bark *Clan Galbraith* (282'9"–40'4"–2,149) ran high and dry on the South Shore at Water Mill in July, 1916. Despite her size she was successfully salvaged, but lasted only one more year before succumbing to a German submarine's torpedo. In 1897 she had sailed from Liverpool to San Francisco in 118 days.

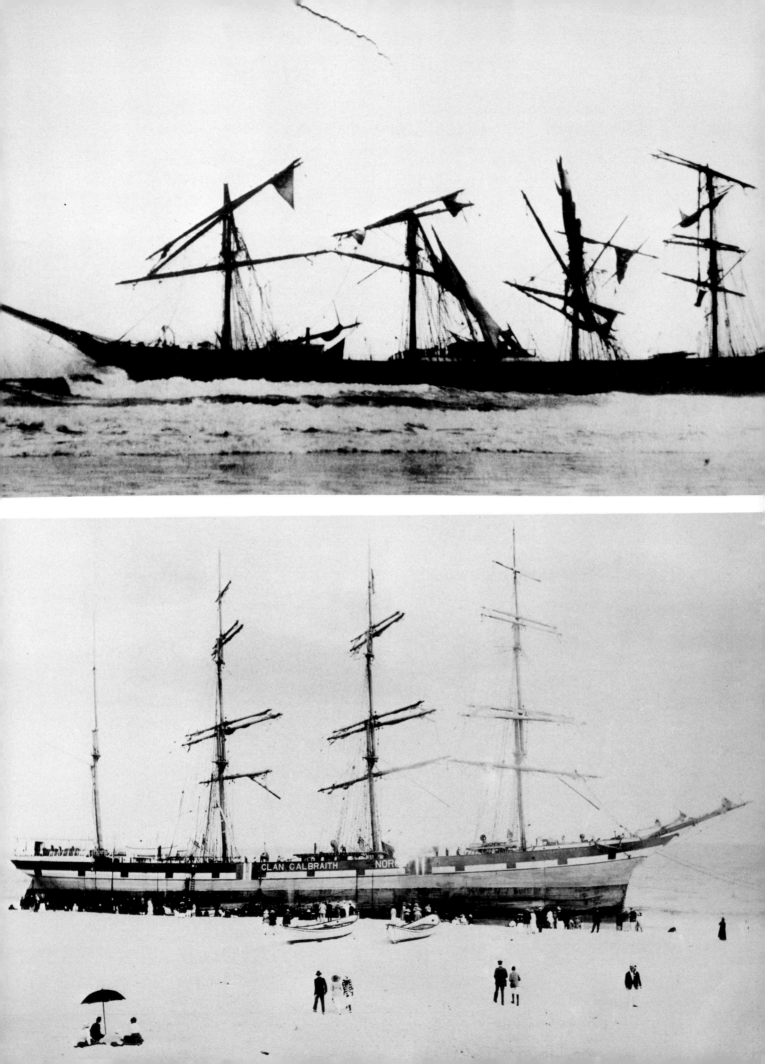

THE HUDSON RIVER

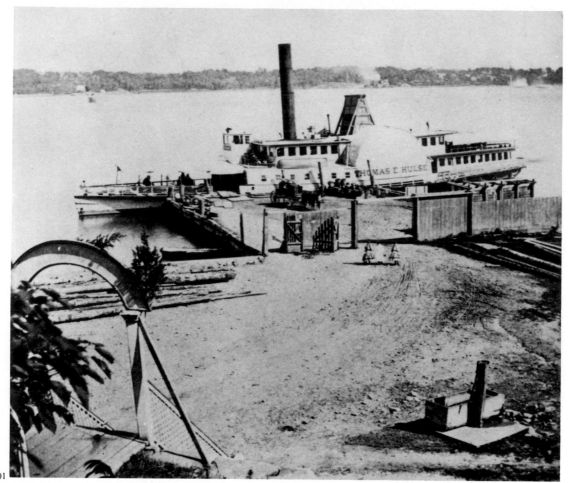

201

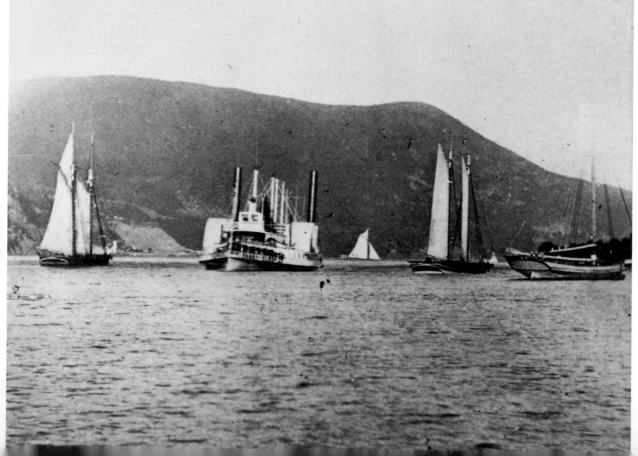

202

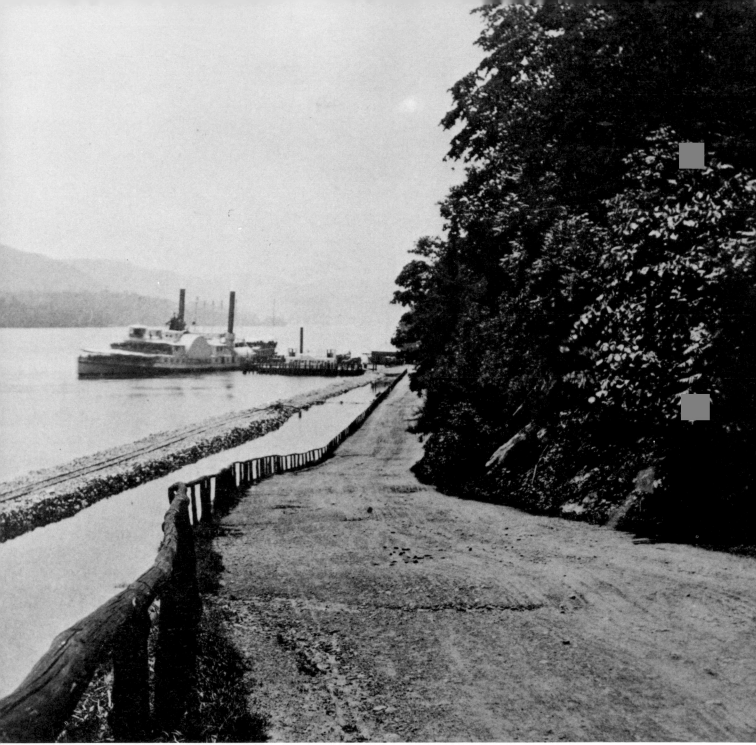

203

201. The steamboat *Thomas E. Hulse* was photographed by D. Barnum at Fort Lee, New Jersey in 1860. Commuters living along the Palisades were taken to Spring Street and the North River aboard this boat. The *Hulse* and the *Norwich* were the last vessel on the Hudson using steeple engines to operate a horizontal cross-beam up and down.

202. The grand old steamer *Mary Powell* approaches Cornwall Landing on the Hudson in 1865. She was built in 1861 by Michael S. Allison of Jersey City for Capt. Absalom Anderson of Rondout, N.Y. After being lengthened 21 feet the following year, she made some fast runs and was paired with the *Daniel Drew* on the New York to Albany run. She remained in service until 1920, becoming one of the best-known and -loved steamboats in the world. She was finally broken up in 1923. This Anthony picture also shows two two-masted schooners and two sloops, a sampling of the heavy traffic of sailing vessels

characteristic of the river for many years.

203. A fine day boat on the Hudson was the wooden-hulled *Daniel Drew* (254'–30'6"–670). She was built in 1860 by Thomas Collyer of New York for Daniel Drew, to operate in the New York-Albany trade. Her engines had been salvaged from the large side-wheeler tugboat *Titian*, which went ashore on Squan Inlet, N.J. and was totally wrecked on September 3, 1856. The *Daniel Drew* was rebuilt in 1884 at a cost of $90,000. She made her last run to Albany in June 1886, and was destroyed by fire on August 29 of that year while laid up at Kingston Point on the Hudson. This picture shows her at West Point Ferry in 1875. The ferryboat *West Point*, operating between West Point and Garrison, is in the slip. The roadbed for the New York, Ontario and Western Railroad is being laid along the shore with fill removed from the West Point railroad tunnel, also under construction.

The Hudson River 149

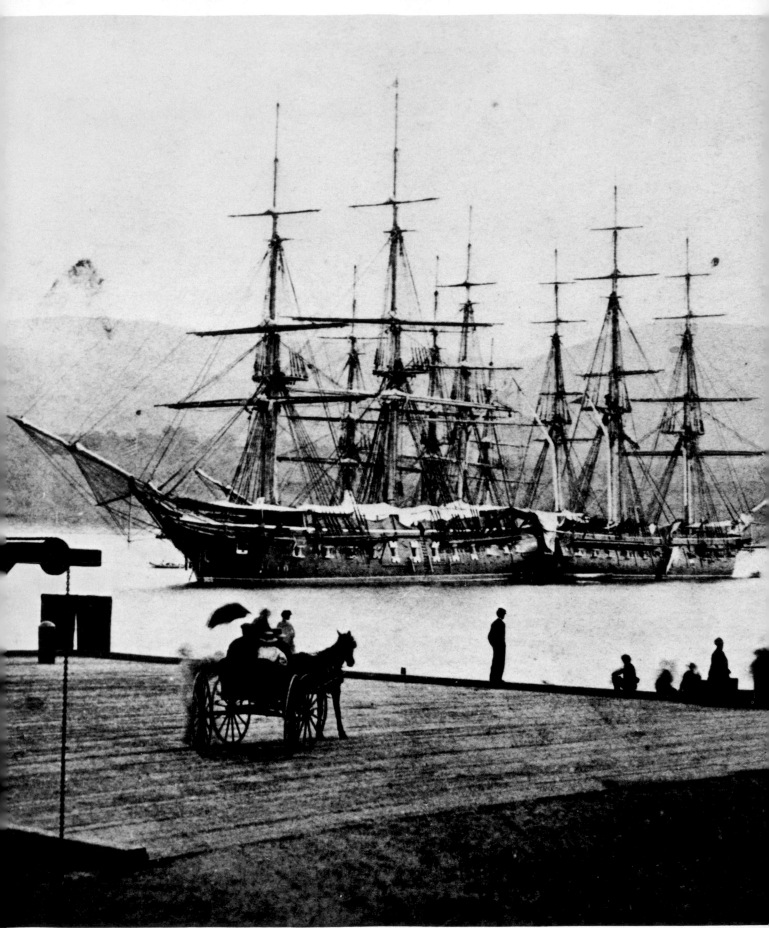

205

204. Three U.S. Navy ships of war surprised the citizens of the Hudson Valley on June 14, 1868, by visiting West Point. They are shown, in a photograph by William B. Chase of Baltimore, anchored off the South Wharf of the U.S. Military Academy. The *Macedonian*, on the left, is stern-to-stern with the *Savannah*, on the right. The bowsprit and masts of the *Dale* are visible through the rigging of the *Macedonian*. Foul-weather canvas has been rigged over the decks of the vessels. The small fleet, under the command of Commander S. B. Luce, arrived with Naval Academy midshipmen at the time of graduation, when General U. S. Grant, soon to be President, awarded diplomas. The Azores were the next port of call for the fleet after leaving West Point. The *Macedonian* (164'–41'–1,341) was the second ship of her name in the U.S. Navy. A 36-gun frigate, she was rebuilt from the keel of the first *Macedonian* at Gosport (later Norfolk) Navy Yard, and launched in 1836. She was part of the West Indies Squadron, and also patrolled the west coast of Africa. Later assigned to the East India Squadron under Commodore Matthew C. Perry, she participated in Perry's second visit to negotiate the opening of Japan to foreign trade and then patrolled in the North Pacific and Mediterranean. During the Civil War, she cruised among the West Indies and off the coast of Portugal in search of Confederate raiders. She was decommissioned and sold in 1875. The *Savannah* (175'–45'–1,726) was also the second of her name in the navy. She was a frigate, armed with eight eight-inch shell guns and 42 32-pounders. Her construc-

tion began in 1820, but she remained on the stocks for 22 years until launched at the Brooklyn Navy Yard on May 25, 1842. She served as the flagship of the Pacific Squadron in the war with Mexico on the West Coast, and later was the flagship of the Brazil Squadron. During the Civil War she was in the Federal Blockading Squadron. She was scrapped in 1883. The sloop of war *Dale* (117'7"–33'10"–566) was launched November 8, 1839 at the Philadelphia Navy Yard. She was armed with 16 32-pounders, short guns. She served off the west coast of South America in 1841, and was transferred north to the California and Mexican coasts during the war with Mexico. Between 1850 and 1859 she made three cruises to the African coast for the suppression of the slave trade. During the Civil War she joined the South Atlantic Blockading Squadron. On July 22, 1906, she was transferred to the U.S. Coast Guard at Baltimore.

205. In 1880 Stoddard took this photograph of the steamboat *Chrystenah* at dock on the Hudson River, below Englewood Cliffs, N.J. A 571-ton boat launched in Nyack, N.Y. in 1866, she traveled between New York and Peekskill until 1920, when she was sold for ferry service across Long Island Sound between Oyster Bay and Connecticut. She was the last steamboat owned by the Smiths of Nyack, and had an engine that had been salvaged from the Smiths' first steamboat, the *Arrow*, which had sunk in the Hudson. While working on the Hudson, she docked at West 22nd Street in New York.

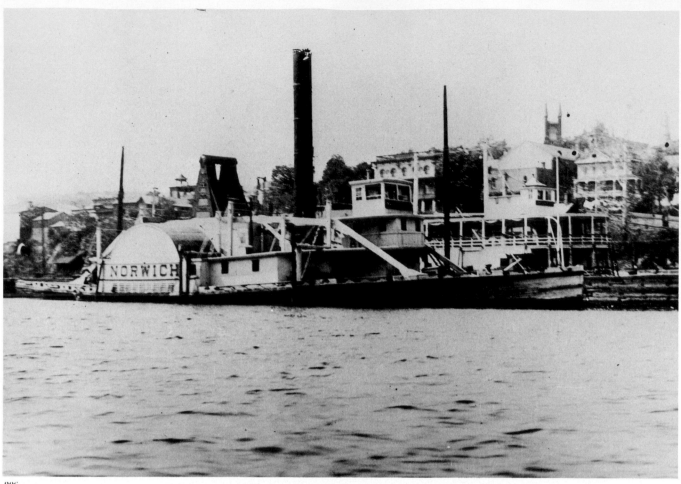

206

206. One of the longest-lived steamboats was the *Norwich* (160'–25'3"–255 gross tons), built in 1836 by Lawrence & Sneeden of New York for the New York and Norwich Steamboat Co. She was not large enough to compete with the large steamboats coming onto the sound and was sold to the New York & Rondout Line for passenger and freight service on the Hudson. Converted to towboat service, in which she operated from 1850 to 1923, she was unexcelled as an ice-breaker, opening up the channels in the spring. The Erie Railroad paid her to clear a passage through the ice for its barge and steamboat traffic from the rail terminal at Piermont to New York. Verplanck and Collyer, in *Sloops of the Hudson*, write that Capt. Jacob Dubois required one week to work the *Norwich* 20 miles through heavy ice to New York City from Piermont. This photograph was taken in 1878 at Rondout.

207. The *Richard Stockton*, as shown on the Hudson, mak-

ing her scheduled run from Jersey City to Newburgh, N.Y. in 1885, has been rebuilt since an earlier 1868 photo (page 140). Her former twin stacks and boilers on the guard are now a single stack with boiler amidship. The Pennsylvania Railroad keystone insignia is visible on the stack. She was scrapped in 1895.

208. Hudson River Day Line steamers, the *Albany* (left) heads upstream to Albany, the *New York* (right) is bound for New York City in this 1887 view, taken at Poughkeepsie. The railroad bridge was the rendezvous point for passing Day Line steamers. Both vessels were built by Harlan & Hollingsworth, Wilmington, Del. with iron hulls, three boilers and stacks, beam engines and sidewheels. The *Albany* (285'–40'–1,346) was constructed in 1880. The *New York*, built in 1886, was 15 feet longer.

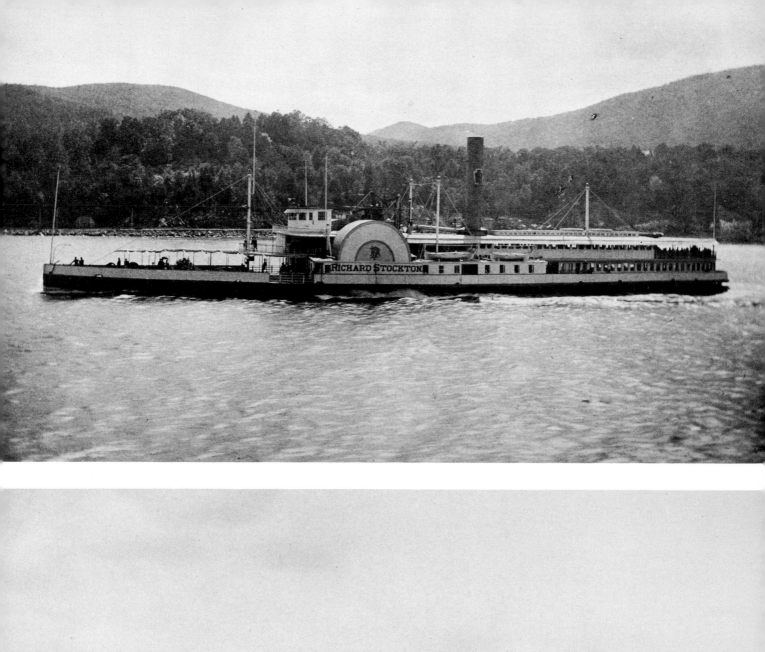

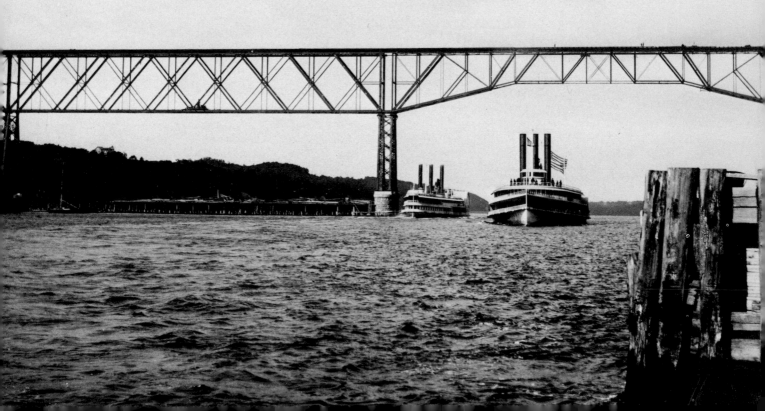

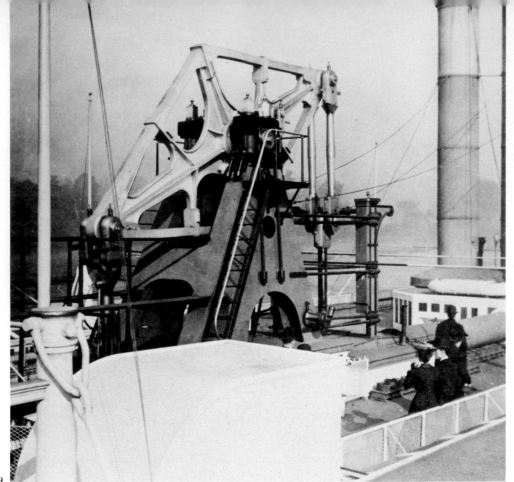

209

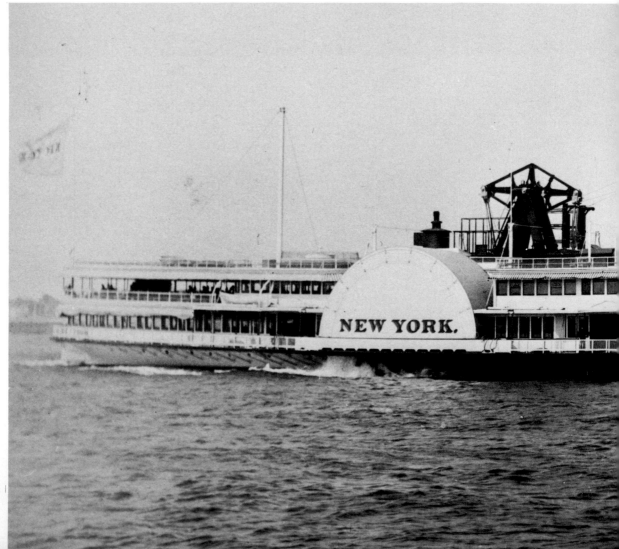

210

209. Some idea of the massiveness of the machinery in the Hudson River steamboats is conveyed by this close-up, published by H. C. White, of the walking beam of the Hudson River Day Line steamer *Albany*.

210. An 1895 photograph of the Hudson River Day Line steamer *New York* is a fine example of the instantaneous work possible on large glass plates with high-speed emulsions. Here, as well as in other photographs of steamboats under way, there is no visible smoke at the stacks. Proper fuels and efficient burning were well understood by marine engineers at an early date.

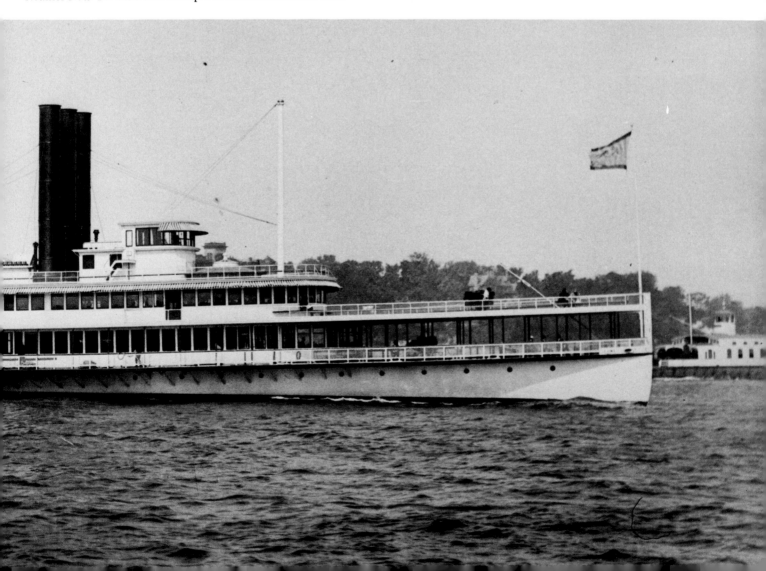

INDEX

Unless otherwise noted, references are to caption numbers. Ships are indexed by the first letter of the first word or initial. Thus *Ann Eliza* is indexed under A, *City of Albany* under C, etc.

Adams, John, page 116
Adriatic, 3
Alarm, 167
Albany, 208
Alert, 99
Alexander Nevsky, 38
Alfred Bennet, 131
Allison, Michael S., 153, 202
America, 65
America's Cup Races (1885), 60, 128–130
Anderson, Capt. Absalom, 202
Anna, 112
Ann Eliza, 86
Anthony Brothers, 6, 7–11, 13, 15, 20, 22, 26, 28, 29, 32, 34, 38, 44–46, 48, 50, 52, 53, 61, 63, 69, 88, 164, 174, 175, 188, 190, 202, page xiv
Arrow, 205
Asa Eldridge, 126
Asiatic Squadron, 166
Atlanta, 169
Atlantic Squadron, 159
Austin, 108
Austen, Alice, 136

Babbitt, Platt B., page xiii
Baltimore & Ohio Railroad, 33
Barges, 12, 51, 69, 108, 112, 114, 175, 206
 canal, 51, 188
 Maryland, 148
 oyster, 97, 150, page xiv
Barkentines, 86, 185
Barks, 138, 146, page xii
 Cape York, 141
 Clan Galbraith, 200
 four-masted, 200
 Frank Stafford, 138
 F. Reck, 52
 Iron Age, 89
 three-masted, 52, 89, 114
Barnum, D., 30, 201
Barnum, P. T., 56
Battery Seawall, 92
Beale's New York Harbor Panorama, 77, 100–105, page 75
Bennett, James Gordon, 50
Bering Sea Patrol, 98
Betty I. Conway, 53
Bierstadt Brothers, 112, 119, 173, page xiv
Big Balance Dry Dock, 57, 67, 105, 179
Black Ball Line, 29, 54, 62, page ix
Boston & Providence Propeller Line, 35
Brazil Squadron, 204
Brigantines (half- or hermaphrodite brigs), 7, 175
Briggs Brothers of Boston, 75, 126

Brigs, 7, 12, 51, page xii
Bristol, 63, 64
Brooklyn, 154
Brooklyn Bridge, 76, 77, 79, 85, 88, 102, 110, 118, 132, 183, 185, pages 75, 116
Brooklyn Navy Yard, *see* New York Naval Shipyard
Brooks Brothers, 103
Brown & Bell, 89
Brown, Vernon H., & Co., 93
Bureau of Ordnance, 167
Burtis, Devine, Jr., Shipyard, 147

Cady, Mr., page xiii
Cambria, 60
Camden & Amboy Railroad & Transportation Co., 41, 187, 190
Camilla, 57
Canal boats, 4, 91
 Simcoe, 52
Cape York, 141
Castle Clinton, 56
Castle Garden, 24, 56, 145
Castle Garden Erie Railway Depot, 145
Castle Williams, 56
Chase, William B., 93, 94, 204
Cheesman, Forman, page 116
C. H. Northam, 77, 78, 109
Chrystenah, 205
City of Albany, 109
City of Boston, 57, 105
City of Brockton, 186
City of New York, 57
City of Peking, 72
City of Tokio, 72
City of Troy, 43
City of Washington, 23
Clan Galbraith, 200
Clermont, page x
Clippers, 36, 105, pages ix, xii
 Cyclone, 75
 Dreadnought, 94
 extreme, 81, 171
 four-masted, 121
 Great Republic, 171, 172
 medium, 44, 75
 Pegasus, 121
 Reliance, 121
 Young America, 81
Clyde Line, 103, 151
Cob Island, 170
Cochrane, John, & Sons, Oyster House, 198
Collins Line, 3, 18, page x
Collyer, Thomas, 149, 203

Collyer, William, 14
Colorado, 36, 55
Columbia, 71
Commercial Line, 85
Commonwealth, 31
Compañía Transatlántica Española, 152
Comstock & Harris, 29
Comstock, Capt. Joseph J., 17
Continental, 77, 101, 109
Continental Iron Works, 163
Conway family, 53
Corsair, 130
Corsar, Charles W., 121
Cotton Depot, 134
Crescent City, 71
Crocker & Haley, 29
Croton Water Works Co., 114
Cruiser, armored
 Brooklyn, 154
 C. S. Allison, 53
Cunard Liners, 51, page x
 Russia, 191
Cuneo Importing Co., 157
Currier & Townsend Yard, 44
Curtis & Peabody, 75
Cutter
 Harriet Lane, 24
Cyclone, 75

Daily Line, 103
Dale, 204
Daniel Drew, 202, 203
Daniels, Josephus, 158
Davis, Capt. Daniel, 194
Delaware, Lackawanna and Western Railroad, 18, 149
Denmark, 171
Detroit Photographic Co., 157
Dewey Celebration, 153, 154
Dispatch Line, 85
Double-enders, page 116
"Down Easters," 114, page xii
Dreadnought, 44
Drew, Daniel, 203
Dubois, Capt. Jacob, 206
Dunderberg, 37
Dusen, J. B. & J. D., Shipyard, 33

East India Squadron, 204
Eckford, Henry, 159, page 116
Edward VII, 24, 25
Electra, 57
Eliza Hancock, 153
Elm City, 77, 109, 118
Emily, 30
England, William, page xiii

Englis, John, & Son, 55
 shipyard, 39
Erastus, Wiman, 133
Ericsson, John, 162, 163
Europa, 51
European Squadron, 166
Excursion boats, 128, 137
 General Slocum, 137, 147, 148,
 Sam Sloan, 149
 Thomas Collyer, 149

Fair Queen, 187
Fall River Line, 17, 55, 90
Federal Blockading Squadron, 204
Ferries, 12, 18, 45, 49, 50, 88, 89, 122,
 155, 183, 205, page x
 America, 65
 Fair Queen, 187
 Fulton, 181
 Hunchback, 15
 Mineola, 66
 Pavonia, 189
 Phoenix, 187, page x
 Republic, 172
 Staten Island, 40
 Thomas Hunt, 14
 train, 187
 Transport, 187
 Union Ferry Co., 10, 46, 65, 124, 172
 West Point, 203
Fiske, James, Jr., 192
Floating Bethel (Floating Church of Our
 Saviour for Seamen), 104, 105, 107
Flushing Railroad, 28
Fortress Monroe, 163
Fourth of July Regattas
 1859, 8, page xiv
 1860, 20, 21, page xiv
Fowler and Pearsall, 29
Frank Stafford, 138
F. Reck, 52
French Line, 108
Frigates, 7, 100, 159
 Alexander Nevsky, 38
 Colorado, 55, 166
 General Admiral, 17, 18
 Macedonian, 204
 President, page 116
 Savannah, 204
Fronti, 3
Full-riggers, 136
 Norfolk, 126
 Sea Witch, 136
Fulton, 181
Fulton, Robert, page x
Fulton Street Ferry Building, 54, 62, 76,
 84, 101, 181, 183
Fulton Market, 29, 54, 58, 62, 66, 77, 78,
 119, 122, page xiv
Fulton Market Fish Monger's Association,
 185

General Admiral, 17, 18
General Slocum, 137, 147, 148
Genesta, 128, 130
George Catlin, 9
George Law, 30
George M. Ferriss, 131
George Starr, 145
Georgetown & Alexandria Steamship
 Line, 44
German Lager Bier Haus, 103
Gingrass, J. E., 125

Gosport Navy Yard, 204
Grampus, 70
Grain elevator, floating, 52
Grand Republic, 137, 153
Grant, 98
Grant, Ulysses S., 72, 204
Great Eastern, 19, 24, page xiii
Great Republic, 105, 171, 172, 177, page
 xiii
Greenock, 67

Hallet, Henry S., Co., 126
Harbor cutters
 Alert, 99
 Harriet Lane, 24
Harbor lighters, 11, 61, 78, 88, 109, 151
Harlan & Hollingsworth, 89, 190, 208
Harland & Wolfe, Ltd., 94
Harlem, 77
Harlem & New York Navigation Co., 68,
 123
Harlem & Spuyten Duyvil Navigation
 Co., 30
Harper's, 79
Harriet Lane, 23
Harrison, Benjamin, 132, 133
Harrison, C. C., page xiii
Hero, 25
Hibernia, 41
High Bridge, 30
Hoboken Ferry Terminal, 189
Hoboken Land and Improvement Co., 18
Holt's Hotel, 26
Hoyer, page xiii
Hudson River Day Line, 150, 208–210
Hudson River Shipyards, 53
Hull, Commodore Isaac, 159
Hunchback, 15
Hurlbut's Line, 85
Hydrostatic Lifting Dock, 105

Ice-breaker
 Norwich, 206
Inman Line, 23
Innocents Abroad, The, 8
Iron Age, 89
Ironclads, 36, 37
 Merrimac, 163
 Monitor, 162, 163
 Re di Portogallo, 36
Iron Steamboat Co., 132
Ismay, Thomas Henry, 94
Italian Navy, 36

Jackson, Robert E., 136
Jarvis, J. F., 153
J. M. Waterbury, 34
John D. Jones, 23
J. S. Warden, 153
Juliana, page x

Kalakaua, King, 160
Kapiolani, Queen, 169
Keystone View Co., 146, 151, page xiv
Kilburn Benjamin W., 109, 114–117, 120,
 124, 127, 132, 134, 140–142, 155,
 178, 180, 182, page xiv
Knickerbocker Steamship Co., 137, 147,
 153

Lamport & Holt Steamship Line, 178
Landing ships, page 116
Langenheim Brothers, 1, 2, page xiii

Large Screw Dry Dock, 105
Law, George, 30
Lawrence & Foulkes, 68
Lawrence & Sneeden, 206
Leutze, Admiral E. H. C., 158
Liebert, A., & Co., 37
Lind, Jenny, 56
Liverpool, 89
Lloyds, 5
Loeffler, J., 139
London Stereoscopic Co., page xiii
Long Island Railroad, 73, 195
Low, A. A., & Brother, 171
Luce, Commander S. B., 204
Lyles, 141

Macedonian, 204
Macmillan Shipyard, Scotland, 67
Magenta, 74
Magic, 60
Maine, page 116
Majestic, 94
Mallory, C. A., & Co., 100
Mallory Line, 83
Manhattan Railway Co., 155
Martin Stores, 178
Mary Alice, 194
Maryland, 148
Mary Powell, 202
Massachusetts, 193
McAlpin, William Jarvis, 158
McKay, Donald, 105, 171, page 116
Mediterranean Squadron, 159
Merchant's Despatch Propeller Line, 35
Merchants Line, 86
Merchant Steamship Co., 63
Merrimac, 163
Mineola, 66
Monitor, 163
Monmouth, 133
Montague Street Ferry Terminal, 173
Montauk, 195
Montauk Steamship Co., 195, 197
Monticello, 46
Morgan, J. P., 130
Morgan Line, 100
Morris and Essex Railroad Co., 18, 187
Morrisania, 28, 30, 109
Morrisania Steamboat Co., 68, 77, 109
Morro Castle, 71
Morse, Samuel, page xiii
Moulton, John S., 58, 59, 65, 66, page xiv
Murray Line of Barges, 112

Narragansett, 70
Narragansett Steamship Co., 63, 189, 192
National Despatch Line, 104
Nautilus, page x
Naval vessels, 160
Navy Department, 158
Navy gunboats, 15, 43, 164
 Alarm, 167
 North Carolina, 165
 Vermont, 165
Neptune Steamship Co., 33
New Bedford and New York Steamship
 Co., 104
New Haven and Hartford Steamship Line,
 59
New Haven Line, 101
New Haven Steamboat Co., 77, 78, 109,
 118
Newport, 55

New Providence Line, 193
Newton's Ship Chandlery, 6
New York, 150, 208, 210
New York & Havana Direct Mail Line, 71
New York and Liverpool United States Mail Steamship Company, page x
New York & Philadelphia Steamboat Co., 70
New York & Rondout Line, 206
New York Barge Office, 40, 50
New York Floating Dry Dock, 105
New York Herald, 50
New York Nautical Schoolship
 St. Mary's, 82
New York Naval Shipyard (Brooklyn Navy Yard), 55, 158–161, 164–168, 170, 204, page 116
New York, Ontario and Western Railroad, 203
New York Regatta Club, 8
New York Salt Water Floating Bath, 16
New York Screw Dock Co., 105
New York State Commissioners of Immigration, 56
New York Yacht Club, 60, 128, 130
 station, 129
Norfolk, 126
Norfolk Navy Yard, 166, 204
North Alaska Salmon Co., 136
North Carolina, 160, 161, 164, 165
Norwich, 201, 206
Norwich and New London Line, 104
Norwich & New York Transportation Co., 57
Norwich Steamboat Co., 206

Occidental and Oriental Steamship Co., 94
Ocean Belle, 5, page xiii
Oceanic, 94
Oceanic Steam Navigation Co., 94
Ohio, 159, page 116
Old Slip House, 157
Oregon, 57

Pach, George W., 72, 191, page xiv
Pach Brothers, 72, page xiv
Pacific Mail Line, 95
Pacific Mail Steamship Co., 30, 36, 127, 174, 177
Pacific Squadron, 82, 159, 204
Packet ships, 2, 36, 62, 85, 86, 172, pages ix, x
 Black Ball Line, 41, 54, 62, 79, page ix
 Dreadnought, 44
 Hibernia, 41
 Liverpool, 89
 square-rigged, 84
 three-deck, 89
Palmer, Capt. Nathaniel B., 72, 171
Panama Railroad Co., 30
Pavonia Ferry, 189
Pegasus, 121
Pennsylvania Railroad, 207
Perry, Commodore Matthew C., 204
Peter Rickmers, 199
Philadelphia Navy Yard, 160, 204
Phoenix, 187, page x
Pike Street Sectional Dock, 105
Piledrivers, 51, 123
Pilot boats
 J. M. Waterbury, 34
 John D. Jones, 23

Pinto, F. E., 175
Pook, Samuel, page 116
Porter, Admiral D. D., 167
Portland Steamers, 104
Post Office, 79, 80, 102
Powerboat
 Betty I. Conway, 53
Produce Exchange, 131, 145
Propeller
 Electra, 57
Protected cruiser
 Atlanta, 169
Providence, 63
Providence Line, 57
Puritan, 128–130

Quaker City, 8
Quartermaster Corps, 153

Rabineau, Dr. Jacob, 17
R. A. Stevens, 9
Rea & Pollock, House and Ship Plumbers, 45
Receiving ship
 North Carolina, 160
Re di Portogallo, 36
Reliance, 121
Revenue Cutter
 Grant, 98
Revenue Cutter Service, 98
Rhode Island, 193
Richard Stockton, 190, 207
Roach, John & Sons, Shipyard, 169
Robbins, John N., Co., 63
Robbins Ship Yard, 148
Robins, W., Sail Loft and Thorn, 6
Roche, Thomas C., 45, 46, page xiv
Rogers, Commodore John, 160
Roosevelt Ferry Terminal, 73, 102
Row, William H., 149
Royal Baking Powder, 146
Royal Thames Yacht Club, 60
Rupp, M., & Co., 140
Russel & Co., 199
Russia, 191
Russian Imperial Navy, 17

St. George Line, 44
St. Laurent, 108
St. Mary's, 82
St. Paul's Church, 101
Sam Sloan, 149
Samuels, Capt. Samuel, 44
Sappho, 77
Savannah, 204
Schermerhorn Row, 54, 78
Schley, Admiral Winfield, 154
Schooners, 7, 10, 16, 22, 29, 48, 53, 60, 66, 69, 77, 79, 86, 88, 117, 135, pages x, xii
 Ann Eliza, 86
 C. S. Allison, 53
 fishing, 29, 66, 185
 Mary Alice, 194
 Montauk, 196
 three-masted, 77, 79, 123, 182, 183, 196, 202
 two-masted, 53, 182, 183
Screw Dry Dock, 179
Seamen's Boarding House, 73
Seamen's Church Institute of New York, 107
Seamen's Friends Society, 104

Sea Witch, 136
Sectional Dry Dock, 105
Seymour, Commodore, 25
Shadyside, 107
Shinnecock, 46
Ships of the line
 North Carolina, 161, 165
 Ohio, 159
 Vermont, 165
Simcoe, 52
Simonson, Jeremiah, 192
Sirius, 132, 133
S. J. Christian, 57
Skiffs, 13
Sleibrecht, 125
Sloops, 7, 21, 22, 48, 202, pages ix, x
 George Law, 30
 of war, 82, page 116
 sailing, 97
Smiths, 205
Sneeden, Samuel, 57, 118
Sneeden & Whitlock, 171
Soper, Dr. George A., 16
Soule, John, 42, 43, page xiv
South Atlantic Blockading Squadron, 204
South Ferry, 116
South Side Railroad's Ferry Terminal, 73
South Street Seaport Museum, 26, 54, page xiii
Southworth and Hawes, 159
Spirea, 77
Springfield Line, 110, 111
Square-riggers, 34, 84, 135, 179, 184, 189
 Cyclone, 75
 Greenock, 67
Stacy, George, 12, 19, 25, 27, 31, page xiii
Stag Hound, 105
Standard Fruit Co., 157
Starin, George, 149
Starin Line, 149
Staten Island & New York Ferry Co., 15
State of New York, 57
Statue of Liberty, 100
Steamboats and steamships, 3, 8, 13, 18, 22–24, 28, 30, 31, 33, 36, 39, 41, 42, 47–49, 55, 57, 61, 63, 68, 70–72, 74, 77, 78, 93, 94, 101, 104, 107, 108, 111, 122, 123, 127, 132, 147, 151, 183, 189, 195, pages x, xii
 Adriatic, 3, 18
 Albany, 208, 209
 Arizona, 174
 Arrow, 205
 Atlantic, 18
 Baltic, 18
 Bristol, 63, 64
 C. H. Northam, 77, 78, 109
 Chrystenah, 205
 City of Albany, 109
 City of Boston, 57, 105
 City of New York, 57
 City of Peking, 72
 City of Tokio, 72
 City of Washington, 23
 coastal, 64, 123
 Colorado, 36, 55
 Columbia, 71
 Commonwealth, 31
 Continental, 77, 101, 109
 Crescent City, 71
 Cunard, 93

Daniel Drew, 202, 203
Elm City, 77, 109, 118
Emily, 30
excursion, 192
General Slocum, 137, 147, 148
Grampus, 70
Grand Republic, 137, 153
Great Eastern, 24
Great Republic, 177
Harlem, 77
iron-hulled, 190
Magenta, 74
Majestic, 94
Mary Powell, 202
Massachusetts, 193
Mineola, 124
Montauk, 195, 197
Morrisania, 28, 30, 109
Morro Castle, 71
Narragansett, 70
Navy, 33, 170
Newport, 55
New York, 208, 210
Norwich, 201, 206
ocean, 83, 94
Oregon, 57
paddle, 108
Plymouth Rock, 192
Providence, 63
Quaker City, 8
Rhode Island, 193
Richard Stockton, 190
river, 123
St. Laurent, 108
Sappho, 77
Spirea, 77
State of New York, 57
Shadyside, 107
Sirius, 132
sternwheelers, 109
Stonington, 70
Sylvan, 30
Sylvan Dell, 68
Sylvan Glen, 13, 68, 123
Sylvan Grove, 68
Sylvan Shore, 61, 68
Sylvan Stream, 68
Teutonic, 94
Thomas C. Hulse, 201
Thos. P. Way, 74
Tiger, 30
Tiger Lily, 38
Wilbur A. Heisley, 109
William Cook, 41
Yang-tse-Kiang, 39
Steel ship
Peter Rickmers, 199
Steers, George, Shipyard, 3
Steers, Henry, Shipyard, 174, 177
Stevens, Robert L., 41, 190

Stoddard, 205, page xiv
Stonington, 70
Stow, John E., 84
Stonington Steamship Co., 70, 192
Strand, L. G., 135
Strohmeyer & Wyman, 137, 143
Suwonada, 39
Swallow Line, 89
Swatara, 168
Sylvan, 30
Sylvan Dell, 68
Sylvan Glen, 13, 68, 123
Sylvan Grove, 68
Sylvan Shore, 61, 68
Sylvan Stream, 68

Teutonic, 94
Thomas Collyer, 149
Thomas E. Hulse, 201
Thomas Hunt, 14
Thos. P. Way, 74
Thorn, Lieutenant Jonathan, page 116
Thorne, George W., 35, 187
Tiger, 30
Tiger Lily, 30
Titian, 203
Todd Shipyards, 63
Todd, William H., 63
Towboats, 11, 12, 42, 57
 Anna, 112
 Austin, 108
 City of Troy, 43
 George Catlin, 9
 George Starr, 145
 Norwich, 206
 paddle-wheel, 112, 145
 R. A. Stevens, 9
 Virginia Seymour, 145
Transport, 187
Tribune Building, 80, 102
Trinity Church, 101
Tugboats, 88, 112, 124, 132, 145, 148,
 150, 176, 182, 184
 Camilla, 57
 S. J. Christian, 57
 Titian, 203
Twain, Mark, 8
"Typhoid Mary," 16

Underwood & Underwood, 185, page xiv
Union Blockading Fleet, 163
Union Ferry Company, 10, 46, 65, 124,
 172
United States Coast Guard, 98, 204
United States Hotel, 26, 54, 62, page xiii
United States Mail Steamship Company,
 30
United States Military Academy, 204
United States Navy, 33, 159, 160, 164

Vanderbilt, Cornelius, 15, 192, page x
Van Dyke's Hotel, 103
Vaughan and Lynn, 8
Veeder, A., 75
Vermont, 165
Vermont Central Railroad, National Des-
 patch Line, 104
Verplanck and Collyer, 206
Virginia Seymour, 145

Wales, Prince of (Edward VII), 24, 25,
 page xiii
Warships, 36–38
 Dale, 204
 Dunderburg, 37
 Macedonian, 204
 Savannah, 204
Washington Building, 145
Washington, George, Centennial Cele-
 bration (1889), 132, 133
Washington, D.C., Navy Yard, 82
Washington Market, 143
Waterboats, 114
Webb, Isaac, 159, page 116
Webb, William, 17, 18, 37, 63, 67,
 81, 105, page 116
Webb, William H., Shipyard, 36, page
 ix
Webb & Bell, 65
Webster & Albee, 138
Weld, William F., & Co., 136
West Battery, 56
Western Hotel, 19
Western Union Telegraph Building 101
Western Union Telegraph Company, 50
Westervelt, Jacob A., page ix
West Indies Squadron, 204
West Point, 203
West Washington Market, 150
Wheatstone, Sir Charles, page xiii
White, Franklin, 5 page xiii
White, H. C., 148, 209
White, H. C., Co., page xiv
Whitehall boats, 20, 34
White Star Line, 94
William Cook, 41
Williamsburg Bridge, page 116
Williams, Capt. Jerome W., 31
Wood, Fernando, 24
Woodard, C. W., 166

Yachts
 Cambria, 60
 Corsair, 130
 Genesta, 128, 130
 Magic, 60
 Puritan, 128–130
Yang-tse-Kiang, 39
Young America, 81
Young, R. V., 154